Vernacular Visionaries

Yale University Press
New Haven and London

in association with
The Museum of International Folk Art
Santa Fe, New Mexico

Vernacular Visionaries International Outsider Art
Visionaries Outsider Art

Edited by Annie Carlano

This book is published on the occasion of the exhibition *Vernacular Visionaries: International Outsider Art in Context*, Museum of International Folk Art, Santa Fe, 31 October 2003–29 August 2004.

Designed by Daphne Geismar
Set in Scala Sans type by Amy Storm
Printed in Singapore by CS Graphics

Library of Congress Cataloging-in-Publication Data
Vernacular visionaries: international outsider art / edited by
Annie Carlano.
 p. cm.
Exhibition catalog.
Includes bibliographical references and index.
ISBN 0-300-10173-2 (cloth: alk. paper)
ISBN 0-300-10226-7 (pbk.: alk. paper)
1. Outsider art—Exhibitions. 2. Art, Modern—20th century—
Exhibitions. I. Carlano, Annie. II. Museum of International
Folk Art (N.M.)
N7432.5.A78V47 2003
709'.04'0707478956—dc21
2003009886

ISBN 0-300-10173-2: distributed by Yale University Press
ISBN 0-300-10226-7: distributed by the Museum of International Folk Art

A catalogue record for this book is available from the British Library.
The paper in this book meets the guidelines for permanence and durability of the Committee on Production Guidelines for Book Longevity of the Council on Library Resources.

10 9 8 7 6 5 4 3 2 1

FRONT COVER (cloth edition)
Carlo, *Untitled*, c. 1962
Tempera and cigarette wrapper collage on paper
13 3/4 x 19 5/8 in. (35 x 50 cm)
Collection de l'Art Brut, Lausanne, Switzerland

FRONT COVER (paperback edition)
Carlo, *Untitled* (detail), 1957
Tempera and ink on paper
Overall dimensions: 19 5/8 x 27 in. (50 x 70 cm)
Collection of Eugenie and Lael Johnson

To my family

709.04

7

Contents

Foreword

The cultural history of the twentieth-century United States may be seen broadly as a series of struggles toward inclusion and full participation for immigrants, women, African-Americans, Latinos, gays, lesbians, and transgendered people, among others. Scholarship in the arts reflects this same impulse in its treatment of various genres and their inclusion in the canon. Nowhere is this more evident than in the field of Outsider Art.

Vernacular Visionaries: International Outsider Art explores an art form that has long been on the fringes of fine and folk art studies. As exhibition and publication, *Vernacular Visionaries* probes the relationships and discontinuities, not only of this type of art, but also by implication the connections between museums and the concepts of art that guide the development of collections, exhibitions, and programs. It is the first such international exhibition of this material to be shown in an American museum. Engaged in presenting vernacular arts in cultural context since its opening in 1953, the Museum of International Folk Art builds upon its record by organizing an exhibition and publication that take an in-depth approach to subject matter too often detached from its cultural roots and spiritual influences. Through a multidisciplinary, international perspective, this book recognizes the individual genius of the art and situates it within the continuum of invention and tradition, continuity and change, that describes the work of eight individual artists and the breadth of the museum's programs.

The questions raised by the essayists in this volume provoke fascinating discussions. The question of terminology alone sparks conversations in such diverse settings as graduate seminars, professional conferences and staff meetings, cocktail parties, exhibition galleries, and university presses. The debate over definitions of contested terms is equally energetic. While the ambiguity of the artists' relationships to the slippery boundaries of the art world may be the subject of ongoing discourse, the validity and power of their creations are undeniable. Around the edges of blurred borders, these works suggest enticing possibilities for delving into the range of human creativity and artistic expression.

For their support of this complex and challenging project, thanks are due to the International Folk Art Foun-

dation, the Museum of New Mexico Foundation, the Folk Art Committee, and Lael and Eugenie Johnson. Many individuals believed in this endeavor and helped to make it a reality. First and foremost, Annie Carlano deserves a multitude of accolades. She transformed the germ of an idea into a book and exhibition of major importance to the study of twentieth-century Outsider and Visionary Art. Her professionalism, expertise, and scholarship have been a catalyst for success. With Cate Feldman's assistance, she has assembled a compelling selection of works for the exhibition and guided the publication to completion. We are indebted to the scholars who lent their expertise to this project, and especially to those who authored essays for this volume. Lenders to the exhibition have graciously shared their art with the museum and its international visitors. We are pleased to present *Vernacular Visionaries* as a contribution that will stimulate ongoing conversation among its audience.

Joyce Ice
Director
Museum of International Folk Art

Acknowledgments

The making of this book has been a long but, happily, not a solo journey. At the Museum of International Folk Art, no aspect of this project would have been possible without the assistance and consummate professionalism of research associate Cate Feldman; if "god is in the details" she is indeed a goddess. Bobbie Sumberg gave generously of her office space and editing skills, and Tey Marianna Nunn and Tamara Tjardes lent much moral support. Paul Smutko, collections manager, helped in myriad ways, his enthusiasm for Outsider Art a constant buoy. Debbie Garcia, registrar, guided the loan process, and Ree Mobley, librarian and archivist, greatly facilitated the research and editing phase of the project; both she and Debbie Garcia displayed much altruism, for which I am deeply grateful. Mary Margaret Moore and Rosemary Sallee, interns, happily handled an array of tasks. Jacqueline Duke and Frank Cordero managed the complicated financial details with care and skill. Administrative staff Chris Vitagliano and Laura May helped ably with technical glitches and shared their innate common sense. Former director Charlene Cerny was the first to champion my idea of *Vernacular Visionaries*. Without the approval of my colleagues on the Collections Committee, the project would not have gone forward. I thank them for their interest and their trust. Joyce Ice, director, was always there to discuss and navigate the more challenging situations with me, offering her typical calm and balanced view.

The exhibitions staff, under the direction of Barbara Hagood, has created an exhibit installation that is both stunning and informative. Working with designer John Tinker was ideal; we agreed from the beginning on an approach to *Vernacular Visionaries*. The process of creating the show has been a true partnership. Phil Nakamura and Paul Singdahlsen worked diligently on the installation.

Thanks also to Claire Munzenrider, Patricia Morris, and the conservation staff for their efforts, and to Aurelia Gomez and the educators.

Jennifer Marshall led the public relations and marketing endeavors with much energy and spunk. John Stafford and Pamela Kelly of the Museum of New Mexico Foundation were able to see the visual potential and popular appeal of this artwork.

Mary Ellen Stuart of Masterpiece International Shipping cheerfully advised on global loan issues and coordinated a tedious process. Her ability to solve problems in a New York minute is astounding.

The lavish color plates that grace the pages of this book are the work of a group of gifted art photographers: Addison Doty, Umberto Tomba, Paul Smutko, D. James Dee, Tereza Kabůrková, Guy Vivien, Blair Clark, Chung-hsin Lin, Joseph Painter, William H. Bengston, Laurent Lecat, Tom van Eyende, Deidi Von Schaewen, Claude Borand, and Don Tuttle.

My gratitude to the following collectors and institutions: Rémy Audouin, Sig.ra Maria Pia Balestrieri, Edward "Monty" V. Blanchard III, Jill and Sheldon Bonovitz, Linda and Larry Feiwel, Tom and Pei-Ling Isenberg, Lael and Eugenie Johnson, Vincent Monod, Collection de l'Art Brut, Leslie Muth Gallery, Ron Jagger, Phyllis Kind, Phyllis Kind Gallery, Cavin-Morris Gallery, Jim Nutt and Gladys Nilsson, The CAAC and Collection Jean Pigozzi, Philippe Boutte, Angela and Selig Sacks, Sig. Alessandro Zinelli, Fondazione Culturale Carlo Zinelli, Zemánková Family Archive, Jack Lindsay, Innis Shoemaker, The Philadelphia Museum of Art, The Milwaukee Art Museum, Ricco Maresca Gallery, Geneviève Rosset, Cheng-kuang Ho, the Hung Tung family, Hung Tung Museum, Ellen and Les Kreisler, director Gérard Viatte of the Musée National des Arts d'Afrique et d'Océanie, Judith Wang, Pauline Shaver, Williams Collection, Yü Chow, Taiwan Museum of Art, and several anonymous individuals.

At Yale University Press Patricia Fidler, art and architecture publisher, deserves my deepest thanks for her belief in this book from the beginning. Thanks also to Michelle Komie, assistant art editor and the master juggler who kept everything moving, photo editor John Long, and Jeffrey Schier, manuscript editor extraordinaire who smoothed the painstaking process of the final edit. My thanks to Daphne Geismar, designer, and to Mary Mayer, who managed the production of this book. As a team they are superb, and I feel blessed to have had the opportunity to work with such talent.

Engaging scholars and writers John Beardsley, Caterina Gemma Brenzoni, Victoria Lu, John Maizels, Jacques Mercier, Randall Morris, and Susan Brown McGreevy were formidable authors. Ceil Friedman and Jennifer Thévenot translated complex texts with intelligence, sensitivity, and enthusiasm for the subject.

Colleagues and friends who helped with *Vernacular Visionaries* include: Cliff Ackley, Gregory Amenoff, Brooke Davis Anderson, Chase Ault, Herb Beenhouwer, Simon Carr, Riann Coulter, Susann Craig, Charles Daudon, Julia Elmore, Francine Goldenhar, André Magnin, Charlotte Lacaze, Daniel and Josiane Fruman, Susan Jenkins, Maggie Maizels, Emilia Kabakov, Britta Lee, Pauline Shaver, Terezie Zemánková, Marketa Paurova, Alena Nádvorniková, Ann and John Ollman, Shari Cavin, Judy Saslow, Andrea and Jacques Valerio, Jan Petry, Angie Mills, Barbara Šafárová, Jennifer Pinto Safian, Cele and the late Myron Shure, Diane Karp, Joyce and Jim Idema, Eugenie and Lael Johnson, Jane Reid, John Ravenal, Roger Ricco, John Rossetti, Laurel Seth, Lynn Spriggs, Bob Roth and Cleo Wilson, Jeff and Jeannie Wolf, and Ben, Jim, and Joan Wright.

The Museum of New Mexico Foundation, through the Visionary Art Initiative, provided the seed money and consciousness-raising in the early stages. A special thank you to the following for their generosity: Leslie Muth, Charmay Allred, Elisabeth and James Alley, Jane and Bill Buchsbaum, Peggy T. Hall, Kay Delle Koch, Lisa K. Leinberger, Jack and Elaine Levin, Barbara Rose and Ed Okun, Joan and Cliff Vernick, Mary Adams Wotherspoon, Susann Craig, Debbie and Marty Fishbein, James Q. Hall, Natalie Fitz-Gerald, Margaret Z. Robson, Sandy and the late Diane Besser, Roz and Lowell Doherty, Eileen Wells, and Eugenie Johnson.

Among other things, The Folk Art Committee made possible my research trip to the Czech Republic. Lael Johnson, with typical stealth and élan, contributed substantially. Major financial support for *Vernacular Visionaries* came from the International Folk Art Foundation, the safety net without which a project of this magnitude would have been impossible.

Annie Carlano
Curator of European and
North American Collections

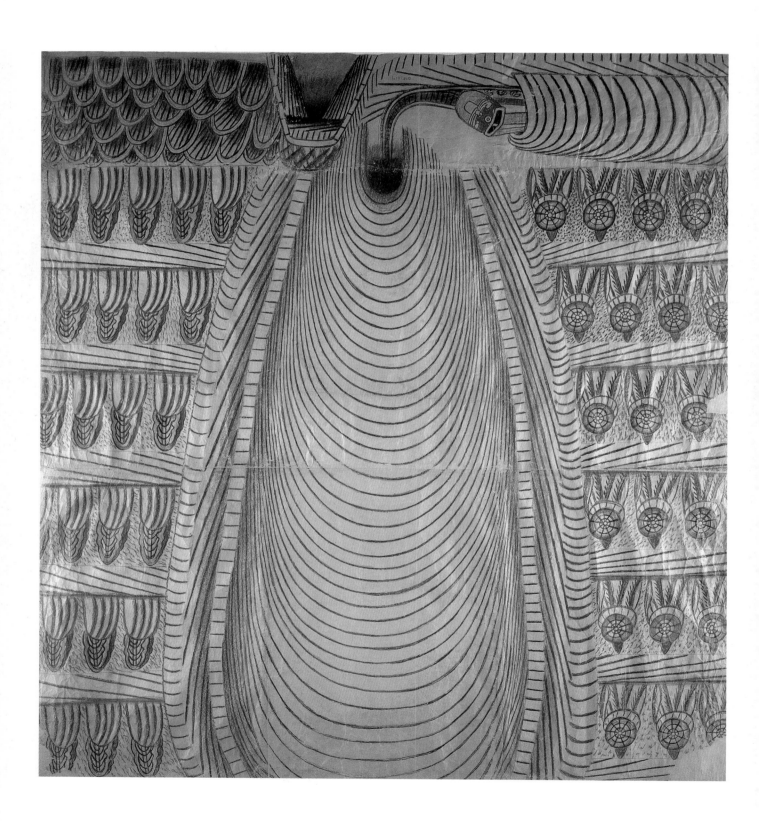

Introduction

Annie Carlano

Vernacular Visionaries: International Outsider Art is about the art of Gedewon, William Hawkins, Martín Ramírez, Nek Chand, Hung Tung, Charlie Willeto, Anna Zemánková, and Carlo. From Ethiopia, the United States, Mexico, India, Taiwan, the Diné (Navajo) Nation, the Czech Republic, and Italy, respectively, these individuals created drawings, paintings, collages, mixed-media works, and sculpture at the peak of imagination and spirit. *Vernacular Visionaries* focuses on the paradox of this artwork, which is at once the expression of deeply personal visions yet is encoded with visual and written references to the maker's particular place and time. The art communicates both a "vertical" identity—coming from family, religion, folklore, and geographic location—and a "horizontal" identity— coming from the time in which they lived.[1] This approach challenges the pervading premise that the raw, enigmatic, and even sublime attributes of Outsider Art stem almost exclusively from the mind of the maker, the collective unconscious, or supernatural beings, divorced from the realities of everyday experience.

Although the term *outsider* is currently controversial in the United States we use it here for the same reason William Rubin and the Museum of Modern Art decided to keep the word *primitivism* in the title of *"Primitivism" in Twentieth Century Art*, the critically successful publication and exhibition of 1984. They recognized that the term *primitivism* was contentious but could propose no alternative that would accurately convey the same meaning.[2] Unlike them, however, we have chosen not to put the word in quotes (see John Beardsley's essay).

Why limit the exhibition to eight artists? We chose not to carry out an encyclopedic world survey, as this would have been unnecessary; our goal is to disseminate as much visual and historical information as possible on the most engaging and enlightening artwork, creations that inspire us to see more Outsider Art and to know more about it. Why these specific eight? The art of each individual meets the most rigorous connoisseurship standards, each oeuvre encompassing more masterworks than can be reproduced in this book. Connoisseurship may be out of fashion, but it is crucial to the future of Outsider Art. A spectacular range of styles and feelings punctuates these pages, and each image commands attention—it is

these qualities that provide a constant thread. This art stands on its own universally, and each artist will undoubtedly one day be the subject of individual scholarly monographs.

Determined to include the best art from around the world, we discriminated on the grounds of quality alone, selecting the work of those both known and obscure. In this way, *Vernacular Visionaries* goes beyond "the usual suspects"—the American and European self-taught superstars such as Edmonson, Traylor, Wölfli, or Aloïse. All born in the nineteenth century, these artists have been written about extensively, and their art belongs to an earlier generation. Instead, this book reaches across continents and forward in time; the subjects of our inquiry are the creations of those born in the early 1900s and whose art belongs to the mid and late twentieth century. Certainly there are others in the outsider world whose art merits advanced study and publication, but consideration of Gedewon, William Hawkins, Martín Ramírez, Nek Chand, Hung Tung, Charlie Willeto, Anna Zemánková, and Carlo is timely: their oeuvres have been researched in depth, revealing meaningful insights. Equally relevant is the balance of two- and three-dimensional work among the eight, featuring a variety of media and moods.

These eight share something else in common. They have become cult heroes of sorts in their own communities, recognized as individuals who possess special gifts and who have made important contributions to their respective cultures through their art. "Outsiders" for sure, they remain mavericks, eccentrics, and, not unlike prophets, admired and feared. In every case the culture as defined above is essential to the nature of their creative act, and their art is steeped in a language of visual clues to these aspects of individual and collective life. These artists were indeed capable of culling from external influences, shattering a sacred myth of Outsider Art. This cultural context presents a new way of experiencing these works of art beyond reveling in their feral beauty without an inkling of their deeper meaning. *Vernacular Visionaries* restores the culture to the art, and in so doing unleashes a fascinating universe of history, myths, folklore, magic, and the occult. At the same time it acknowledges that much of the art of these visionaries belongs to the realm of the unknowable, innately spiritual, and otherworldly. Indeed it is this more elusive aspect of the art that has such an irresistible allure, akin to that of tribal, ethnographic, and much folk art with which we have similar visceral, primal associations.

The art of the cleric Gedewon (1939–2000), mesmerizing in its interlaced originality, is essentially derived from a long history of Ethiopian scroll painting (fig. 1). In fact, it is from a tradition in which a colorful drawing is more an act of healing than it is conscious art making, the end result destined for the privacy of the patient in an impoverished village near Addis Ababa. That these works by Gedewon happen to be truly spectacular images is the result of culling fragments from his cultural milieu and combining them into compositions reflecting his unique visionary world.

1

Gedewon, *Untitled*, 1996
Colored ink on paper, 29 1/2 x 21 1/2 in. (75 x 55 cm)
Museum of International Folk Art,
a unit of the Museum of New Mexico
Gift of Thomas Isenberg

Similarly, William Hawkins (1895–1990) pillaged images from American culture and assimilated them into his own dynamic, richly textured paintings and collages (fig. 2). Like Gedewon, Hawkins took the most mundane images and reinvented them in enthralling ways. Hawkins's work is energetic and raw—different from Gedewon's but equally compelling. Hawkins's oeuvre is rife with a sense of African-American rhythms and spirituality, and with the detritus of urban life. On a par with the work of Andy Warhol, Hawkins's oeuvre is the best of American pop art, seen from this outsider's perspective.

Both Gedewon and Hawkins incorporated words into their art; Gedewon used both magic spells and prayers, and Hawkins incorporated both titles and signatures. Martín Ramírez (1885–1960), whose powerful compositions contain obsessive beehive-like patterns reminiscent of

Edvard Munch's curvilinear distensions, occasionally incorporated letters or words into his elaborate works on paper (fig. 3). Tunnels, trains, animals (especially deer), Christian iconography, and secular Mexican subjects provided rich scenographic themes. Honored with a retrospective exhibition in Mexico City in 1989, Ramírez was recognized as a quintessentially Mexican artist who drew on his Spanish and Indian roots as prime sources for the art he created many years later in California. In the United States he was considered primarily a schizophrenic and a man whose drawings are symptomatic of his disease, rather than of his artistic genius.[3] That may be, but *Vernacular Visionaries* is an art and cultural history.

Nek Chand Saini (b. 1927) is a national hero in his native India; his work is even featured on an Indian postage stamp. A visionary artist, Nek Chand, as he is

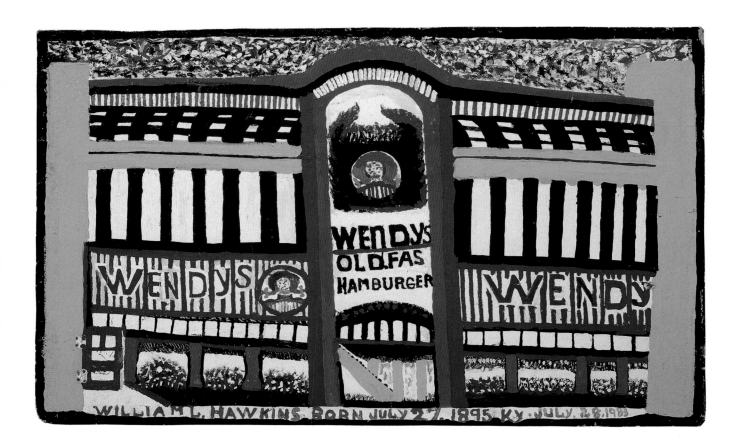

2

William Hawkins, *Wendy's Hot 'n Juicy*, 1983
Enamel on particleboard, 37 x 61 in. (94 x 154.9 cm)
Collection of Pria Harmon

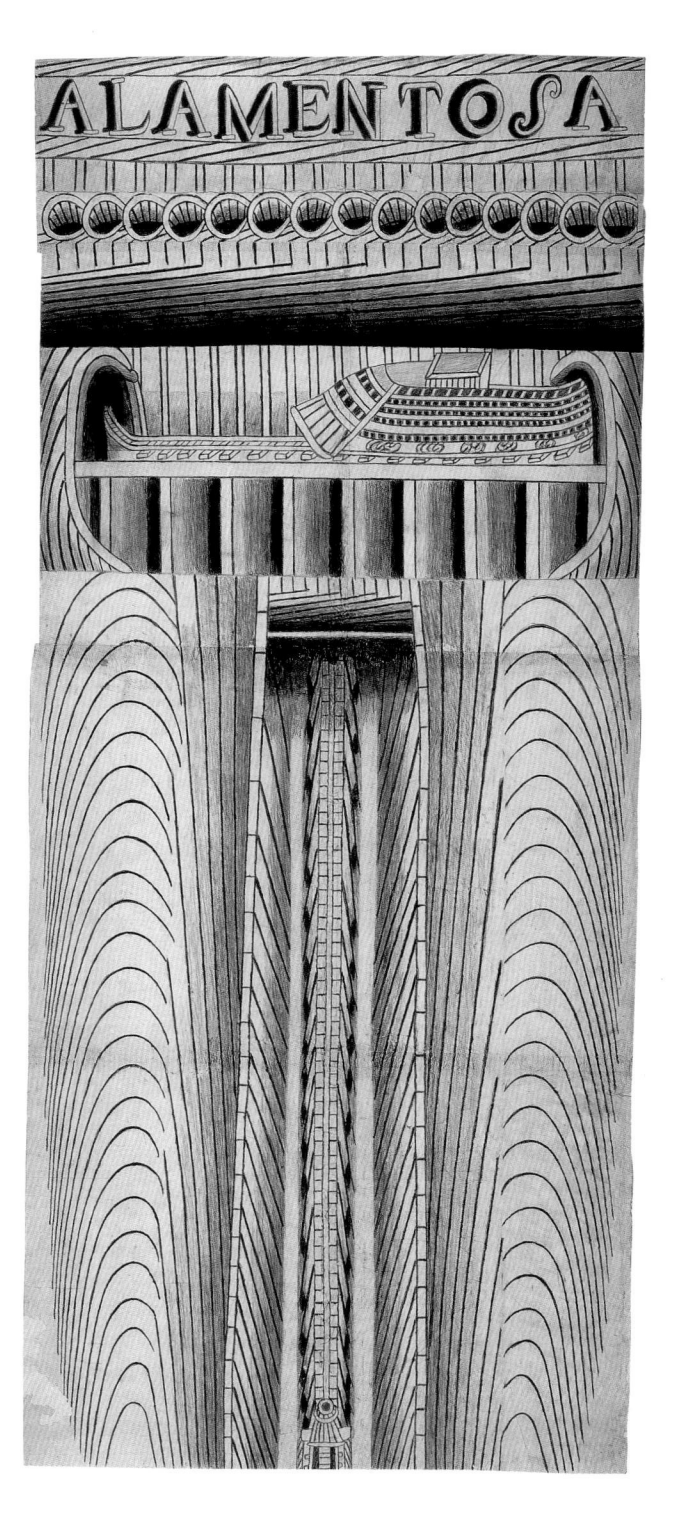

known, recounted that he received a calling from God to create what is now known as the Rock Garden, located at Chandigarh. Whereas the above-mentioned artists all scavenged metaphorically from their cultures, Nek Chand literally took things from the world around him; for example, from discarded and broken materials he built a magic kingdom (fig. 4). The only living artist included in this catalogue, he is of the same generation as the others, with the most accomplished of his visionary creations belonging to the past century. Myths of the Punjab and stories of Nek Chand's youth are told here for the first time, anchoring the art in its cultural place.

In a remote economically depressed neighborhood of Tainan County near Taiwan, Hung Tung (1920–1987), who had channeled spirits for a local temple, inexplicably began to paint at the age of fifty. Like the other artists

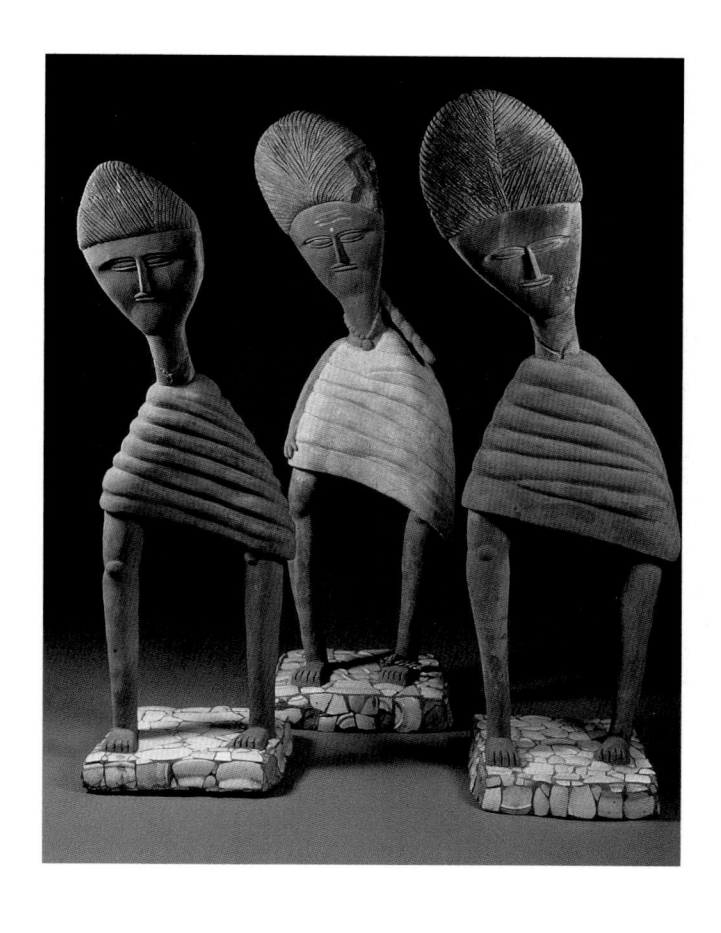

3

Martín Ramírez, *Untitled* (*Alamentosa*), c. 1953
Colored pencil on paper, 80 1/4 x 34 1/2 in. (214 x 88 cm)
Private collection

4

Nek Chand, *Followers of Gandhi*, c. 1995
Cement with inlaid ceramics and jute,
height of each approximately 60 in. (152 cm)
Museum of International Folk Art,
a unit of the Museum of New Mexico
International Folk Art Foundation Purchase

herein, with no formal training and little knowledge of "art," Hung produced compositions of extraordinary visual potency, incorporating the traditional Taiwanese format and color schemes with characters from religious and secular life (fig. 5). Eventually, the Taiwanese art community learned of the painted scrolls of the reclusive Hung, and they were immediately recognized as astounding examples of contemporary art.

The raw and expressionistic woodcarvings of Charlie Willeto (1906–1964) are anomalies in his culture, as the Diné, or Navajo Nation, is distinguished for its weavings, ceramics, and silver work (fig. 6). Most of the visionary sculptures of Willeto are, however, unmistak-

ably Diné, as they depict both tribal members in traditional garb as well as ceremonial and mythological figures. The idea of Outsider Art is foreign in most tribal societies worldwide, because they perceive altered states of being, mental illness, and visions differently than does Western culture. Traditional tribal societies also have no concept of, or word for, art. Nonetheless, within his own clan were those who understood the unexplainable originality and compulsion of individuals such as Willeto as what we call Outsider Art.

Certain parts of Europe are renowned for their spiritualist and occult histories. The Czech lands have been the capital of the metaphysical for centuries; in all seg-

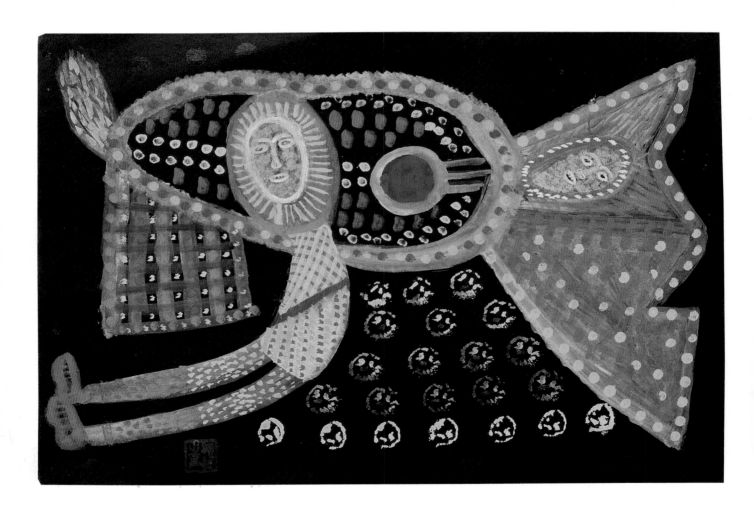

5
Hung Tung, *Entities*, c. 1975
Gouache on paper, 24 x 36 in. (61 x 91 cm)
Private collection, Taiwan

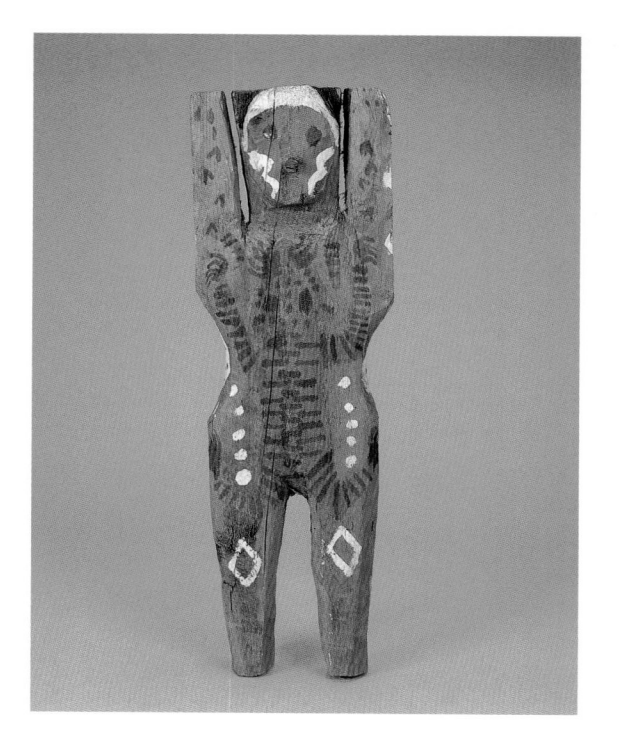

ments of its society and among its three predominant cultures—Czech, German, Jewish—belief in alchemy, fortune-telling, woodland fairies, and the Golem still exists in the quotidian folklore. Active communities of mediums have existed throughout the Czech lands, and a few still remain. The art of Anna Zemánková displays some of the hallmarks of mediumistic art, with its soft, dreamy imagery and radiant light (fig. 7). Most likely her early experience with Moravian needlework, her love of plants, and the environment surrounding her adult life all influenced her artwork. Paradoxically, her works on paper have a feeling of automatic drawing, yet we know she thought of herself as "an artist."

6

Charlie Willeto, *Tiger Man*, c. 1960–64
Carved and painted wood, height 19 in. (48 cm)
Museum of International Folk Art, a unit
of the Museum of New Mexico
Massey Collection

7

Anna Zemánková, *Untitled*, c. 1970
Oil pastel on paper, 17³/₄ x 24¹/₂ in. (45 x 63 cm)
Zemánková Family Archives, Prague

Carlo (Carlo Zinelli, 1916–1974) produced bold, colorful, obsessive paintings that range from the amusing to the frightening (fig. 8). As an adult in an urban hospital, Carlo began to depict episodes from his life with a repetitive force akin to pattern painting. Screaming at us in word/sounds—"Grrrrrrrrr" and "brrrrrrrrrrr," to name but two—or soothing us with tender vignettes of his bucolic San Giovanni Lupatoto, his work is about a give-and-take with his environment. Viewing the world through the refracted prism of his mind, we see the village, boats, cherry trees, and farmhouses of his childhood, reminiscences from his days as an *alpino* soldier, and his experiences in army hospitals. Other images, seemingly from the realm of dreams or nightmares, are astounding, such as a sheet of paper covered with a wall the color of the Mediterranean Sea, or an advancing black monster.

This catalogue focuses on cultural context as it presents an interdisciplinary approach to the art of these individuals, and to the exploration of the multidimensional aspects of Outsider Art. In this age of increased globalization, it may seem especially odd that some were so isolated that we can even speak of a singular cultural influence. As you read through this book, keep in mind the paradigm of cultural identity described above, and its relationship to place and time.

The essays that follow are informative and enlightening. Written with authority and grace, they were contributed by a distinguished group of art historians (both academics and curators), cultural anthropologists, and art critics from Asia, Europe, Africa, and the United States. Each of these individuals deftly demonstrates the broad crossover approach necessary for such a project. In so doing, they expand our general knowledge of Outsider and Visionary Art through the universal in the art of these eight, while introducing us concomitantly to the larger worlds of specific artists and their communities.

Proffering extraordinary mastery of the visual form, Gedewon, William Hawkins, Martín Ramírez, Nek Chand, Hung Tung, Charlie Willeto, Anna Zemánková, and Carlo created distinct aesthetics under the umbrella term *Outsider Art*. There is not one way nor one style to be seen in the gorgeous color reproductions of their artwork in this book. Rather, the common ground is in the stories

8

Carlo, *Untitled* (detail), 1957
Tempera and ink on paper, overall dimensions 19 5/8 in. x 27 in. (50 x 70 cm)
Collection of Eugenie and Lael Johnson

of their lives, marginal to the mainstream, and in the consistency with which their art hits the high notes. Revising the notion of simple folks making simple things, *Vernacular Visionaries* illuminates some of the most riveting and beautiful images of the twentieth century and lauds these accidental artists for their naturalness.

Yet this is just the tip of the iceberg. Trenchant, timely, and profound, *Vernacular Visionaries: International Outsider Art* will serve as a force to help propel this subject to further research, discoveries, and, ultimately, recognition (fig. 9).

Notes

1 Amin Maalouf, *In the Name of Identity*, trans. Barbara Bray (New York: Arcade, 2000), 102.
2 This was recounted by the late Sir E. H. Gombrich in *The Preference for the Primitive* (London: Phaidon Press Limited, 2002), 201.
 The chapter titled "The Twentieth Century" is relevant to the discussion of the allure of the "primitive" in Outsider Art.
3 The relationship between genius and madness as a scientific study has a substantial body of literature, from Hans Prinzhorn to John MacGregor. See John Beardsley's essay in this book, "Imagining the Outsider."

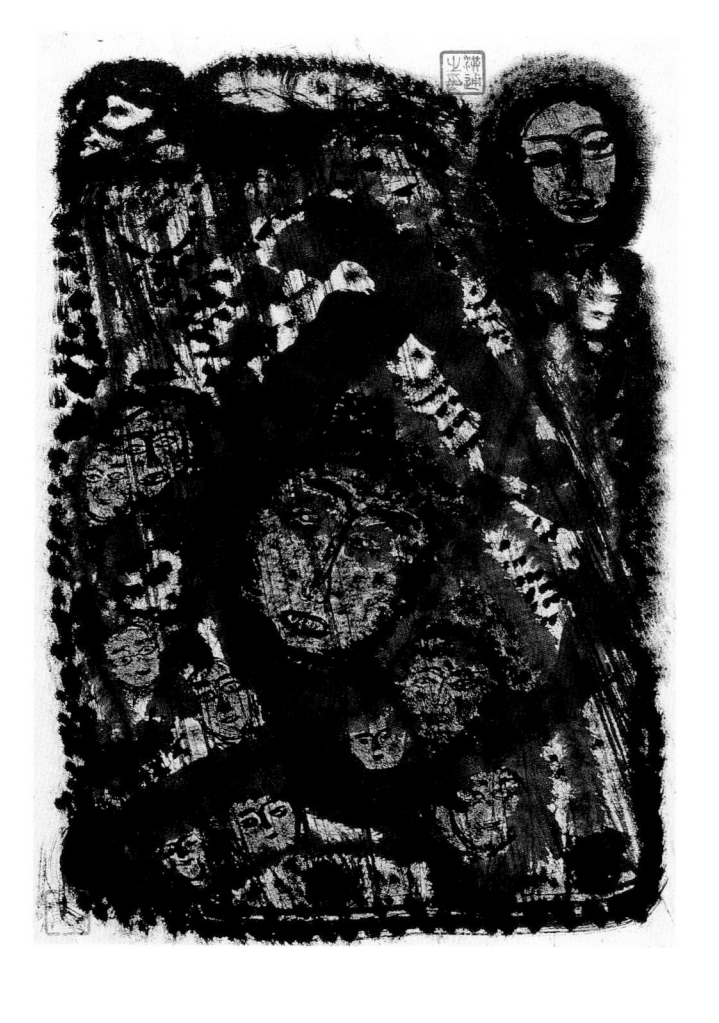

9
Hung Tung, *Faces*, c. 1970
Ink on paper, 24 x 18 in. (61 x 46 cm)
Private collection, Taiwan

Imagining the Outsider

John Beardsley

Substantial confusion surrounds the understanding of Outsider Art—and with good reason—for it is less a fixed phenomenon than a flexible construction, the meanings of which vary from time to time and from place to place. The conception of Outsider Art in Europe, for example, is markedly different from that in the United States; moreover, within this country perspectives on the subject have shifted significantly over the past generation. Although the American understanding of the term owes a great deal to ideas originating in Europe in the early decades of the twentieth century, Outsider Art in the United States has proved to be a more confusing and elastic category than in the Old World, embracing folk, self-taught, and naive art along with that of various ethnic groups, the institutionalized, and even children. In Europe, patterns of collecting resulted in clearer distinctions among these categories. What we might call folk art went into ethnographic collections, while naive art went into collections of popular art. Folk art, as understood in Europe (and by some folklorists in the United States), is made by people who have subordinated their individual creativity to collective culture or to established artistic models and traditions, whether in textiles, woodcarving, metalwork, or basket weaving. Outsider Art, by comparison, is considered to be more idiosyncratic, even intense and obsessive, and is made by people who are unaware of, or indifferent to, normative artistic standards.

As the term was initially conceptualized in Europe, *outsiders* are understood to live and work at some distance from prevailing artistic cultures. In other words, they are not part of the art world and are sometimes unaware of themselves as artists or of their creations as art. They work instead out of a sense of personal necessity, often obsessively, over many years. They frequently create independent lives or even alternate personalities for themselves through their art. Unlike ordinary talents, these artists seem to emerge fully developed from the first: there is little sense that their work evolves in response to outward stimuli, especially stylistic trends. They also reveal a propensity to create fantastical personages and events, which they often describe in cryptic texts. Moreover, their works reveal shared compositional strategies. Among those who favor abstract expression there is an impulse to cover every part of a surface with dense pattern or ornamen-

tation; among those whose work is more representational there is a tendency toward distorted, caricatured, and hybridized form. In all, Outsider Art gives one the sense of entering another world, with its own peculiar logic and its own codes of representation. It conveys a simultaneous intensity and inwardness that has been characterized as an "autistic air."[1]

The term entered general usage in English through Roger Cardinal's 1972 book *Outsider Art*, which detailed some of the features by which such work is understood to this day—notably its intensely imaginative qualities and its origins among people whom Cardinal described as exploring "the psychic elsewhere," especially various kinds of spiritualists, mediums, and visionaries, in addition to the mentally ill.[2] Cardinal's book title was his translation of *art brut*, a designation developed after the Second World War by the French artist and collector Jean Dubuffet to describe work that he perceived to be created in a technique and style that was raw and unadulterated (*brut*) and thus authentically inventive, rather than cooked according to the conventional recipes favored by art academies and museums. The notion of the outsider has still-deeper origins, however, going back to a period during and just after the First World War when the art of the mentally ill was studied and collected by mental health professionals and artists alike—notably the Heidelberg psychiatrist Hans Prinzhorn and the surrealists Max Ernst and André Breton.

Interest in such art was part of a broader effort on the part of modern European artists to invigorate their own work by looking beyond academic models for examples of creativity unhindered by convention. Picasso was a well-known enthusiast of both African tribal art and untutored artists within his own milieu, notably Henri Rousseau. Paul Klee embraced perhaps a still-wider range of creative expression than did Picasso, including the work of children and the mentally ill along with that in ethnographic collections. "All this is to be taken very seriously," Klee asserted in 1912, "more seriously than all the public galleries, when it comes to reforming today's art."[3]

For the surrealists, eager to demonstrate their ideas of pure or "automatic" creativity unhindered by constraining cultural habits or assumptions, mental illness provided one of the most compelling paradigms of unfettered

artistic activity. Both Ernst and Breton had some background in psychiatry and were exposed to the mentally ill—Ernst as early as 1910 during study visits to an asylum near Bonn; Breton during the First World War when, as a medical student, he was assigned to a neuropsychiatric center at Saint-Dizier to help treat the victims of shell shock. Referring to the challenges faced by the mentally ill, Breton suggested in a 1916 letter to the poet Guillaume Apollinaire the affinities he felt with their experience: "I instinctively feel my destiny is to put the artist to the same sort of test."[4]

Ernst later collaborated on a 1919 exhibition of Dada art in Cologne, which included tribal objects as well as work by children and psychotics. While many today would object to the uncritical commingling of art from such divergent sources, Ernst's exhibition is further confirmation of the origins of Outsider Art within a larger context of interest in non-Western, nonacademic creations.

Breton went on to become the primary author of surrealist theory, beginning with his 1924 *Manifesto of Surrealism*. Rejecting "absolute rationalism" and "the reign of logic," the manifesto looks to children and madmen as the exemplars of imaginative freedom. Breton credited Freud with the recovery of the most important part of the mind—the unconscious—and privileged the functioning of the brain in its trance or dream state over the workings of the conscious mind. He established the outlines of one of the modern era's most influential notions of creativity when he defined surrealism as "pure psychic automatism," the expression in any medium of "the actual functioning of thought . . . in the absence of any control exercised by reason, exempt from any aesthetic or moral concern."[5]

Breton's fascination with the "psychic elsewhere" also led him to embrace the art of spiritualists, mediums, and compulsive visionaries. Surrealist notions of "automatic writing" or "psychic automatism" are akin to the techniques of mediumship, though Breton would remain steadfast in his insistence that such messages originated in the unconscious, not in another world. Surrealist authors recorded messages received while in hypnotic trances; their efforts were oral and written, but they recognized the affinities between their work and that of certain visual artists. In an article in the first issue of *La Révolution Surréaliste* (1924) Max Morise announced, "Let us admire the lunatics and the mediums who manage to impart fixity

to their most fleeting visions, in the same way the man dedicated to surrealism tends to do, albeit on a somewhat different footing."[6]

By 1933, in an essay "Le message automatique," Breton himself would trace parallels between mediumship and surrealism. The essay was accompanied by some two dozen illustrations, including paintings by the coal miner and medium Augustin Lesage and a photograph of the fabulous *Palais Ideal*, the late nineteenth-century stone and mortar construction near Lyon by the postman Ferdinand Cheval, whom Breton called "the uncontested master of mediumistic architecture and sculpture."[7]

Indeed, it might be argued that it was the spiritualist mediums more than the mentally ill who most closely approximated the "automatic creativity" to which the surrealists aspired: they could hardly hurl themselves into the maelstrom of psychosis. Enthusiasm for mediumistic art would continue to resonate and later lead to the embrace in England of the paintings of Madge Gill, who created under the guidance of a spirit she called "Myrninerest."

In the early decades of the twentieth century, mental health professionals also began to take an interest in the creations of the mentally ill. The great Swiss artist Adolf Wölfli, for example, came to the world's attention through the efforts of Dr. Walter Morgenthaler, a psychiatrist who was the head physician at the Waldau asylum near Bern, where Wölfli spent most of his adult life. Institutionalized for mental illness after several attempted assaults on young women, Wölfli rewrote his troubled personal history in books of paintings and prose, then invented an elaborate hagiography with hymns and psalms devoted to his alter ego, St. Adolf II. Morgenthaler arrived at the asylum in 1907 and encouraged Wölfli's drawing, writing, and musical composition throughout his tenure there. In 1921 he published *Ein Geisteskranker als Künstler* (*A Mentally Ill Person as an Artist*), a monograph on the artist's life and work.[8]

Both an art historian and psychiatrist, Prinzhorn is credited with creating the first extensive collection of the art of the institutionalized. Between early 1919 and 1921, more than five thousand objects — mostly by people diagnosed as schizophrenic and primarily from asylums in German-speaking Europe — entered the collection of the Psychiatric Clinic at the University of Heidelberg, where

Prinzhorn was an assistant. The clinic already had a small collection begun in the first decade of the century; in about 1917, the director, Karl Wilmanns, proposed to study and enlarge it. Prinzhorn joined the staff at the clinic in 1919 at about the time Wilmanns circulated his first request to other institutions to donate to Heidelberg for exhibition and study purposes any works of art collected from their patients. The opportunity of interpreting the collection fell to Prinzhorn. In 1922, the Berlin publisher Springer-Verlag produced Prinzhorn's book *Bildnerei der Geisteskranken* (*The Artistry of the Mentally Ill*).[9]

Like Morgenthaler, Prinzhorn emphasized the artistic character of the patients' work and downplayed either diagnostic or pathological concerns. Prinzhorn's book was chiefly about art: it included ten short monographs that wove together, in art-historical fashion, the lives and case histories of patients with presentation and analysis of their work. Like the surrealists, Prinzhorn felt that the mentally ill provided a glimpse into the true workings of creativity, as their imaginative processes were relatively untouched by external influences or concerns. Although he ignored the social contexts in which they created and was overly reliant on vaguely defined ideas of "authenticity" and "primordiality," he helped define the artistry of the mentally ill as different from, but on a par with, the work of professional artists.[10]

His perspectives proved influential: Klee kept a copy of Prinzhorn's book in his studio, and when Ernst left Germany for France in 1922 he took with him a copy of Prinzhorn's book as a gift to the poet Paul Eluard. This was apparently the first copy of *The Artistry of the Mentally Ill* to reach the Parisian surrealists, among whom it became a kind of underground bible.

Clearly, there are vast differences in class, education, and social experience between professional artists and the institutionalized creators with whom they felt such kinship. To the extent that professionals celebrated the art of the mentally ill but ignored the painful personal circumstances in which it was made, their interest might even be seen as callous or voyeuristic. Moreover, it could be turned against them, as it was by the German National Socialists in the 1930s. Most famously, the Nazis' 1937 Munich exhibition *Entartete Kunst* (*Degenerate Art*) juxtaposed modern — especially Expressionist — art with the

creations of the mentally ill, and it dismissed both by analogy. The exhibition guide for the 1938 Berlin showing of the exhibition denounced artists whose ideal is "the idiot, the cretin, and the cripple," along with those who break down form and produce "sheer insanity." Illustrations of the work of modern painters such as Paul Klee and Oskar Kokoschka were compared to images from the Prinzhorn collection. This condemnation was a prelude not only to the banishment of modern artists, but also to the extermination of people the Nazis considered "incurable," including several patients whose work was represented in the Prinzhorn collection.[11]

After the Second World War, the French artist Jean Dubuffet became the preeminent champion of creators outside the mainstream; he amassed perhaps the most important inventory of this art in Europe, now the Collection de l'Art Brut in Lausanne, Switzerland. In July 1945, Dubuffet and the editor Jean Paulhan visited several Swiss asylums, where Dubuffet acquired work by Wölfli and other institutionalized artists, including Heinrich Anton Müller and Aloïse. As Paulhan rather skeptically reported of his companion, "He is pursued by the idea of a direct and untutored art—an *art brut*, he says—which he thinks to find among the insane and imprisoned. If he heard that in some place a bear had begun to paint, he would dash there immediately."[12]

Thus began what can only be called Dubuffet's crusade on behalf of art brut. In late 1945 he proposed a series of publications on the subject, the *Fascicules de l'art brut*, though only one volume appeared around this time (1947; publication resumed in 1964). The first of a series of Paris exhibitions of his collection was held in 1947; in 1948 he enlisted Breton and Paulhan, among others, to form a group devoted to collecting and promoting nonconformist, powerfully idiosyncratic art, the Compagnie de l'Art Brut. In 1949 the notable exhibition *L'art brut préféré aux arts culturels* (*Outsider Art in Preference to Cultural Arts*), which included some two hundred works by sixty-three artists, was held at the Galerie Ren, Drouin. In a catalogue manifesto, Dubuffet explained his preference for untutored artists, "who are untainted by official culture . . . for whom mimesis plays little or no part . . . allowing their creators to draw everything (subject, choice of material, expressive means, rhythms, spellings, etc.) from their own inner selves

and not from the commonplaces of classical or currently fashionable art."[13]

Dubuffet here overstated his case, for no one can be entirely exempt from cultural influences—a point he later acknowledged. In his most extended polemic on the subject, the 1968 book *Asphyxiante culture* (*Asphyxiating Culture*), Dubuffet presented "rawness" as a tendency, not as a fixed state; he recognized that we are all, to some degree, "impregnated" by culture. But he continued to celebrate the asocial—if not antisocial—position of the marginal artist: "We must still mention the spirit of systematic refusal . . . the spirit of contradiction and of paradox, the position of insubordinance and of revolt—all precious compost for the budding of creation and enthusiasm. Nothing salvational ever grew but from this sort of rich soil."[14]

Also in the postwar years, the Sainte-Anne Hospital in Paris emerged as a center for research and exhibition of Outsider Art. Even before the war, artists such as Breton, Marcel Duchamp, and Alberto Giacometti visited the asylum to observe the art of inmates or to hear lectures by one of its notable psychiatrists, Dr. Gaston Ferdière. Ferdière spent the war years in charge of an asylum at Rodez in the south of France, where both the surrealist poet Antonin Artaud and the artist Guillaume Pujolle came under his care. In 1946, Sainte-Anne was the site of a celebrated exhibition of more than two hundred works collected from artist-patients at several hospitals around France; the show was conceived at least in part as a retort to the Nazis' exhibition of "degenerate" art. An even larger exhibition, *the International Exhibition of Psychopathological Art*, was presented at the hospital in 1950 in conjunction with the first International Congress of Psychiatry. Including more than two thousand works by sixty-three artists from seventeen countries, the show was seen by some ten thousand people. Such efforts on behalf of the mentally ill created a climate of acceptance not just for their work, but also for artists such as Dubuffet, who advocated them.[15]

The 1950 Sainte-Anne exhibition might be seen as a prelude to the popularization and institutionalization of Outsider Art, which began to pick up speed in the 1960s. The Swiss curator Harold Szeemann organized the first major museum exhibition of such work for the Kunstmuseum Bern in 1963; in 1967 a major showing of Dubuffet's collection was held at the Musée des Arts Décoratifs in Paris. Michel

Thévoz published his book *Art brut* in 1975, detailing the formation of Dubuffet's theories and discussing many of the principal works in his possession; the collection itself was given a permanent home at the Château de Beaulieu in Lausanne in 1976, with Thévoz at the helm. Szeemann continued to feature outsider artists in his exhibitions, including *Documenta 5* in Kassel, Germany, in 1972 and *Der Hang zum Gesamtkunstwerk* (*The Tendency Toward the Total Work of Art*) in 1983. Meanwhile, Roger Cardinal's book had appeared, followed by the landmark 1979 exhibition *Outsiders*, organized by Cardinal and Victor Musgrave for the Arts Council of Great Britain. Cumulatively, these events testified to the march of marginal artists from the borders of society into—or, at least, part way into—its major cultural institutions; they also confirmed the terminology—*L'art brut* in French and Outsider Art in English—by which the phenomenon is still most commonly known.

At the same time, the boundaries began to blur. Initially focused on the art of the mentally ill, Outsider Art—especially under the influence of Dubuffet—began to encompass numerous other categories as well: the art of the self-taught, for example, along with that of various isolates, eccentrics, prisoners, and other socially marginalized individuals. Breton, initially sympathetic to Dubuffet, broke with him in 1951 when Dubuffet disbanded the initial Compagnie de l'Art Brut. Breton objected to Dubuffet's increasing monopoly over something that had long been the province of the surrealists; he also felt that Dubuffet was confusing matters by being too inclusive. "The organic fusion he proposed to effect between the art of certain autodidacts and that of the mentally ill has revealed itself to be inconsistent and illusory."[16]

This inconsistent, illusory legacy is with us to this day. In fairness to Dubuffet, however, the surrealists bequeathed their own confusions. Their emphasis on "pure psychic automatism" created an illusion of creation independent of historical and social contexts, and this is still being deconstructed by more culturally minded critics. Their notion that creation could be exempt from moral concern continues to blind us to the religious dimensions of much Outsider Art, notably that of spiritualists, mediums, and other visionaries. And their enthusiasm for the art of the institutionalized has contributed to many a mistaken assumption that all outsiders must be mentally ill, even in the absence of confirming diagnoses.

As diffuse as the outsider phenomenon has become in Europe, it is even more desultory in the United States. Outsider Art shares space under the broad umbrella of folk art with self-taught, naive, vernacular, and visionary art, among numerous other phenomena. The diversity of the folk art category in this country and its link to self-taught and popular art was anticipated in the years before and during the Second World War by Holger Cahill's 1938 Museum of Modern Art exhibition and publication *Masters of Popular Painting: Modern Primitives of Europe and America*, and by Sidney Janis's 1942 book *They Taught Themselves*. This was confirmed in the 1970 exhibition *Twentieth-Century Folk Art and Artists*, organized by Herbert W. Hemphill, Jr., at New York's Museum of American Folk Art, which manifested a fine disregard for categories. Hemphill's exhibition featured self-taught artists previously celebrated by Cahill and Janis, among them the naive painters Morris Hirshfield and Grandma Moses and the African-American stone carver William Edmondson. It also included new discoveries, including the apocalyptic paintings of New Orleans street preacher Sister Gertrude Morgan and the visionary landscapes of Chicago artist Joseph Yoakum, as well as anonymous material: a Mickey Mouse kachina, a neon trade sign, and traditional New Mexico carvings of saints.[17]

Hemphill followed up on this controversial project over the next three years with similarly category-busting exhibitions on macramé, tattoo, and the occult as aspects of contemporary folk art. He displayed a similar eclecticism in his own collecting. He began with familiar forms of folk art, including trade signs, textiles, face jugs, whirligigs, and decoys. But he eventually gravitated toward the more idiosyncratic expressions of isolated artists, such as the paintings and sculptures of apocalyptic Georgia evangelist Howard Finster; the watercolors of the Chicago recluse Henry Darger, author of a nineteen-thousand-page, twelve-volume war epic partially titled *The Story of the Vivian Girls*; and the crayon and pencil drawings of Martín Ramírez, a Mexican-born artist diagnosed as schizophrenic and institutionalized in California. All of these individuals conformed more closely to the outsider designation as it was articulated in Europe than did most artists Hemphill collected.

Of the several broad modes of inquiry into Outsider Art in the United States in recent decades, two are based on European precedents: one traces the biography of the artist, confirming a distance from art world institutions, and a second addresses the aesthetic attributes of the work, looking for evidence of stylistic originality and obsession. A third mode of analysis that has become increasingly prevalent in this country examines the art for its links to particular historical contexts and excavates its social meanings. In this view, for example, the work of Ramírez would be less important for its aesthetic strategies or its connections to the illness of its creator than for its confirmation of the social experience of an economically disadvantaged immigrant or its depiction of Mexican and American popular icons such as the cowboy or the Virgin of Guadalupe. The biographic aesthetic and the cultural history modes are not inherently incompatible, and several books have attempted to synthesize both approaches, notably the 1994 anthology *The Artist Outsider: Creativity and the Boundaries of Culture*, edited by Michael D. Hall and Eugene W. Metcalf, Jr. But the different approaches have, at times, been in open conflict. Indeed, some anthropologists or historians discount the aesthetic entirely, speaking of outsider creations as artifacts or expressions of material culture rather than as art.

The tension between these interpretive strategies was well illustrated by the critical fallout from the 1982 exhibition *Black Folk Art in America, 1930–1980* at the Corcoran Gallery of Art in Washington, D.C. Although hailed in *Time* magazine as a "finale for the fantastical," the exhibition was criticized in academic quarters for conflating folk art—an expression of tradition—with the more idiosyncratic expressions of self-taught artists. As folklorist John Michael Vlach later asked, "How can folk art logically be called the art of a group and at the same time be labeled as the art of the self-taught?" Others thought that the category "black folk art" was inherently political—an effort on the part of one group to control the classification and hence the perception of another.[18]

In recent years, criticism of the outsider designation has continued to focus on these hegemonic implications. Outside of what, the category prompts us to ask, and according to whom? The term correctly implies a distance from high art and academic culture, but it can be

argued that, in thus describing artistic and social differences, it reinforces hierarchies rather than subverting them. It correctly conveys the geographical, social, or mental isolation usually experienced by its makers, but it incorrectly conveys the idea that people can be entirely innocent of a common culture. Most problematic, it reveals uneven power relationships. All cultures define themselves in part by an understanding of who and what they are, not by measuring themselves against some designated "other." Like the notion of *primitivism*, the concept of the *outsider* says as much about the values of the category-creating culture as it does about its ostensible subject. Often, such categories are used to establish boundaries and to solidify the authority of one cultural group over another. The cultural historian Eugene Metcalf has been perhaps the most forceful proponent of this perspective. "To begin to understand outsider art," he insists, "we must view it not as the solely aesthetic creation of individual eccentrics disconnected from culture, but as the symbolic product of a complex and ambiguous relationship between more- and less-powerful social groups." The outsider label, in this view, stigmatizes and marginalizes such art, preventing us from seeing it as equal to the productions of tutored artists or of those more connected to the conventional systems of art production and distribution. Most problematically, Metcalf concludes, "the epistemology utilized to define and study Outsider Art . . . has little place for the views or values of those whom it represents as outsiders."[19]

Indeed, the category seems to demand the presence of the cultivated insider who can recognize outsider qualities—a Breton or a Dubuffet who knows the history of taste well enough to know what is ignored or scorned. But what the cultured insider expresses in the admiration for Outsider Art is often as much the rejection of dominant values as it is the embrace of unappreciated ones. It takes a rare degree of empathy to value Outsider Art on its own terms—to enter into communion with creations that can be extreme in their level of self-engrossment.

All that said, the concept of the outsider remains quite useful. For one thing, aesthetic value in our culture is still intensely vertical or hierarchical: it is concentrated in a few artists, a few modes of expression, a few historical episodes. We need some such concept, however flawed, to remind us that there continue to be things

less celebrated and valued; for the most part they are the productions of people with little education, economic clout, or social standing. Acknowledging the outsider might be a step toward a more democratic, horizontal realignment of cultural values. For another, it's important to recognize that some people are relatively immune or indifferent to the prevailing artistic culture, its dominant codes, its aesthetic standards, and its methods of promotion and distribution—though in an era of globalized mass communication there are inevitably fewer such people. As most writers on Outsider Art have observed, creativity alters course when the artist becomes aware of the expectations of others. Finally, there remains a distinct aesthetic pole —dense, hermetic, obsessive, complex—toward which those who are identified as outsiders tend to gravitate.

So the outsider designation must soldier on, under fire from without and beset by dissent from within the ranks of its own supporters. Sharper definition of the phenomenon is clearly in order, although it seems doubtful that the debate over so inherently problematic a category will ever be concluded. We might begin by trying to resolve the conflict that Breton articulated between his more restrictive and Dubuffet's more inclusive notions of Outsider Art: I favor Breton's, as it seems to me that there are pronounced differences between the work of the self-taught and that of compulsive visionaries of various kinds. Still, there is evidence that some semantic consensus is emerging, with recent writers taking greater care than they have in the past to distinguish among different terms, particularly *self-taught*, *folk*, and *outsider*."[20]

Beyond these semantic matters, we need to develop more empathic interpretive strategies, paying closer attention to the experiences and values of the artists themselves. It might be helpful, for example, to see Outsider Art in the light of recent neurological and psychological ideas as evidence of extraordinary faculties of adaptation. Much Outsider Art is the record of exceptional struggle—with illness, with personal misfortunes of various kinds, and with social adversities such as extreme poverty and racism. The use of art as a way of compensating for psychological struggle might represent a paradigm for all Outsider Art, helping us to see it as a way of dealing with personal difficulties of an uncommon order. In the words of neurologist Oliver Sacks, "Defects, disorders,

diseases . . . can play a paradoxical role, by bringing out latent powers . . . that might never be seen, or even be imaginable, in their absence." In this view, the brain is a dynamic, adaptable system that can find ways around the impediments that physiology or experience might throw in its path. Disturbances—however terrible in their own right—might have the effect of producing extraordinary developments of another kind, geared especially to creating an integrated picture of the self and of the world in the face of extreme personal and social fragmentation. Given the plasticity of the brain, Sacks is moved to wonder "whether it may not be necessary to redefine the very concepts of 'health' and 'disease,' to see these in terms of the ability of the organism to create a new organization and order, one that fits its special, altered disposition and needs, rather than in the terms of a rigidly defined 'norm.'"[21]

In the same way, I find it important to stress that Outsider Art is not the expression of mental pathologies— indeed, it might be a measure of health in the sense that it represents a way of coming to terms with, if not actually triumphing over—various kinds of adversities. Wölfli's "improved" autobiography and his reinvention as St. Adolf II certainly can be seen as a compensatory strategy, consciously or unconsciously produced by the artist to construct a more coherent image of his own personality and life experience. In a similar way, Ramírez's work might be viewed as a way of piecing together the fragments of a life sundered by immigration and illness.

Recent neurological theories are only one possible avenue toward more empathic understandings of the outsider's experience. However we might account for it, the abilities of outsider artists—like the talents of prodigies or savants—do seem to be less dependent on or shaped by cultural and environmental factors than those of "ordinary" artists. Likewise, their creative abilities often seem to emerge fully formed and remain fairly consistent in terms of both technique and proficiency—though they might equally be seen as limited in this regard. Their powers also seem to be more autonomous, even "automatic," than those of customary talents. The emergence of these powers is hardly universal, however: not everyone who experiences severe neurological, psychological, or social stress finds an antidote in creation. The wonder of these artists is that they *did* find ways around mental and emotional

roadblocks, achieving an extremely compelling tempo and form of expression despite—perhaps even because of—the vicissitudes of their lives.

Finally, whatever the genesis of their talents, whatever the level of their achievement relative to more mainstream artists, we mustn't forget the predicament of the individuals who made this art. These were real people who grappled with often desperate circumstances. We need to move beyond the pathological construction of the outsider as either social misfit or clinical curiosity. We also need to put to rest the romantic notion of the "pure" creator, entirely independent of cultural and historical circumstances: it is possible to celebrate Outsider Art both as an expression of individual imagination and as the record of shared cultural experience. Given empathy for these creators and for their works, we can then begin to grasp the complexity of Outsider Art as an aesthetic *and* as a social phenomenon. We may even discover that our experiences and theirs differ only by a matter of degree and that inside and outside are contiguous. Conceived as an "other," the outsider may turn out to be not so different from everyone else after all.

Notes

This essay is a revised and expanded version of a text initially published as "Creating the Outsider," in *Private Worlds: Classic Outsider Art from Europe* (Katonah, N.Y.: Katonah Museum of Art, 1998).

1 My definition of Outsider Art is borrowed from Roger Cardinal's essay "Toward an Outsider Aesthetic," in *The Artist Outsider: Creativity and the Boundaries of Culture*, ed. Michael Hall and Eugene Metcalf (Washington, D.C.: Smithsonian Institution Press, 1994), 21–43. The notion that Outsider Art conveys an "autistic air" appears on p. 33.

2 Roger Cardinal, *Outsider Art* (New York: Praeger, 1972). The reference to the "psychic elsewhere" appears in his essay "Surrealism and the Paradigm of the Creative Subject," in Maurice Tuchman and Carol S. Eliel, *Parallel Visions: Modern Artists and Outsider Art* (Los Angeles: Los Angeles County Museum of Art, 1992), 95.

3 Paul Klee, quoted in Lucienne Peiry, *Art Brut: The Origins of Outsider Art*, trans. James Frank (Paris, Flammarion, 2001), 15. See also Reinhold Heller, "Expressionism's Ancients," in *Parallel Visions* ed. Maurice Tuchman and Carol S. Eliel (Princeton, N.J.: Princeton University Press, 1992), 78.

4 André Breton, quoted in Cardinal, "Surrealism and the Paradigm," 95.

5 Breton, "Manifesto of Surrealism," in *Manifestoes of Surrealism*, trans. Richard Seaver and Helen R. Lane (Ann Arbor: University of Michigan Press, 1969), 9, 26.

6 Max Morise, "Les yeux enchantés," in *La révolution surréaliste*, no. 1 (Nov. 1, 1924): 27.

7 Breton, "Le message automatique," *Minotaure*, nos. 3–4 (December 1933). The essay was also published in his book *Point du jour* (1934).

8 Walter Morgenthaler, *Ein Geisteskranker als Künstler (Madness and Art)*, trans. Aaron Esman (Lincoln: University of Nebraska Press, 1992).

9 Hans Prinzhorn, *Bildnerei der Geisteskranken* (Berlin: Springer, 1922); translated as *Artistry of the Mentally Ill*, trans. E. von Brockdorf (Berlin: Springer, 1972, 1994).

10 For a more detailed analysis of Prinzhorn's perspective on the art of the mentally ill, see Bettina Brand-Claussen, "The Collection of Works of Art in the Psychiatric Clinic, Heidelberg—from the Beginnings Until 1945," in *Beyond Reason: Art and Psychosis; Works from the Prinzhorn Collection* (London: Hayward Gallery, 1996), 7–23.

11 Ibid., 18–19.

12 Jean Paulhan, quoted in Daniel Baumann, "The Reception of Adolf Wölfli's Work, 1921–1996," in *Adolf Wölfli: Draftsman, Writer, Poet, Composer* ed. Elka Spoerri (Ithaca: Cornell University Press, 1997), 213–17.

13 Jean Dubuffet, *L'art brut préféré aux arts culturels*, exh. cat. (Paris, 1949), reprinted in Jean Dubuffet, *Prospectus et tous écrits suivants*, vol. 1 (Paris: Gallimard, 1967), 1.

14 Jean Dubuffet, *Asphyxiating Culture and Other Writings*, trans. Carol Volk (New York: Four Walls and Eight Windows, 1988), 40–41.

15 For more on the activities at Sainte-Anne Hospital, see Sarah Wilson, "From the Asylum to the Museum: Marginal Art in Paris and New York, 1938–68," in *Parallel Visions*, 120–26.

16 André Breton, letter, Sept. 20, 1951, in Dubuffet, *Prospectus*, 493.

17 Hemphill's exhibition is discussed in Lynda Roscoe Hartigan, *Made with Passion: The Hemphill Folk Art Collection* (Washington, D.C.: Smithsonian Institution, 1990), 29–33. Hartigan's book is a good general source on the collection, exhibition, and interpretation of twentieth-century folk art in America.

18 Robert Hughes, "Finale for the Fantastical," *Time* (March 1, 1982): 70–71; John Michael Vlach, "'Properly Speaking': The Need for Plain Talk About Folk Art," in *Folk Art and Art Worlds*, ed. John Michael Vlach and Simon J. Bronner (Ann Arbor, Mich.: UMI Research Press, 1986), 19; Eugene W. Metcalf, Jr., "Black Art, Folk Art, and Social Control," *Winterthur Portfolio* (Winter 1983): tk.

19 Eugene Metcalf, "From Domination to Desire: Insiders and Outside Art," in Hall and Metcalf, *The Artist Outsider*, 215, 221. Lucy Lippard advances similar arguments in her essay in the same volume, "Crossing into Uncommon Grounds," 3–18.

20 Recent efforts to clarify terminology include Margit Rowell, "Familiar, Yet Somehow Unfamiliar," in Frank Maresca and Roger Ricco, *American Vernacular: New Discoveries in Folk, Self-Taught, and Outsider Sculpture* (Boston: Bulfinch Press, 2002), 11–17; and Brooke Davis Anderson, "American Anthem: Masterworks from the American Folk Art Museum," *Folk Art* 27 (Summer 2002): 41–44.

21 Oliver Sacks, *An Anthropologist on Mars* (New York: Alfred A. Knopf, 1995), xvi–xvii.

Gedewon
A Talismanic Art

Jacques Mercier

Gedewon[1] is an initiate of talismanic art—an accursed art, according to its origins as recounted by the Ethiopians.[2] And, as was often the case in the past, this form of art remains forbidden in modern Ethiopian society.

The Ethiopian art of talismans[3] is the most graphic branch of this art. It is the most plastic of a bimillenary knowledge, the most well-known branches of which are Pythagoreanism, hermetism, Arabic alchemy, and Jewish Cabala. Their basic ingredients are letters of the alphabet, names, the elements, and texts. They are not simple contemplative speculations; rather, they attempt to produce effects using the creation of the world and the human being as models. This is a demiurgic art and, clearly for the Ethiopian talisman, a demiurgic graphicness.

Gedewon is a paradox in that he possessed a revealed, and thus immutable, knowledge, but at the same time his is an original graphic work. He was not a modern artist in search of his roots; he was an initiate exploring modernity. In the absence of a role model he went his own singular way, reinventing ancient heritage. While others are content to make a profit from the remains of this heritage—just enough to survive in a state of despair—Gedewon despaired more with regard to the size of the paper at his disposal. He required increasingly large surfaces to attain an impossible completeness, because in his art there is enthusiasm, violence—that of a demiurge who fashions the world and his heritage in accordance with his wishes.

Innovative and adventurous, Gedewon's art is immediately recognizable. Viewers who draw near the surface of the paper and let their gaze vibrate over the muting forms should beware of eye strain. This art is not the innocence of raw art or autodidactic art. Structured by a very ancient learning, it has been rethought and updated, which gives to its graphicness a strength beyond the means of the dilettante.

In spite of Gedewon's remarkable talismanic talent, this was not his primary profession. He was a professor of *qené* (rhetoric poetry) in the church schools. Obtaining the status of *debtera*—an ecclesiastic not ordained as a priest—he had a certain ethical freedom but did not go so far as to advertise his knowledge of medicine and the esoteric sciences—or his Solomon-like wisdom (*t'ebab*).[4] When the wise speak of their life in a propitious moment,

they appear to be performing, because they must appear powerful in order to persuade potential clients to call upon their talents. Furthermore, rather than a life history, they have a life of histories. In this discussion it is important not to unearth the events disguised in these stories, but rather to understand the protean embodiment that they shape and remodel, like an epic text having other, earlier versions.[5]

If there is a recurring refrain in Gedewon's past, it is violence; his relationship with his family—even before he was conscious of his acts, as the Ethiopians say—had a backdrop of violent property disputes.[6] Murders and acts of vengeance alienated his relatives from each other, especially on his mother's side, whose family was descended from King Fasil.[7] These events all took place in the mountainous region of Gayent, about one hundred kilometers east of Lake Tana, during the 1940s.[8]

When Gedewon was about seven or eight years old, a teacher came to the house to teach him to read, and then to teach him the Psalter. His father encouraged him to study, but his mother, who adored him, feared that education would transport him into the world and away from her. He was the only child in the family to study. Gedewon also was a fighter, and he liked weapons. He made a rifle with two pieces of wood and practiced his aim by throwing stones at targets. Although these activities were child's play, they took on another dimension in the existing atmosphere of suspicion. His maternal uncles, who did not like him, feared that Gedewon would kill them one day. His brothers also grew jealous of Gedewon after the death of their father. When Gedewon was thirteen his mother became ill and died, leaving her possessions to Gedewon. His brothers took and sold them, however. Fearing for his life, he ran away and began a life as an errant student. The only baggage he carried was the prophecy of his first master, who said that Gedewon would become a teacher of qené and would never return to his homeland.

After dabbling in religious singing, Gedewon did turn to qené, in which he rapidly excelled.[9] His studies, stretching over a period of ten years, required him to travel throughout the Amhara, first to Wadla and Begemdir, then to Lasta, Zobel, Amhara-Sayent, Menz, and Gojjam. During this time his goals alternated between simple survival

(he found constant begging repugnant) and a search for good teachers. He also met an aged gyrovague monk who was knowledgeable about talismanics.[10] They agreed that Gedewon would revise the lessons of the monk, and the monk would teach him the talismans and prayers. Gedewon did not know how to write, and so the monk guided his hand to trace the letters and the talismans.

In the years that followed, Gedewon developed an interest in medicine and the esoteric sciences. He chose certain of his qené masters for their "wisdom," or, more precisely, in the language of the clerics, their "accomplishment."[11] But, wishing to be served before revealing any secrets, they were hard on Gedewon. Aware of his brilliance, the masters either were jealous and rejected him or they wanted to appropriate him as assistant and member of their family. Meanwhile, the students fought incessantly, both with the priests during banquets and assemblies, and, worse, with the peasants and bandits. A proud man, Gedewon always carried a grenade and a pistol that he did not hesitate to brandish. Cautious of his enemies, he would not eat an item of food if he was unsure of its source, for fear of being poisoned.

His greatest talismanic masters were Wolde-Senbet in Zobel and Tekle in Wadla. One day, after chasing away a band of arrogant peasants with his grenade, Gedewon noticed that he was wearing a protective talisman given to him by Tekle.[12] Tekle was much hated and envied because of his reputation as a magician; for example, Gedewon knew that Tekle's enemies had never successfully set fire to his house. These coincidences, and others, whetted Gedewon's interest in talismanics.

As recounted by Gedewon, these tales are a crude indication of the social tensions that lead to wisdom. They differ from those of other clerics less by their factual content than by their accentuated tension and violence, but tension and violence are precisely characteristics of his talismans. How, then, could this graphicness, as constant as the stars, be imbued with such unique violence?

In Gojjam, at Washära, one of Ethiopia's most renowned schools of qené, Gedewon became an assistant to the master Fentaye and later succeeded him upon his death. Attracted to this village by what ultimately proved to be the empty promises of employment made by a

university academic who wished to appropriate his rhetoric knowledge, he gladly left for Addis-Ababa in 1964. Although he was ignored or rejected at first, he ultimately found a position teaching Amharic and earned the admiration of some for his secret knowledge.

I first became aware of Gedewon in 1975 when I was looking for healing artists. After meeting him I gave him a notebook and asked that he fill it with drawings of talismans. At his request, I also gave him several colored inks. When he returned the notebook and I saw what he had created, his penetrating explanations turned my initial astonishment to admiration.

The eight talismans of the notebook are called *Dertehal*—an angel's name—and they contain the first letter of the alphabet, *h*, which has the shape of a Latin *u*. The third talisman (fig. 10) is intended to bring home the victim of a spell that has induced madness and ceaseless wandering. While the angel at the top center (1B, as noted by horizontal columns 1–5 from top to bottom, and vertical columns A–C from left to right) chases him, the two angels below and on each side (2A, 2C) bring him back. These two angels are the power and the authority of God. They are the emissaries, such as speech, of the central figure (2B), which has human features and which resembles a king. To gaze upon the first is to be pursued; to gaze upon the others is to be brought home. These four angels dwell in the air, between God and the Devil, and they must be drawn together. The wings (1A, 1C) represent the appearance of the angel of strength (1B). They are also an opening signifying madness. As this talisman is intended to heal, only a small opening is shown, because the opening causes madness. The talisman has seven horns or points—the seven horizontal bars—which signify the return. The person returns in a space filled with flowers (3A–C) and will remain there—from where he had been banished. But if he is found in the space with blue bars (4B), he will not regain health. The face at the bottom is the hidden carrier, who can both heal and attack. His emanations appear in 5B; and on both sides and immediately below are his wings that hide him and his jewels. The colors indicate the places where the person was attacked. The drawing must be completed by a prayer and shown to the sick person.

From these explanations emerge two themes. First is the juxtaposition of opposites: the opening and the closing, banishment and return, the dual status of the carrier, and illness and health. The talisman does not open the space without closing it, does not heal without inflicting madness: it actualizes madness to chase it away, but it can produce madness by slight modifications of the drawing. The second theme is the use of color: green is the prairie where the victim perceived his attacker, where he began to go mad. Adding green to a talisman will prevent the attacker from entering the prairie. But, as Gedewon said, the spirits mock us and our ineffective protection. They are constantly changing appearance, becoming flower, butterfly, flash of light, etc., thereby foiling our defenses. Consequently, the talisman has to anticipate the unpredictable and place the colors in unexpected ways. It is a matter not simply of providing a static representation of the negative element with a shape and place, as is the custom in many esoteric traditions, including those of Ethiopia, but rather of creating a graphic dynamism that, to be effective, must break away from all regularity and harmony. We thus come back to the theme of the juxtaposition of opposites—dynamic opposites—the combative nature of these talismans is exacerbated by Gedewon's own violent character.

When Gedewon told me that he needed more space and colors, I gave him larger sheets and a greater selection of inks. He soon came back with extraordinary drawings that showed mobility and tension such as I had never seen in Ethiopia. The first of these large drawings, titled *Mes*, in particular develops the theme of emissaries in a procession from the (metaphysical) One to the Multiple, then back to the One. In this exceptional work the combinations of colors and fleeting shapes are perpetually changed by the spirits who inhabit this talisman.

The second talisman, titled *Hanos* (fig. 11), having no compositional center, comprises colors vying to create tension, though each possesses material references: the blue is water, the green is papyrus, the red is a field, etc. The whole composes a landscape with no top or bottom but with a somewhat infinite completeness, as the design appears to continue beyond the border of the paper.

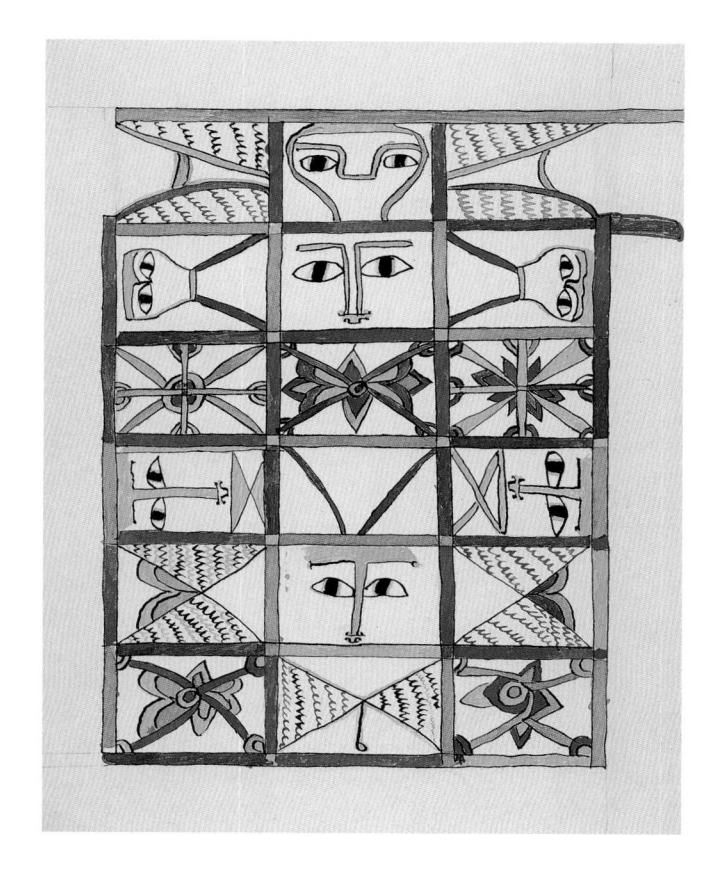

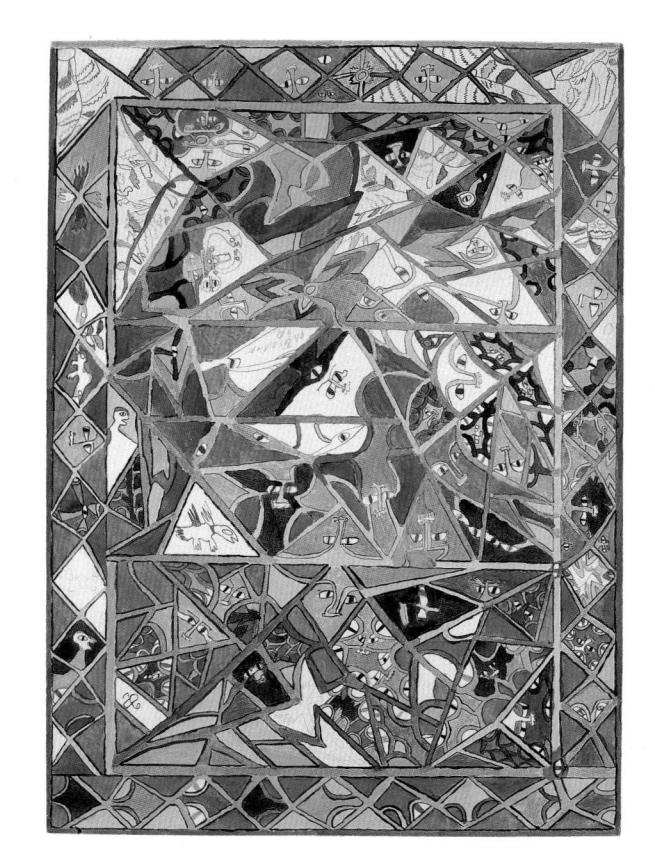

10

Gedewon, *Dertehal*, 1975
Ink on paper, 12 ¹/₂ x 9 ¹/₂ in. (32 x 24 cm)
Private collection, Paris

11

Gedewon, *Hanos*, 1975
Ink on paper, 39 x 29 ¹/₂ in. (100 x 75 cm)
Musée National des Arts d'Afrique et d'Océanie, Paris
Gift of Jacques Mercier

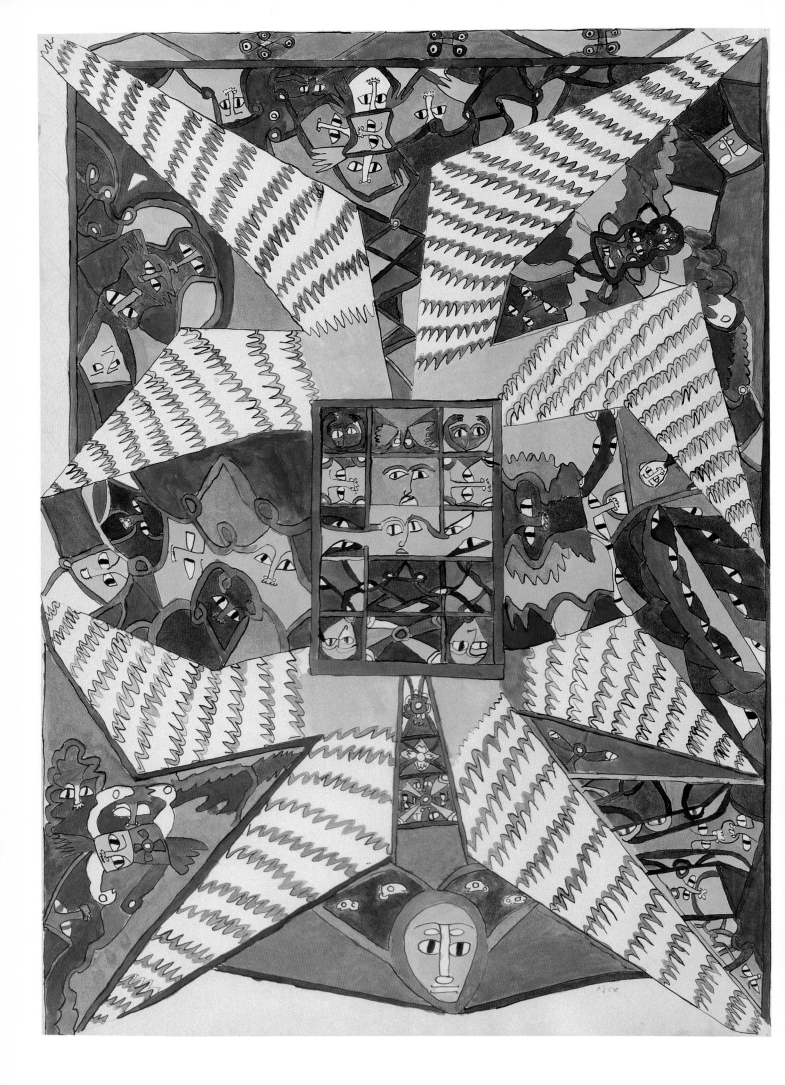

The next talisman (fig. 12), like the first, combines several massive shapes derived from the common talismanic repertory (such as a seal with eight branches and a checkerboard of faces) with landscapes originating from various elements—flowers, birds, weapons, etc.—that are usually integrated, although sparingly, in the interstices of the talismanic scrolls.[13]

I never saw any of Gedewon's personal notebooks or any of his talismans destined for other persons. These 1975 works therefore lack referents in Gedewon's career. I occasionally heard, however, of a patient of his being cured by a talisman that was described as a gaudy, multicolored work. Moreover, Gedewon's basic talismanic language is totally within the norm. Thus the original inflections, such as his theory of colors or the neo-Platonist procession, demonstrate the depth of his knowledge rather than meanderings, as they are entirely coherent with the rest of his dialogue. So why does Gedewon's graphism and his use of color differ so much from contemporary Ethiopian creations? I can propose one theory based on my discussions with Gedewon and other clerics.

Gedewon studied talismanics at a time when the social body of this art was disintegrating. The masters of these secrets traditionally had access to the princely and royal courts, where they compared their knowledge and developed a certain unity among the different dialogues and practices. By the mid twentieth century, however, the only remaining participants were the country peasants, whose practice focused on the summoning of the spirits, and not on the more intellectual aspects of this art. Consequently, Gedewon attained notoriety too late to be summoned to the royal palace.[14]

In this fragmented atmosphere, dialogue is diversified and original, and divergences can occur, particularly among qené professors. Wrestling with hundreds of rules of rhetoric and forbidden to repeat a poem, they must have an unfailing memory and be extremely quick and imaginative. They draw their themes from an oral repertory that lends great importance to angelology and to persons involved with esotericism: Solomon, Enoch, Alexander the Great, Zoroaster—all talismanic personalities. Because Gedewon was impetuous rather than bulimic in all his activities, and because he possessed an extraordinary gift

for draughtsmanship, he could be considered much more than a deviant: he was an activist able to revive a dying ancestral art.

Following my request, Gedewon pushed his interpretation of the talismanic tradition further: his art reached a new level of splendor. At this time I left Ethiopia for several months. Upon my return I found a roll of drawings composed of crude shapes and runny colors. Certain figures had been borrowed from comic strips. What had happened during this time? In the absence of an interlocutor, and therefore acknowledgment, and having almost exhausted his repertory, had Gedewon resorted to artifice? Or was it a matter of new discoveries not yet assimilated with his style? In either case, there was a break in the energy that had engendered the first talismans, and we found ourselves confronted with a crude art: neither comic strip nor talismanic, but rather a monstrous crossbreed. However, in the following months Gedewon produced a notebook (fig. 13)

12 (opposite)

Gedewon, *Protection for Friday*, 1975
Ink on paper, 39 x 29 1/2 in. (100 x 75 cm)
Private collection, Paris

13

Gedewon, *Gawl*, 1978
Ink on paper, 12 1/2 x 9 1/2 in. (32 x 24 cm)
Private collection, Paris

in which his drawing genius blossoms in the marriage of cartoons and talismans.

Fifteen years later I again encountered Gedewon subsequent to his release from prison, where he had been incarcerated by the Marxist regime after he had been made president of the association of traditional healers. I expressed my admiration of as well as my disappointment in his hideous transitional style and told him I wished to promote his talent by means of an exhibition and a book. He accepted the challenge and at an even pace produced works that, although different from the first works, were just as extraordinary. The talismans of this phase are entirely graphic, with no colored areas, and color no longer appears in his explanations. Nevertheless, his work retains

some color, first simply to highlight the talismanic outline (fig. 14)[15] according to tradition, and then as lines of color so that the talisman presents colored zones composed of these multitudes of lines. Gedewon circumvented the forbidden use of the talismanic in Ethiopia by titling his works "study and research talisman."

In preparing for the exhibition Gedewon exchanged a drawing with the Chilean-born surrealist painter Roberto Matta, who had expressed great interest in his work (fig. 15). The theme was the Earth. Each commented on the work of the other. Obviously, their commentaries carried different cultural referents, but what is important with these adventurers is the manner in which they assimilated the work of the other—each considered the other his peer —above and beyond differences of cultural origin.

In 1992 Gedewon went to Paris to participate in an exhibition at the Musée National des Arts d'Afrique et d'Océanie.[16] The success of this exhibition brought him critical acclaim and brought his talismans to the attention of the world. He then showed his works in São-Paulo (traveling there himself), New York, Berlin, Tanlay (France), and Tokyo.[17] In addition, several of his works were reproduced in *Contemporary Art of Africa*.[18] Fearing jealousy, Gedewon did not want his growing fame to become known among his countrymen. Nevertheless he continued to draw, night and day, and attained a certain financial affluence.

The talismans that Gedewon produced from 1991 until his death in 2000 all have a title and a specific function (fig. 16), and they are rich in a symbolism that is mostly lexical. The theme of the metamorphosis of forms is ever present. Sometimes he increased the figurativeness, for example, by drawing herbalist clerics gathering medicinal plants (fig. 17). Toward the end of his life he reintroduced colored areas (figs. 18, 19), but without explicit explanations.

As a true artist, he was able to make use of technical accidents. Worried about the instability of chemical colors, I had provided him with pigments. These were thick, and the ink ran irregularly from his pen. He complained about it at first, but then he became used to it. And when the technical problem was solved he continued to make trembling lines, which, he felt, served his drawing.

Did Gedewon then become truly and solely an artist, an artist whose imagination was fueled by his history

14

Gedewon, *Éla*, 1991
Ink on paper, 16 1/2 x 12 in. (42 x 29.5 cm)
Private collection, Paris

15 (opposite)

Gedewon, *Diagram*, 1991–92
Ink on paper, 39 x 29 1/2 in. (100 x 75 cm)
Private collection, Paris

16

Gedewon, *Achievement of Love*, 1993
Ink on paper, 39 x 29 1/2 in. (100 x 75 cm)
Collection of Rémy Audouin, Paris

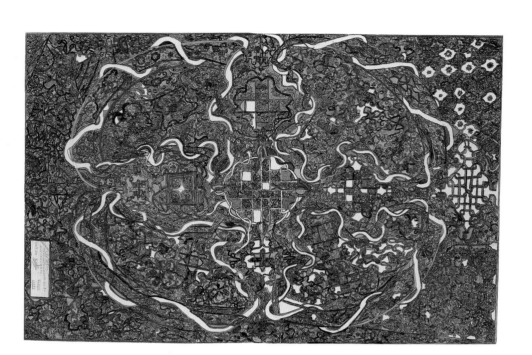

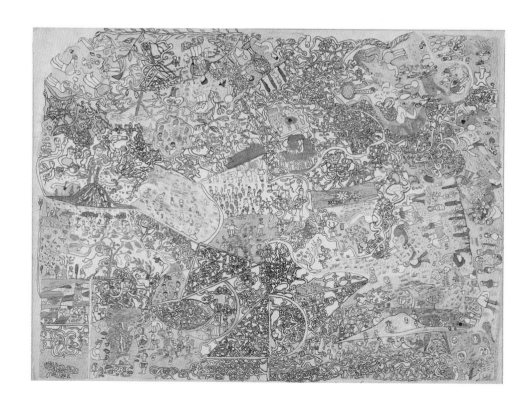

17 (top)

Gedewon, *Herbal Healing*, 1993
Ink on paper, 21¹⁄₂ x 27¹⁄₂ in. (55 x 70 cm)
Collection of Geneviève Rosset, Paris

18

Gedewon, *Talisman*, 1997–98
Ink on paper, 29¹⁄₂ x 39 in. (75 x 100 cm)
Centre pour l'art africain contemporain
Collection Jean Pigozzi, Geneva

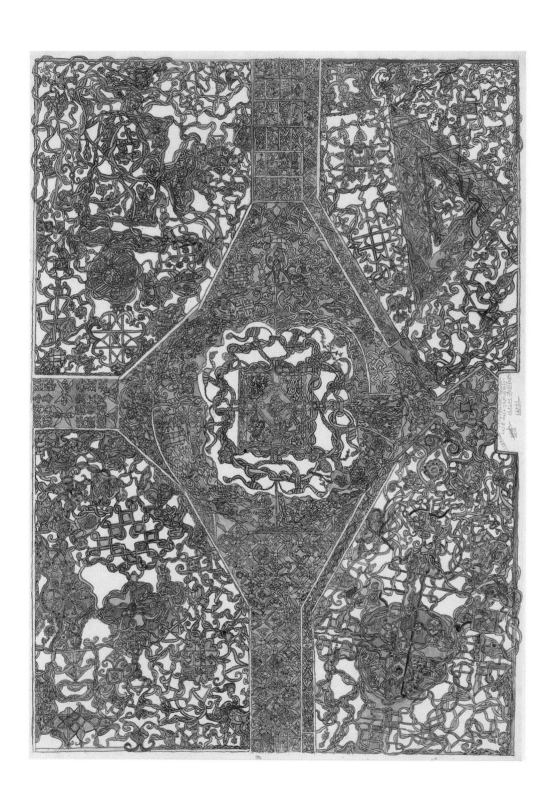

19

Gedewon, *Talisman*, 1997–98
Ink on paper
39 x 29 1/2 in. (100 x 75 cm)
Private collection, New York

and the dance of the spirits, an artist who was fully aware of his art and his responsibility? Among his new Western clients, so different from those of his own culture, one person was healed of his troubles after looking at a drawing that was destined for him. A coincidence, one might say, but a celebrated singularity makes for universality, at least potentially. Could the art of Gedewon have retained its powers? Could Gedewon have enabled the art of his fathers to attain universality?

Notes

1 Gedewon is the biblical name Gedeon transliterated in the Geez language. As the Ethiopians did not have a family name, the name of the person is usually followed by the name of the father—here Makonnen—and possibly that of the grandfather.

2 According to hearsay about the Book of Henoch, the origins were revealed, among the secrets of the Heavens, by angels to human beings, which created a supernormal phenomenon that was drowned in the waters of the Flood.

3 The Ethiopian word *t'älsäm*—like the English *talisman*—is derived from the Greek *télesma*, via Arabic.

4 The word *debtera* originates from the Greek *diphtèra*, meaning "skin, parchment, book." The priest, who cannot divorce, have a concubine, or remarry, is the guarantor of the Christian ethic through his exemplary life. Stripped of his priesthood due to a transgression, he becomes debtera. One can, of course, become debtera without having been a priest. But the debtera are nearly always suspected of wrongdoing or of working evil spells.

5 See Jacques Mercier, *Asrès, le magicien éthiopien. Souvenirs 1895–1985* (Paris: Lattès, 1987).

6 Only bilateral descendants of the first occupant have rights to family property. Land changes ownership only by inheritance or court decision—but always through bilateral descendants.

7 He reigned from 1632 to 1667 and founded the city of Gondar.

8 Like many rural people, Gedewon did not know exactly when he was born. His birthdate must have been toward the end of the Italian occupation, around 1939–40.

9 During religious ceremonies, the professors of *qené* improvise complex poems with hidden meanings. To be a master of qené one must first master the grammar.

10 Although rare, it does happen, because people become monks to survive. The specialty of educated monks is more likely to be singing or hermeneutics.

11 The masters of esoteric sciences are called *fetsum*, meaning accomplished, perfect.

12 Recounted by Jacques Mercier, *Le roi Salomon et les mäitres du regard. Art et médecine en Ethiopie*, exh. cat. (Paris: Reunion des Musées Nationaux, 1992), 220.

13 For images of ancient scrolls, see Jacques Mercier, *Ethiopian Magic Scrolls* (New York: Braziller, 1979), or Jacques Mercier, ed., *Art That Heals: Image as Medicine in Ethiopia* exh. cat. (New York: The Museum for African Art, 1997).

14 The revolution broke out in 1974 just as he was on the verge of being introduced to the court of Haile Selassie.

15 The dates inscribed by Gedewon on his talismans are those of the Ethiopian calendar: 1983 = 1990–91 of the Gregorian calendar.

16 Mercier, *Le roi Salomon*, 188–92, 202, 220–25.

17 These exhibitions were accompanied by the following important publications: Jesus Rafael Soto, *23a bienal internacional de São Paulo* (Caracas, Venezuela: Consejo Nacional de la Cultura [CONAC], 1996), 112–17; Jacques Mercier, *Art That Heals: Image as Medicine in Ethiopia* (Munich: Prestel, in conjunction with the Museum for African Art, 1997), 98–101; Simon Njami, *Die Anderen Modernen* (Berlin: Haus der Kulturen der Welt, 1997), 68–69; *Lumière noire: Art contemporain* (Tanlay, France: Centre d'Art de Tanlay, 1997), 16–19; Toshio Shimizu, *Africa Africa* (Tokyo: Tobu Bijutsukan, 1998), 54–59. Gedewon has been represented by Cavin-Morris Gallery in New York since 1997.

18 André Magnin and Jacques Soulillou, eds., *Contemporary Art of Africa* (New York: Abrams, 1996).

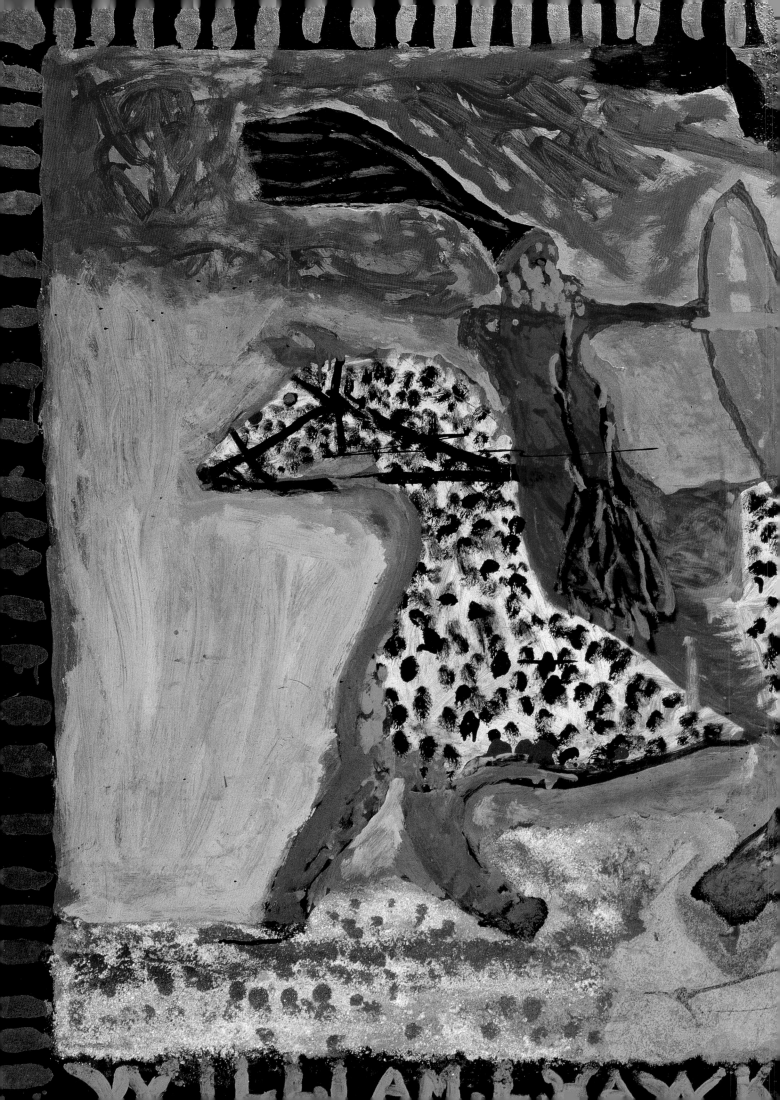

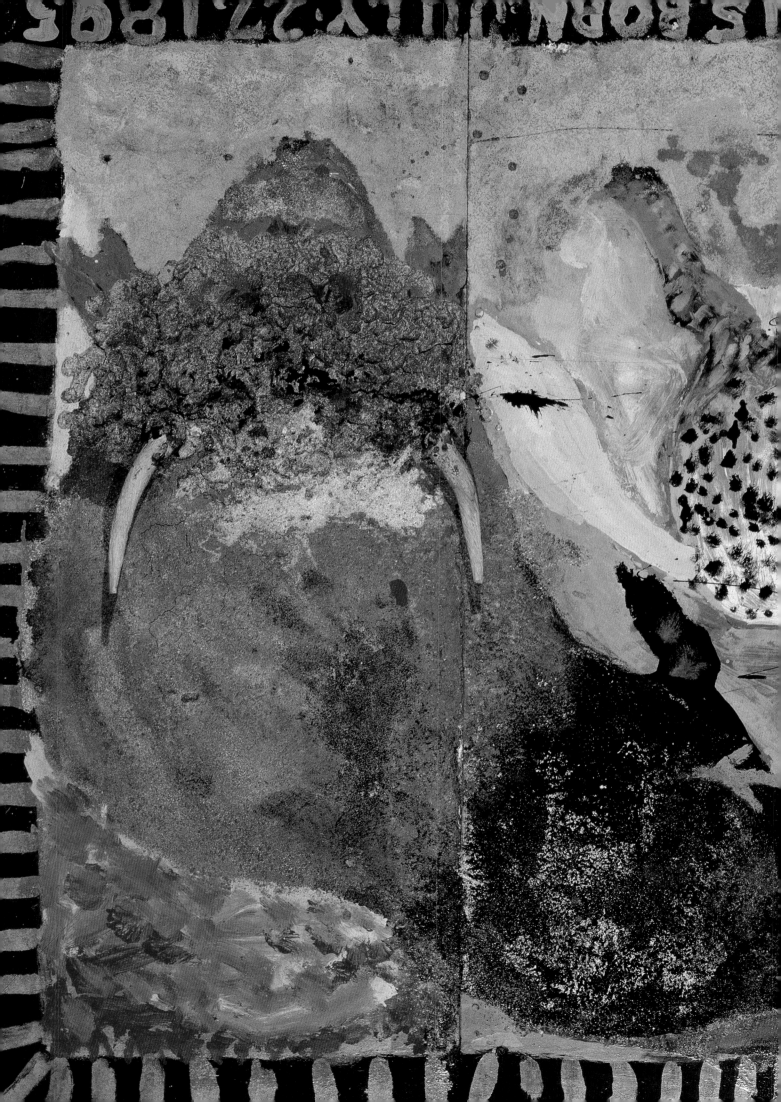

William Hawkins
Junk Man

John Beardsley

William Hawkins evidently believed that two of the most decisive details of his existence were where and when he came into the world. This was information that he inscribed, in some variation, on virtually every painting he made in his later years: *William L. Hawkins Born KY July 27, 1895.* Born on a farm near Lexington, he was taken with his younger brother, Vertia, to Union City a couple of years later by his father after his mother died. There he lived with his maternal grandmother, Mary Mason Runyon Scudder, who would become the most significant formative influence in young William's life, providing him with a stable and comfortable—if undoubtedly hardworking—childhood. She was a relatively prosperous farmer whose homestead was the legacy of her white father, Frank Scudder, a landowner who wanted to provide for the illegitimate daughter of his black housekeeper.[1]

Mary Scudder's house featured fine furniture, rugs, framed pictures, oil lamps, and a foot-pump organ. She was an accomplished quilt maker, assembling her creations principally from a collection of neckties. She bred horses, which young William learned to train. He also maintained and operated farm equipment, repaired buildings and fences, and hunted and trapped to supplement the food produced on the farm. Like many black children in the rural South in the early twentieth century, he had little time or opportunity for book learning; he attended school only through the third grade.

To be sure, these rural origins were crucial to Hawkins, both in his personal development and in his life as an artist. But they hardly give the full measure of the man; for example, he was also city-smart. After his girlfriend became pregnant, his grandmother and an aunt, ruling out marriage, packed him off to live with relatives in Ohio. Hawkins ended up—in 1916, at age twenty-one—in Columbus, where he received his education in urban survival. He labored at any job for which his rural roots had given him the skills, and he learned some new ones as an employee at a steel casting company; in an all-black regiment in the army in World War I; and as a carpenter, a mason, a plumber, and a house painter. Later—and well into his eighties—he drove trucks. From time to time he also indulged in off-the-books employment, running numbers, and operating a flophouse and brothel. Short

PREVIOUS PAGES
William Hawkins
Indian Hunting Buffalo, 1983
(see fig. 24)

of stature—a mere five feet, four inches tall—Hawkins made himself larger than life in his looks and demeanor. He was a flamboyant dresser, given to patterned trousers and printed shirts, studded leather vests, suspenders, decorated hats, and painted boots. He ornamented his car with found objects and paint; decorated with rivets and nails, the vehicle featured a handcrafted spaceship on the trunk and a dashboard collage.[2]

Many African-American yard artists dress their environments with recycled materials and brilliant colors. But Hawkins, who lived most of his life in rental housing, some of it in a room above a barbershop, had no yard until he was ninety—so he dressed his person and his car.

Hawkins was a keen collector, which provided some of the initial impetus to his art. "I'm nothing but a junk man," he once remarked to artist Gary Schwindler, who recorded hundreds of hours of conversations with Hawkins. He collected cardboard, magazines, newspapers, scrap wood and metal, linoleum, and hubcaps. There was an economic motive to his collecting: "You're stepping over money if you don't pick them up," he told Schwindler of all the things he accumulated.[3]

Some of these items were recycled for cash, but others were reborn as art. Hawkins doubtless took pride in the fact that he could transmute other people's debris —he decorated discarded lampshades, collaged pictures on the screens of broken televisions, and assembled sculptures from incongruous fragments. But he may also have felt that these retrieved materials were sanctified by the labor of the people who made or used them. Several self-taught black artists have testified to the power of found objects as interlocutors with the dead. According to Alabama yard artist Joe Minter, "A spirit of all the people that has touched and felt that material has stayed in the material." As such, there can be a kind of protective power in salvage, a summoning of powerful spirits.[4] Although Hawkins was outwardly more profane than sacred in his motivations, his dedication to salvage may well have been more than simply material.

Hawkins engaged in the same sort of recycling for his paintings. He scavenged his supplies at first, collecting plywood, sheet metal, packing crates, cardboard, and old house paint from dumps and construction sites. Around

1981, with the encouragement of a Columbus neighbor, artist Lee Garrett, he began to upgrade his materials, buying Masonite and higher-quality enamels. He preferred nonpermeable surfaces, which preserved the paint's glossy finish and caused it to pool and run. Almost from the start, he thickened his paints with various combinations of cornmeal, sand, glitter, and plaster to produce textural and three-dimensional effects. He also added found objects to his compositions, especially wood, metal, plastic, and—after 1986—collaged photographs. He scavenged for imagery in a similar way. Almost all his subjects originated in photographs or illustrations collected from newspapers and magazines. Hawkins stored his clippings in an old suitcase, the importance of which was eloquently described by Schwindler: "He went through his suitcase over and over, as if it were a vast theater of memory. It was the silent forge of his imagination."[5]

Hawkins's subjects are worth identifying in some detail, as he often repeated them in series with variations. Most prominent are numerous animals, including the horses of his youth, and city scenes, notably the buildings of Columbus (fig. 20). Although these subjects coincide with the two principal phases of his existence —the rural and the urban—seldom do they result in what might be termed memory paintings: nostalgic, even idealized, evocations of the artist's own experience of pastoral folklife or more documentary treatments of bygone urban geographies.[6]

In his representations of animals, for example, Hawkins was fascinated as much with exotic and extinct species as with local ones: he painted rhinos, elephants, mastodons, and dinosaurs along with rattlesnakes, dogs, and deer. The creatures are generally presented individually—like specimens—rather than in naturalistic settings. To convey their size, Hawkins often made them nearly as large as—and sometimes larger than—the picture surface itself, as in *Tasmanian Tiger #2*, in which the panel had to be enlarged to accommodate the top of the animal's head (fig. 21).

Hawkins's depictions of architecture are typically presented the same way; often, the entire frame is filled with just one or two buildings, making the images seem more like portraits than urban landscapes. This device gave

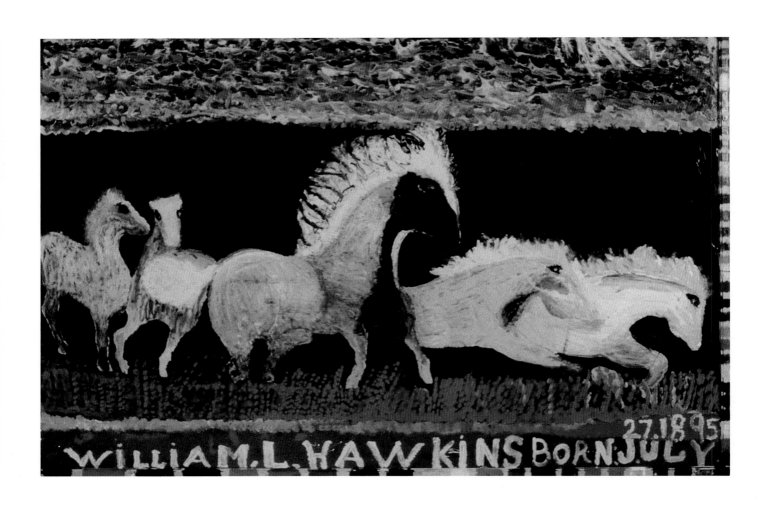

20

William Hawkins, *Five Horses*, c. 1985
Enamel on Masonite, 48 x 72 in. (121.9 x 182.9 cm)
Collection of Lael and Eugenie Johnson

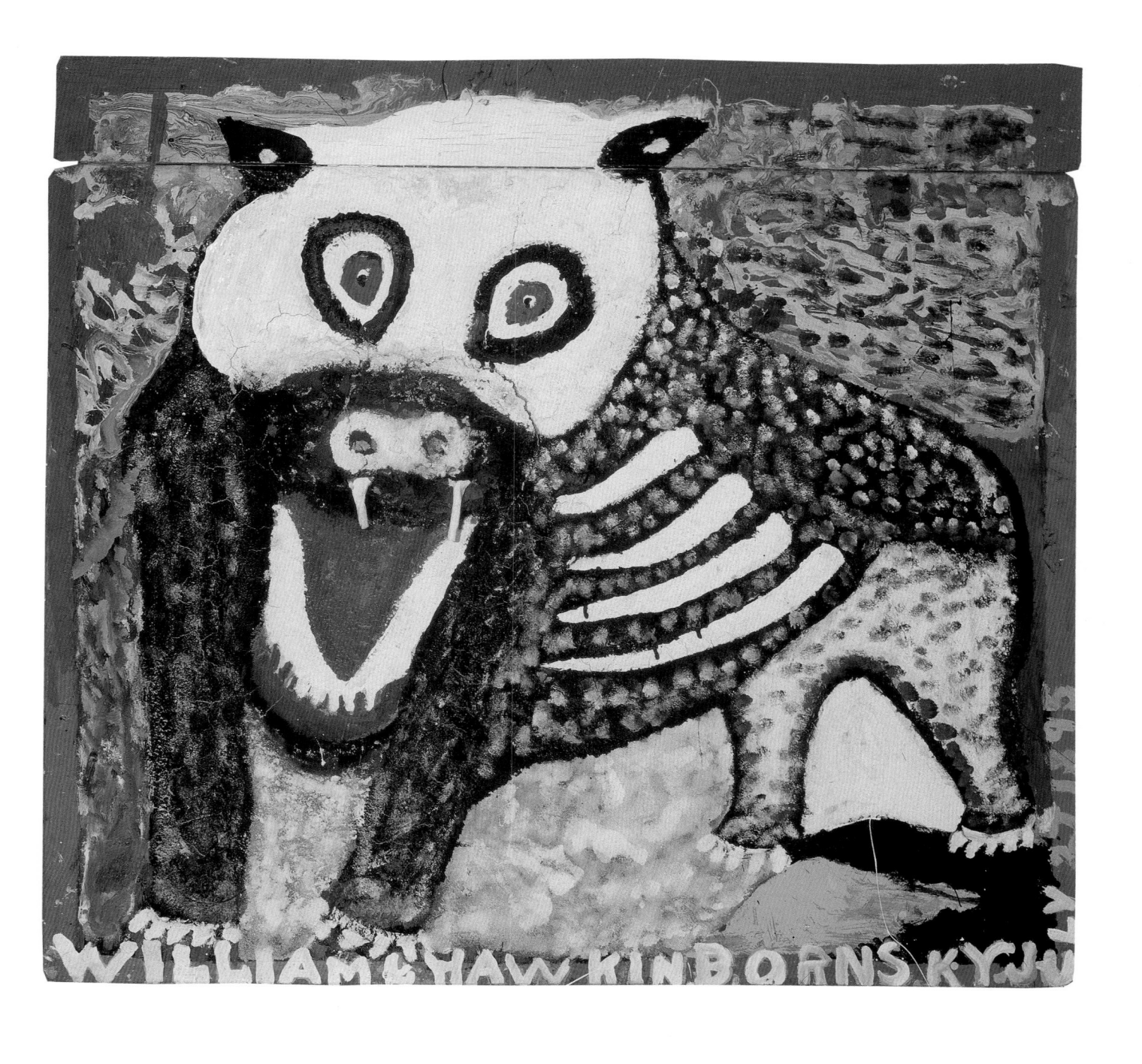

William Hawkins, *Tasmanian Tiger #2*, 1986
Enamel and mixed-media on Masonite and plywood
45 x 48 in. (114.3 x 121.9 cm)
Blumert-Fiore Collection

the particular structures the stature he saw in them. "Don't draw those old junk houses," Gary Schwindler remembers him saying to another artist, "draw . . . them big fine temples and things." Several major Columbus edifices are among his subjects, although they are temples of government, commerce, culture, and sport rather than religion: City Hall, the Neil House Motor Hotel, the stadium at Ohio State University, and the Billy James Theater, for example. Hawkins was evidently fascinated with these buildings more as historic artifacts and as emblems of modernization than as evocations of personal experience. He sometimes labeled the buildings as landmarks, as in his *Atlas Building*; he also noted the building's date of con-

struction, 1905 (fig. 22). Even when Hawkins painted an entire urban scene, his emphasis was on the character of individual buildings rather than on their relationship to each other or to the narratives of his life. This is evident in his depiction of New York in *The Statue of Liberty*, in which the city seems constructed of disjointed parts and even time is discontinuous: the painting contains the splendidly anachronistic representations of a wooden British sailing ship and an Air France Concorde (fig. 23).

Although animals and urbanization were Hawkins's main subjects, they were far from his only ones. He also depicted scenes from American history and politics (such as George Washington, Thomas Jefferson's birthplace,

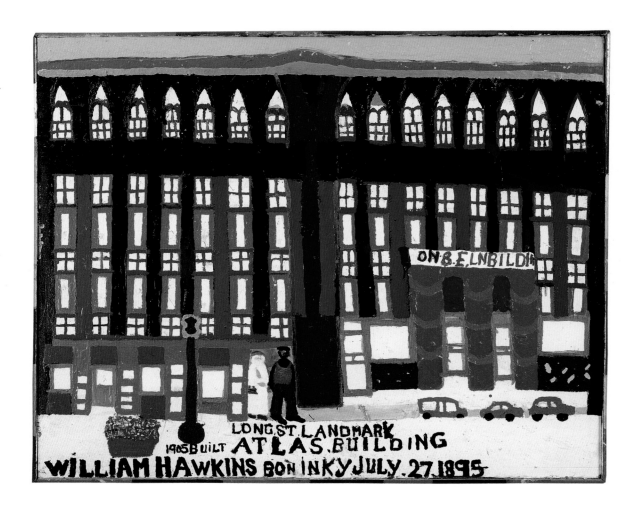

22

William Hawkins, *Atlas Building*, 1983
Enamel on plywood
38 1/2 x 47 1/2 in. (98.4 x 121.1 cm)
Blanchard-Hill Collection

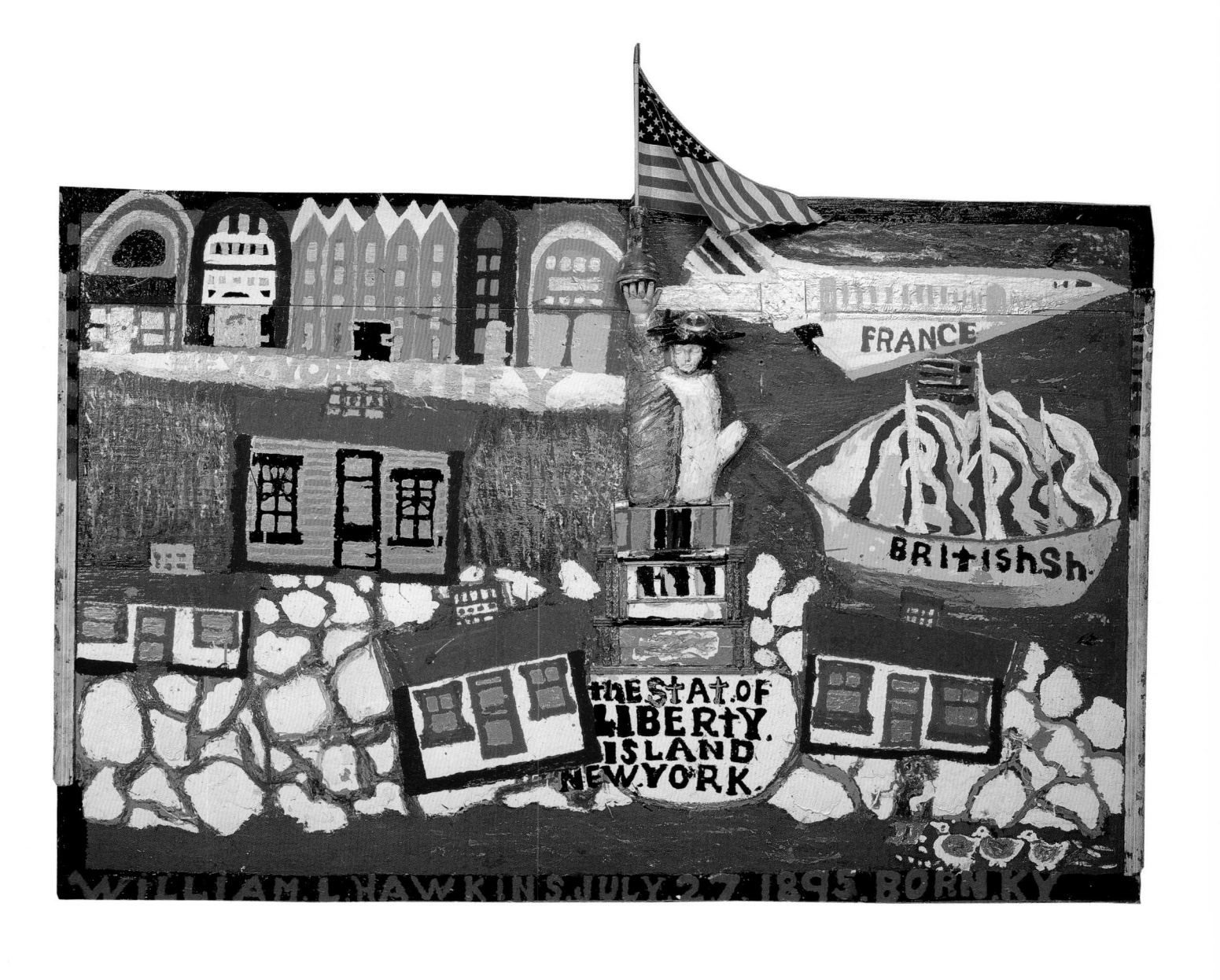

23

William Hawkins, *The Statue of Liberty*, 1986
Enamel and mixed-media on plywood
73 x 84 x 5 in. (185.4 x 213.4 x 12.7 cm)
Collection of Lael and Eugenie Johnson

and the moon landing); religion (Jerusalem, the Nativity, the adoration of Christ, the Last Supper, and the Last Judgment); popular culture (juke boxes, the Ferris wheel, Wendy's hamburgers, and Kool cigarettes); and the myths of the frontier (stagecoaches, American Indians, and buffalo hunting). The repertory of his subjects confirms his practice of finding source imagery in books and periodicals. *Overland Stagecoach* and *Indian Hunting Buffalo*, for example, are based on illustrations from a 1957 edition of *The Golden Book of America*, while *Wendy's Hot 'n Juicy* and the two versions of *Neil House with Chimney* come from newspaper clippings, the former announcing the advent of a new fast-food restaurant, the latter the destruction of a historical landmark (fig. 24). Hawkins also borrowed from the work of other artists—most noticeably, for his several *Last Supper* paintings, from a reproduction of the renowned quattrocento mural in Milan by Leonardo (fig. 25).

Hawkins deployed distinctive compositional techniques. Almost all his images are rendered in two dimensions. His buildings are drawn without perspective or shadow; for the most part, they are presented only as

facades. Human and animal figures alike are depicted without chiaroscuro—intermediate tones that give them volume. This flatness is reinforced by intense, saturated colors, which Hawkins customarily laid down undiluted and unmixed in broad strokes over large areas. The lack of modeling might be interpreted as the self-taught artist's lack of familiarity with conventional painting techniques, especially those deployed to produce the illusions of volume and depth. But it might also confirm the impact on Hawkins of the first art that he saw—his grandmother's strip or patchwork quilts.[7]

Like patchwork quilts, his paintings often appear pieced together, composed of discrete, juxtaposed components—as was noted of *The Statue of Liberty*. The similarity to quilts is most evident in architectural compositions such as *Neil House with Chimney #2*, where the rectilinear patterns of windows create a syncopated rhythm across the picture surface, much like the improvisatory structure of many African-American geometric quilts (fig. 26).[8] Also like patchwork quilts, Hawkins's paintings are sometimes literally cut out and collaged together. The artist

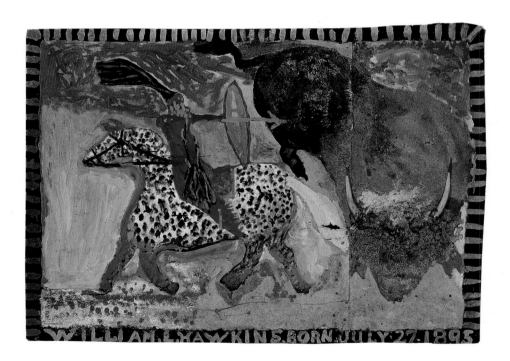

24

William Hawkins, *Indian Hunting Buffalo*, 1983
Enamel and mixed-media on Masonite
48 x 67 in. (121.9 x 170.2 cm)
Private collection

used collaged photographs and mass-produced graphics as a time- and labor-saving tactic and for the superior verisimilitude of mechanically reproduced images: "There isn't any man, don't care how good you are, can't beat no camera," he declared to Gary Schwindler.[9]

But he equally may have favored collage because of its similarity to the aesthetic strategies he had observed growing up. *Robotech Collage*, for example, displays the repetition of many patchwork patterns, with the same mass-produced image recurring at regular intervals across the surface, while the horizontal bands of color—also part of the found imagery—recall the structure of so-called lazy-gal strip quilts (fig. 27). Patchwork also provided Hawkins with a significant precedent for his practice of creating variations on a theme. Quilts can manifest remarkable individual variety within a fairly limited range of patterns—think of how many things can be done with a log cabin or star pattern. Hawkins was a master at coaxing a similar versatility out of his subjects.

Although Hawkins's subjects were generally rendered in two dimensions, his surfaces were not invariably flat.

When he wanted spatial allusions, he created them by building out from the picture plane. As stated earlier, he created impasto effects by mixing paint with cornmeal, sand, and other materials. He layered colors, sometimes scraping through the uppermost hues to reveal the tones beneath in a manner suggestive of the graffito technique. He speckled the colors in his skies or sprinkled glitter on them to suggest atmosphere. Sometimes he even added cloth, metal, and wood to his compositions to produce a hybrid of sculpture and painting something like bas-relief, as he did in *The Statue of Liberty* or *Neil House with Chimney #2*. These are compositional techniques and aesthetic strategies that he shares with other self-taught African-American artists who made a virtue of scavenging for materials: Jimmy Lee Sudduth, who paints with mud, clay, and molasses; and Thornton Dial, who is perhaps even more deliberate and wide ranging in the incorporation of found objects than was Hawkins. *All About Eve* is perhaps the most remarkable instance of a three-dimensional painting by Hawkins: she wears an actual flower-print blouse, a skirt, and boots, and she is wrapped in tubing of various

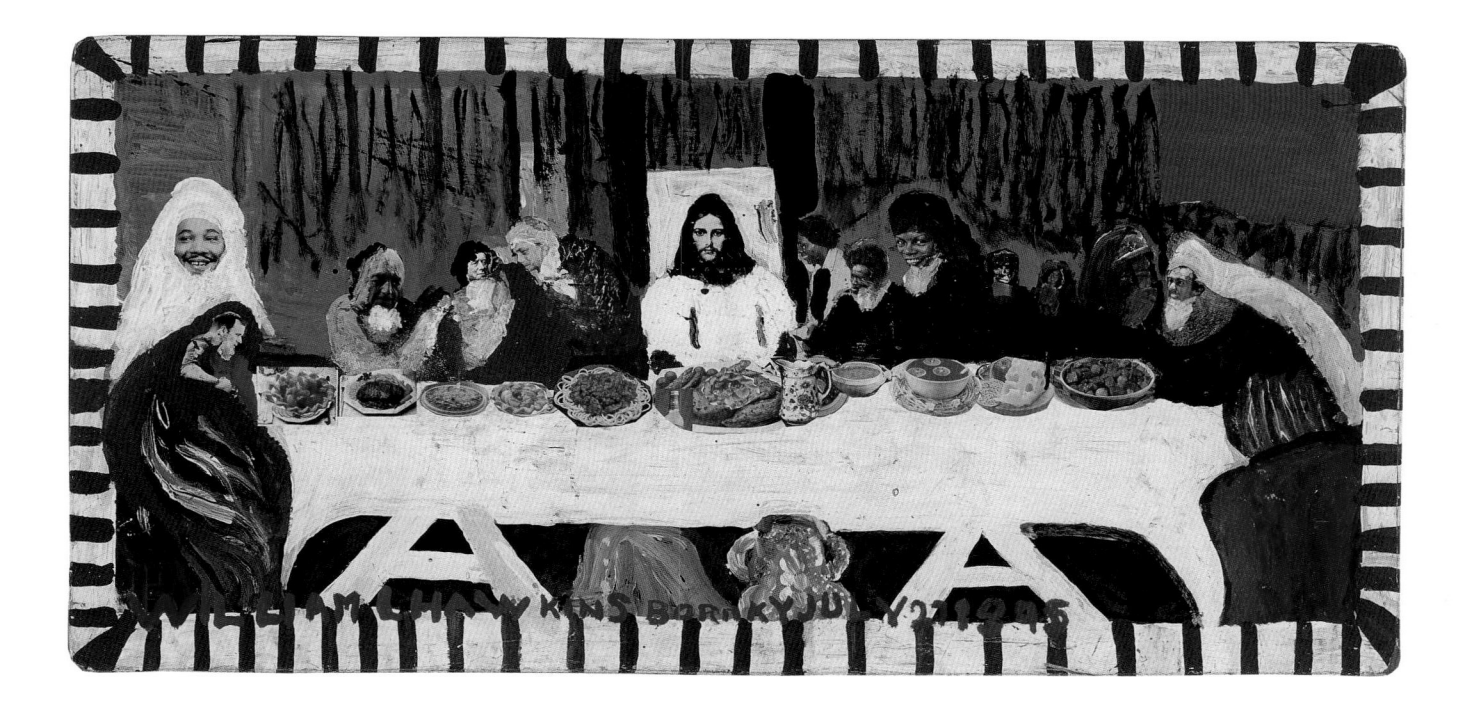

25

William Hawkins, *Last Supper #6*, 1986
Enamel and collage on Masonite
24 1/2 x 48 in. (61 x 121.9 cm)
Collection of Robert A. Roth

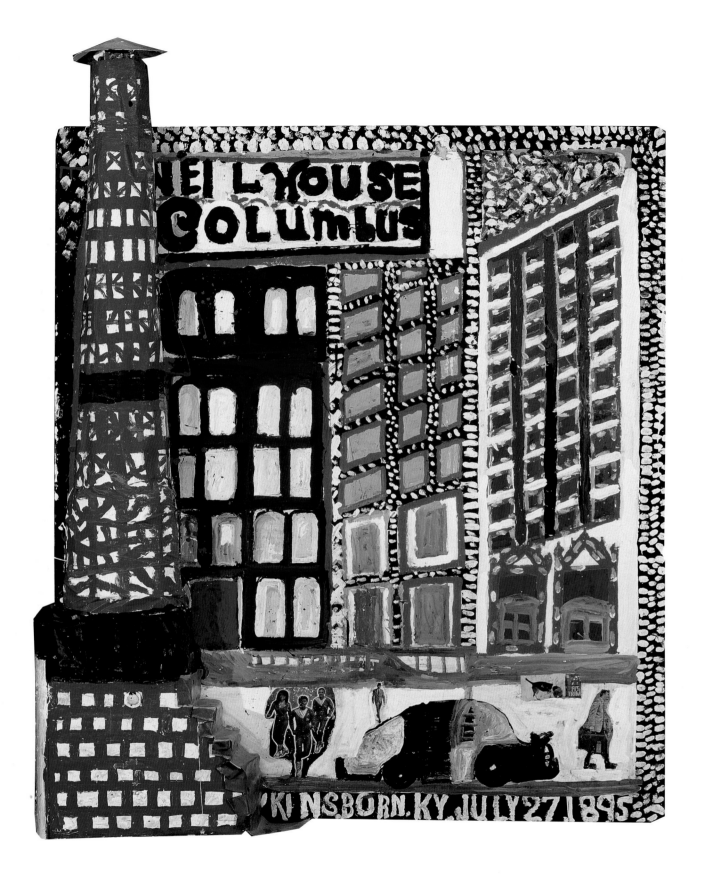

26

William Hawkins, *Neil House with Chimney #2*, 1989
Enamel, collage, and mixed-media construction on Masonite
64 x 48 x 5 in. (162.6 x 121.9 x 12.7 cm)
Marvill Collection

27

William Hawkins, *Robotech Collage*, 1988
Enamel and collage on Masonite
39 1/2 x 48 in. (100.3 x 121.9 cm)
Ricco Maresca Gallery

sizes representing the serpent—who reappears in the equally fantastical *Dragon Snake (Rattlesnake No. 5)*, made from plastic and metal venting pipes from a clothes dryer (fig. 28). *All About Eve* has a Biblical source, but the painting's title may also refer to the witty if cynical film starring Anne Baxter and Bette Davis—Hawkins, after all, was something of a movie buff, as suggested by painted tributes to King Kong and Charlie Chaplin.

For the most part, Hawkins's subjects are imaginative and apparently lighthearted. But some of them hint at brooding and complex subtexts, especially racial conflict. *Indian Chasing White Man* is clearly a representation of discord; moreover, the Indian looks distinctly African-American, which adds another nuance to the theme. *Three Hanging Men* might also have a racial subtext: it looks

eerily like a lynching, notwithstanding the presence of a flag and a soldier (fig. 29). The painting may well have been based on a photograph depicting the punishment of army deserters. Although all three men are hooded, thereby concealing their race, their hands are different colors: brown, white, and red. Hawkins has a bit more fun with racial (and gender) identity in his various representations of the Last Supper. In the first, Jesus and the disciples are all black; by the sixth, Jesus is white but the disciples are completely mixed: some black, some white, some male, some female. The collaged images of food in this version are equally inventive, including an improbable menu of spaghetti and Swiss cheese.

Still others of Hawkins's paintings might have been conceived in code. In the work of the artist Thornton

28 (opposite)

William Hawkins, *All About Eve*, 1989
Enamel and mixed-media construction on Masonite
84 x 48 x 12 in. (213.4 x 121.9 x 30.8 cm)
Ricco Maresca Gallery

29

William Hawkins, *Three Hanging Men*, 1985
Enamel on Masonite
32 x 48 in. (81.3 x 121.9 cm)
Private collection

Dial, the rattlesnake carries symbolic values above and beyond the usual sexual ones. In particular, Dial uses the serpent as a metaphor for various aspects of African-American experience, particularly in conveying scorn while at the same time being regarded as dangerous. Although such meanings are far from universal, Hawkins may have shared Dial's fascination with the snake as something powerful but feared. If so, his serpents might be imagined as symbolic self-portraits.

Some have noted that Hawkins's work recapitulates some of the history of modernist painting.[10] He used the collage technique developed by cubist painters, the brilliant unmixed colors of the Fauves, the found objects of the surrealists, and the appropriated commercial images of the pop artists. At times he even displayed the postmodernist fascination with gender and racial identity. But what does this tell us? When an artist works in relative isolation from the main currents of modern art, can these similarities be anything but coincidence? Such exchanges as occur between self-taught and academically trained artists usually go in one direction only: the latter often look to the former for inspiration in attaining more direct, unmediated, and unselfconscious approaches to subject matter and technique. We know that Hawkins was aware of prior art, although most of his sources were in commercial art or in painting from well before the modern era. But a similar kind of subversive quality does characterize some of the best of both self-taught and modernist art, with a significant difference between them, however: self-taught artists are typically unaware of the rules of conventional art, while tutored artists are striving to overthrow or unlearn them. The recognition of the coincidence in expressive aims between modernist and self-taught artists is bound to have a salutary effect. As the ambitions of artists with different levels of training and different access to economic and cultural advantages are more and more seen to be equal, some of the hierarchical distinctions between the trained and the untrained might be erased.

There is a final pictorial strategy worth noting in Hawkins's work: he had the habit of enclosing his compositions in painted frames of a wonderfully varied character. There are stars, bars, triangles, squares, solid bands, and serpentine lines; there are cloverleaf patterns, bow ties,

crosses, and arabesques, and concentric circles that look like eyes—and that's just a partial list. Some of the frames are monochromatic; more often, they are multihued, sometimes picking up dominant colors in the paintings but just as often in dissonant tones. Again, we might see an economic motive in these painted borders: a poor man's version of the ornate, gilded frame. We might also note their similarities to the colorful pieced bands that often frame African-American quilts—and Hawkins's borders do share with these textiles a determination to make each one unique. But they appear to satisfy a more personal ambition as well. These frames distinguish Hawkins's work from its surroundings, separating the world as found from the world as transfigured by the artist. Like the inscriptions that announce in each painting his advent into the world, these frames seem an expression of the artist's enormous self-assurance. They are his emphatic way of elevating the importance of the image contained within its borders. We might wonder where a little-educated country-boy-turned-urban-survivor obtained such confidence, but it was a fact of his character. "There are a million artists out there," he proclaimed, "and I try to be the greatest of them all."[11]

Notes

1. Information on Hawkins's early life is drawn from Gary Schwindler, "You Want to See Somethin' Pretty?," in Frank Maresca and Roger Ricco, *William Hawkins: Paintings* (New York: Alfred A. Knopf, 1997), vii–viii.
2. Hawkins's car and clothing are vividly described by Chicago artist Mike Noland in "William Hawkins: Remembering the Hawk," *The Outsider*, vol. 4, no. 3 (Summer 2000): 9–10.
3. Schwindler, "You Want to See Somethin' Pretty?," p. tk.
4. Joe Minter, quoted in *Souls Grown Deep: African American Vernacular Art of the South*, vol. 2, ed. William Arnett and Paul Arnett (Atlanta: Tinwood Books, 2001), 503. For more on the protective power of found objects, see "The Hidden Charms of the Deep South," in W. Arnett and P. Arnett, *Souls Grown Deep*, vol. 1 (Atlanta: Tinwood Books, 2000), 66–105.
5. Schwindler, "You Want to See Somethin' Pretty?," ix.
6. For a thorough discussion of this subject, see Roger Cardinal, "Memory Painting," in *Self Taught Art: The Culture and Aesthetics of American Vernacular Art*, ed. Charles Russell (Jackson: University Press of Mississippi, 2001), 95–116.

7 The similarity between Hawkins's work and quilts was noted by William
 Arnett in "William L. Hawkins: Photographic Memory," in W. Arnett
 and P. Arnett, *Souls Grown Deep*, vol. 1, 430.
8 For more on African-American quilting traditions, see *The Quilts of Gee's
 Bend* (Atlanta: Tinwood Books, for the Museum of Fine Arts, Houston,
 2002). There are also important publications on the subject by Cuesta
 Benberry, Raymond Dobard, Roland Freeman, Gladys-Marie Fry, Eli
 Leon, and Maude Wahlman, among others.
9 William Hawkins, quoted in Gary Schwindler, "William Hawkins, Master
 Storyteller," *Raw Vision* 4 (Spring 1991): 44.
10 Jenifer P. Borum makes this point in Maresca and Ricco, *William
 Hawkins*, 123, as does William Arnett in W. Arnett and P. Arnett, *Souls
 Grown Deep*, vol. 1, 430–31.
11 William Hawkins, quoted in Schwindler, "You Want to See Somethin'
 Pretty?," vii.

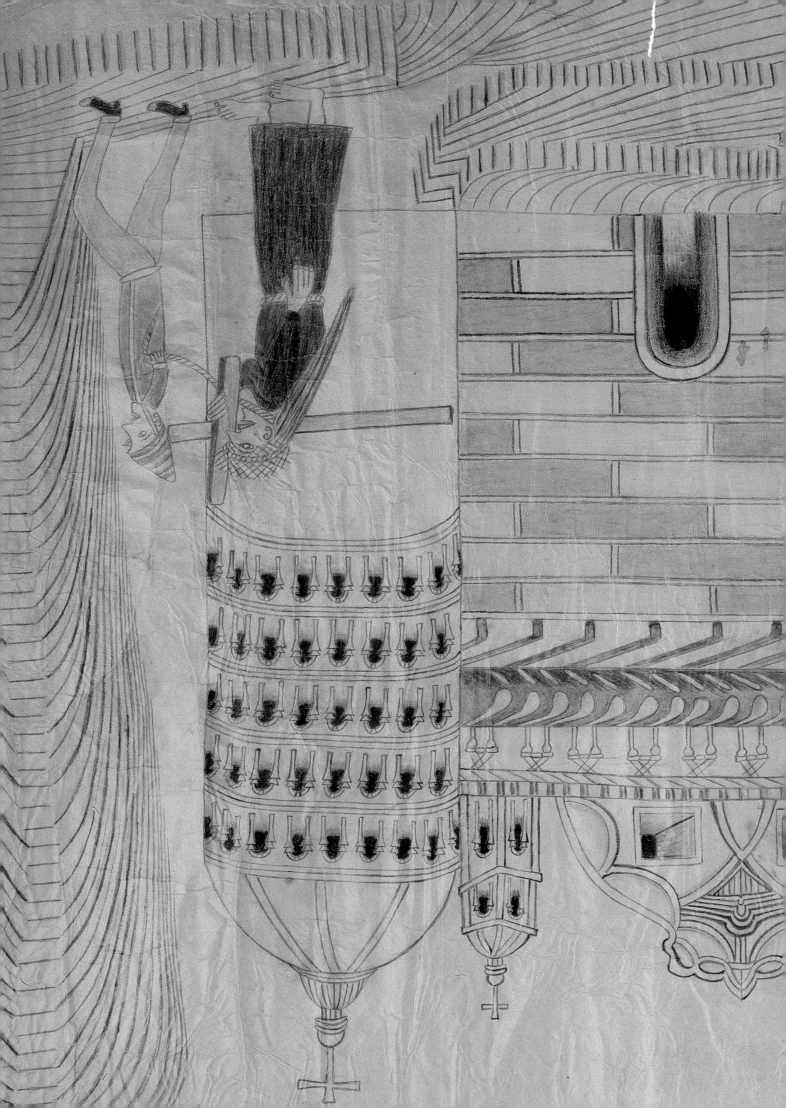

Martín Ramírez
Master of Los Altos

Randall Morris

The Mexican self-taught artist Martín Ramírez has placed a beautiful enigma in our aesthetic lives. He has given us the structures of earth, the animals: rabbits, bulls, cows, badgers, stags, does, fawns, coatimundis, tigers, snakes, and horses (figs. 30, 31). He has posed before us men and women, sacred and secular. He has placed before us his trains, cars and boats, churches, bullets, and highways and rivers. Into all of these immediately recognizable images he has breathed a desert air and a sense of miraculous enigma: the most complex of all mysteries are those that seem the most simple. The tension beneath the drawings is fraught with a grappling between good and evil. They contain the story of Revelation from a folk Catholic viewpoint. The Devil hovers not far away, while good is the nostalgic memory of home and family and church. Ramírez has taken from his experiences the dream sense the surrealists so avidly sought. His is the real surreal. He took the objects of a local mundane and blew them up to mythic proportions, grand in scale and epic in nature.

Los Altos, the region of Jalisco where this visionary artist was born, is a sere tone poem in brown, ocher, and shades of dust-blown dry green.[1] One feels that the ever-present hills have been pushed back as the towns commercialize and grow. In years past they were a frontier, a place where the unknown fused with Nature, a place of animals and caves and mystery. Now they are a tamer backdrop for the Catholic towns they connect. Black and white cattle, horses, pigs, and some sheep muck the ground and confuse the air while parades of goats noisily cross the highway, avoiding huge semis carrying various agricultural products, and SUVs carrying ranchers and locals fortunate enough to have made money in the agave or ranching business.

The arroyos and runnels are deep in the surrounding scape. The hills tend to flatness on top as if sliced by a huge, precise machete. Despite encroaching modernization there are still links to the past that do not escape even the most casual observer's eye: the power of the churches and the poverty of some of the people.

Always there are the churches. During a visit we stood in the presence of church after church, in the chill breezes of early morning, the dry heat of afternoon, the

welcome cool of evening. In each place we tried to conjure Martín Ramírez, to transform a dervish of dust into the form of his slight shoulders, to see if he stood here looking at this same cupola, or this same Virgin, with his arms around his wife, or carrying his baby, his clothes simple but clean, his lungs aching with the tuberculosis that ultimately brought him down. We tried in our imaginations to exchange his soul with the skinny grizzled man sitting on the bench in the square in Atotonilco or Betania or others. We wondered what went on inside Ramírez's mind when he looked at these churches.

He began his life here as a poor Mexican. Until recently this aspect of his life was never investigated; it never occurred to anyone to ask what Jalisco was to Ramírez, what peasant spirituality and Catholic mores meant to him. With the exception of one book[2] the significance of the concept of border to a Mexican like Ramírez was never considered.[3] The skeletal facts have been provided mostly in the words of Tarmo Pasto, a doctor and amateur painter who took an interest in Ramírez's work and who was singularly responsible, by intent and happenstance, for the preservation of the work until Chicago imagist artist Jim Nutt discovered it in storage in the 1970s. Dr. Pasto's primary contact with Ramírez was at DeWitt State Hospital in Sacramento, California, where Ramírez had been committed. Ramírez reportedly attended one of the doctor's lectures at DeWitt and showed him a drawing he had concealed in his clothing. Dr. Pasto was intuitive enough to see the importance of the work, but he was also influenced by the times and so never researched Ramírez in any depth. Nevertheless, he was astute enough and sensitive enough to sense something special about the artwork of this slight, quiet man (fig. 32).

Martín Ramírez is often referred to as one of the grand masters of Outsider Art because of his alleged mental condition and a cursory analysis of his drawings that focuses on their seeming aversion to empty space, or *horror vacuii*, shifting perspectives, and mythomaniacal extraordinary situations. An unbalanced mind is assumed because of the unfamiliarity of the Western eye to these visual narratives — circumstantial evidence at best, particularly without considering the context of the work and Ramírez's cultural background. Complicating

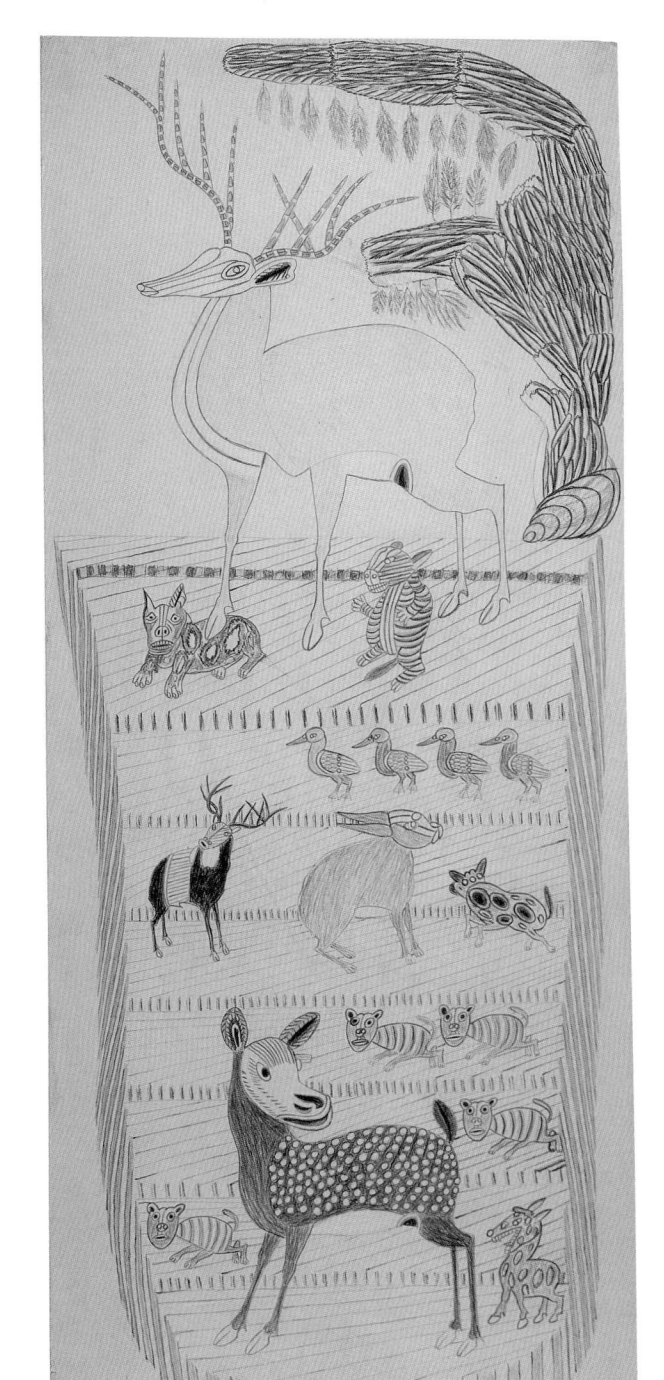

30

Martín Ramírez, *Untitled*, c. 1950
Mixed-media on paper
59 3/4 x 24 in. (152 x 61 cm)
Collection of Phyllis Kind

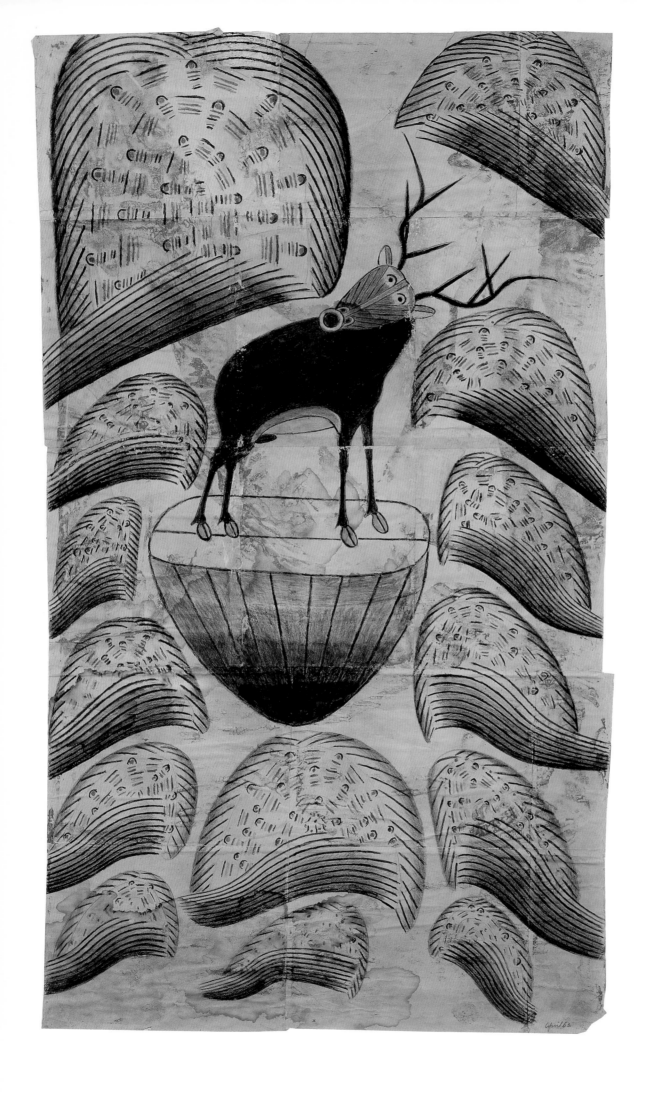

31 (opposite)

Martín Ramírez, *Untitled*, c. 1953
Mixed-media on paper
32 x 19 1/4 in. (81 x 48.9 cm)
Collection of Jim Nutt and Gladys Nilsson

32

Martín Ramírez, *Untitled*, dated June 1955
Mixed-media on paper
11 3/4 x 17 1/4 in. (30 x 44 cm)
Collection of Jim Nutt and Gladys Nilsson

this assessment was the shock treatment that Ramírez received while in the hospital.

Although we may never know the answer, we must never stop asking why Ramírez made these drawings. The vernacular artist typically does not possess the broad range of technical study and exposure by which to choose an aesthetic statement. He or she is not presented with the panoply of art history as a prelude to personal style; these are presented to the trained artist in the privileged arena of academia. The vernacular artist's intentionality is born in his own cultural *homeground*. The work is vernacular because it represents the artist's personal response to the combination of culture and place (fig. 33). The work may coincide superficially through style or materials with that of current or past trained artists, but the rest of the iceberg is composed of entirely different matter.

I have introduced the term *homeground* to indicate a form of double vision that a vernacular self-taught artist uses to locate himself in the world. This double vision refers to the relationship of the artist to his culture and location and his place in the world at large on the one hand, and the location of the artist's interior place (his self-

location) with the language and information of that culture on the other. Homeground is not place alone.[4]

The field of vernacular art is huge. The study of vernacular self-taught artists, even at this rudimentary phase, has taught us that the motivations of these artists can fall into loose-knit but recognizable bottom-line categories, the more notable of which being autobiography, travel, healing, redemption, self-location, or some kind of evangelism or other spiritual service. Ramírez is no exception and must be considered through this lens. Presumably at least some combination of the above elements appears in his drawings.

To the vernacular artist, art is inseparable from life, and formalism is usually subservient to intent, becoming an extension of homeground expression. If this combination of intent and formalism is not unique and strong, if it does not make a grand statement in a way that transcends what we have seen before, if it does not take us somewhere intrinsic to its power and genius, then neither the intention—the homeground—nor the formalism has any meaning as art. Homeground is the result of the artist as much as the artist is the result of his or her home-

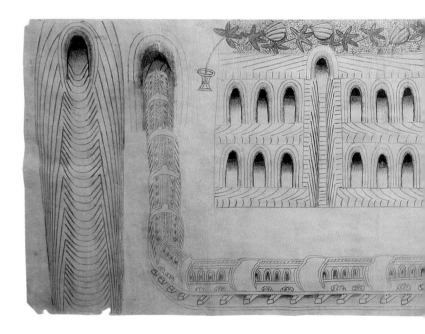

33

Martín Ramírez, *Untitled*, c. 1953
Pencil and crayon on paper
33 3/4 x 114 in. (86 x 289.5 cm)
Philadelphia Museum of Art
Gift of Josephine Albarelli
in Memory of Alphonse Albarelli, 1993

ground. By creating art, the artist has performed a service to at least some of the aspects of homeground. There is a symbiotic relationship between artist and culture at the same time that the great artist creolizes the culture.

The Jamaican vernacular phrase referring to its cultural ethos as "The One and the Many" reads as an ethic for many cultures. A person in a traditional culture (even a creolized one) lives in a double arena. In one arena is the matrix of the larger culture; for Ramírez this would be the conservative form of folk Catholicism in Los Altos. This environment provides the background and pressures and obligations that the individual then works for or against in the community and culture at large; these are the mores, folkways, and language of birth. In the other arena the "One" becomes how the individual then takes that cultural information and locates him- or herself within or without its bounds. State of mind, survival needs, and personal interpretations of culture all influence how the artist chooses to live and what that individual will or will not return to the community.

In cultural communities a charismatic being can develop a more extreme relationship to homeground and can create references that an observer might call art, though they are usually first seen as more idiosyncratic events of the community. This is why we so often hear the claim, "I don't call this art." In the homeground complex these references can be all the manifestations of oral cultures: storytelling, healing, shamanism, cooking, music, and object making. The artwork is the result of the artist's homeground working on the consciousness either symbiotically or parasitically. Artwork by a vernacular self-taught artist can, of course, be innovative, but it still speaks in the patois of its creator's references.

Hard psychological facts likely do not exist about a man declared schizophrenic in the xenophobic United States of the 1950s. We know something may have been wrong with him. James Durfee, who supervised Ramírez's ward during the last four years of the artist's life, indicated that had Ramírez been alive now he would at best be an outpatient. We must also remember that Dr. Pasto was not Ramírez's psychiatrist;[5] Ramírez apparently did not have a personal psychiatrist. He was in a psychiatric tuberculosis ward and was among the first patients in this country to receive antibiotics for the treatment of the

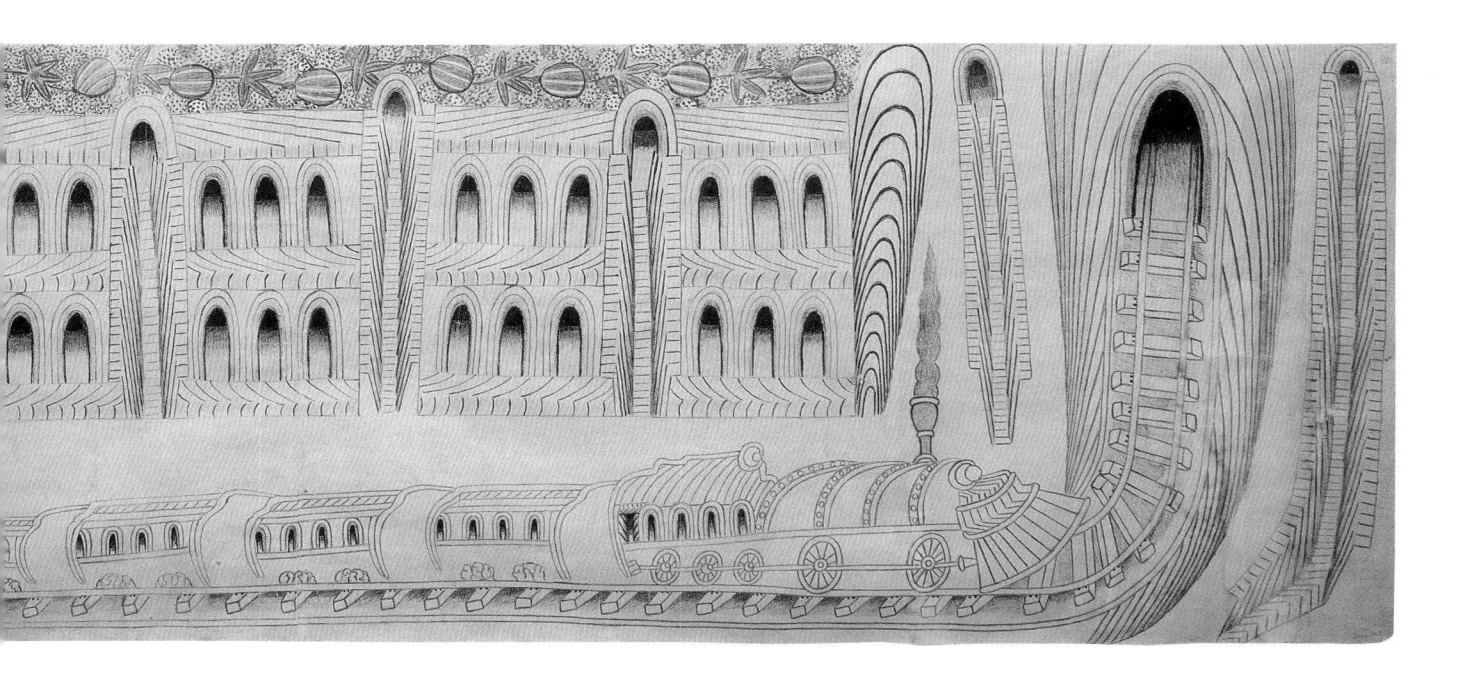

disease. After being cured he was essentially stored in a converted barracks with seventy-four other men in varying phases of psychosis. He was kept alive but not specifically treated.[6]

Interesting revelations have surfaced about Ramírez in the last several years. Before long we will know the exact location of his birth and where he lived for the three or so decades before he left Mexico.[7] In addition there will be anecdotal insights from his family,[8] although in the case of an artist the value of such information is limited.[9] The research of scholars Jorge Durand and Douglas S. Massey led them to Ramírez's origins in the Los Altos region of Mexico. Another researcher, Victor Espinosa, had also concluded that Ramírez was from Los Altos, and he told me that he had been in contact with his descendents. Espinosa declined to provide additional information for professional reasons, but this bit of information was significant in and of itself, as it more specifically defines his place of origin.[10]

Los Altos is a Mexican anomaly. It is the home of an extremely conservative and insulated folk Catholicism. Most significantly it is also almost exclusively Hispanic and mestizo with apparently little impact from Native American populations. (I will avoid entering into a more conceptual debate as to how "pure" a specific population can be in Mexico and the extent to which the Mexican mestizo interacts with others of mixed blood.) The imagery and influences that poured through Ramírez, joined with his various states of mind, with the nature of culture shock itself, as well as with the vagaries of his tuberculosis, can never be completely documented, but by looking at his drawings we know we are seeing some of those experiences already processed or in the state of being processed. This epic journey of self was tempered and influenced by his Mexican heart-language, that tender emotional and psychological place within, formed by his passion for his "homeground" (figs. 34–36).

There are images in Ramírez that remain orthodox Catholic and, to a larger degree, folk Catholic in the model of peasant Spain or even of some of the non-Mexican Hispanic villages of New Mexico; there are images that seem hybrid, and there are images that are purely invented. We have to examine the gray areas between deliberate

and accidental use of non-Catholic spiritual imagery. Some Ramírez researchers have claimed that the nature of the culture of Los Altos is such that there is no reason for any of his imagery to reflect Indian information.[11] This can never be empirically proved or disproved, but it is present in enough quantity to be an ongoing issue. We cannot set in stone what or whom Ramírez himself may have encountered in those parts of his life we never observed, though such a dialogue would certainly include the role of the deer and the drums present in some of the drawings. Also up for eternal debate is the effect on his formal language of the local Indian and mestizo world-views and crafts.

Ramírez's life was a series of borders: borders observed, borders transgressed, borders upon borders that had been with him and his people even before he was born. One cannot enter Ramírez's life without taking into account borders physical, borders moral, and borders spiritual. The most obvious of these borders is, of course, the arbitrary one placed between the countries of the United States and Mexico. A more inherent one was the cultural border of good and evil that can be traced to the very nature of his homeground and, in this case, the tenets of his folk Catholicism. Borders separate dialectics. Good and evil represent the drop cloth against which wilderness/home, home/travel, and family/strangers pose and interplay. We see this in the drawings, in the wild and domesticated animals, the churches and the homes, the virgins and the "other" women—some of them citified, some of them more familiar, more wifelike or more mistresslike—horses and cars, trains and serpents. The ultimate work on Ramírez will not be a dissertation on his life but a placing of his life within the above-mentioned dichotomies.

According to anthropologist John M. Ingham,[12] more attention must be paid to apocalyptic imagery and context in Mexican folk Catholicism. The images are definitely present in Ramírez's work, even down to depictions of the Virgin of the Immaculate Conception, known as *La Inmaculada* or *La Purissima*, as the original apocalyptic woman. Her opposite would be the worldly woman, the harlot, the woman outside the circle of the family—the street as opposed to the home. The different women

34

Martín Ramírez, *Untitled*, c. 1950
Mixed-media on paper
142 ¹/₄ x 39 in. (361 x 99 cm)
Collection of Jim Nutt and Gladys Nilsson

35

Martín Ramírez, *Untitled*, c. 1950
Pencil, crayon, and mixed-media on paper
49 x 44 1/$_2$ in. (124.4 x 113 cm)
Collection of Linda and Larry Feiwel

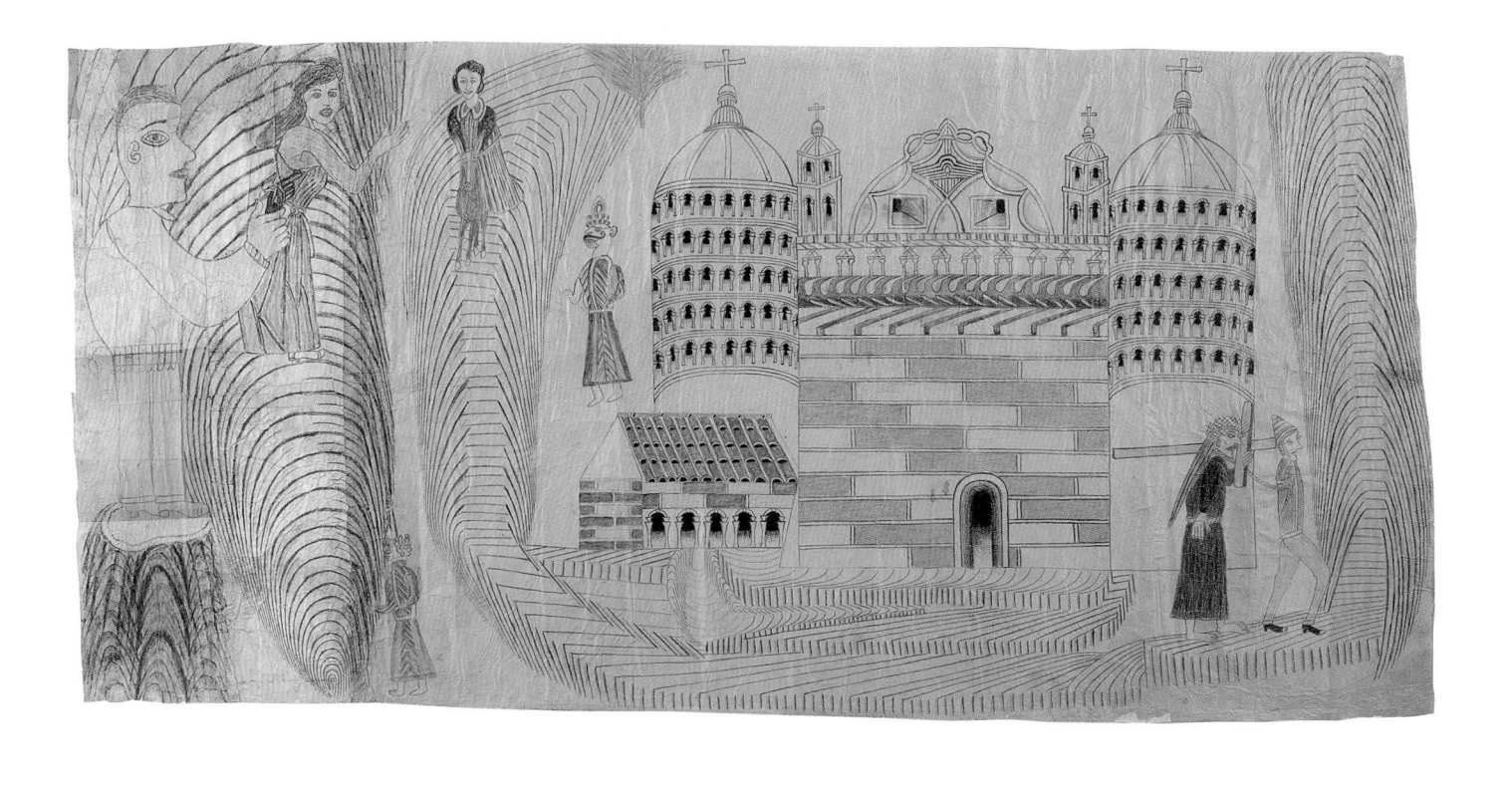

Martín Ramírez, *Untitled*, c. 1950
Mixed-media drawing on paper
39 ¹/₂ x 73 ¹/₂ in. (100.7 x 187.4 cm)
Collection of Jim Nutt and Gladys Nilsson

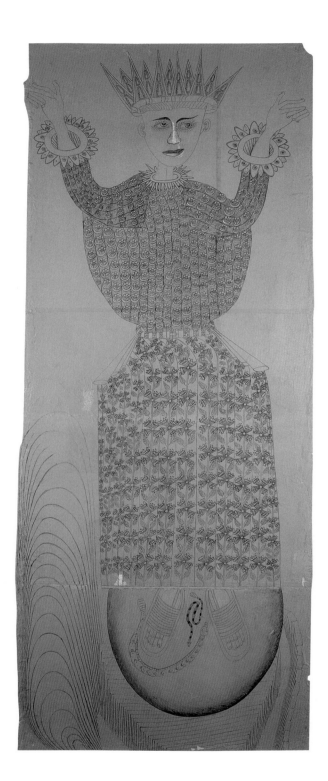

certainly show up in archetypal force in the drawings. They are either Virgins, peasants, or women on pedestals in powerful stances. Ramírez makes much of the stag, doe, and fawn in familial context. Home is comfort, while outside it looms the wilderness and wild beasts in contrast to the domesticated cattle and horses of the mundane world. He was a master fabulist.

We see the Virgin controlling the globe, while a threatening serpent or two appears at her feet (fig. 37); we also see caves, universal symbols of the underworld. We see the wilderness pierced by trains, which even have as their engines the manifestations of evil and the "other" (fig. 38): the snake or apocalyptic dragon. When Ramírez crossed the borderline of home to enter the Wilderness of the North he crossed into a place where there was no longer any assurance of the clarity of good or the awesomeness of evil.

Travel across each border would have affected his personal sense of location and created new layers of visual information over the old ones. He would see all these new events in a Los Altos context. In fact, in Ramírez's drawings the entire world takes place in a Los Altos landscape. The work moves from intimate to grand as Ramírez ponders place, cycles of life, the underworld, and, ultimately, death. The train as serpent of the underworld is a universal symbol he frequently draws in his caves and tunnels under the hilly Los Altos landscape.

Also specific to place are his Virgins, who guard the sanctity of home and who symbolize the local archetype of spiritual femininity. Mistakenly referred to as "Guadelupe" in many of the underresearched catalogs in the field, the Virgin as depicted by Ramírez represents an interesting example of some of the issues discussed here. She is actually a version of La Inmaculada or La Purissima, an extremely different manifestation of the Virgin than the very particular and Indianized Guadelupe. During our visit we showed pictures of several of Ramírez's Virgins to some of the Los Altos Catholic priests. After a cursory glance at the pictures the priest at the Church in Betania grimaced and said: "This man is crazy, this is not how the Virgin is supposed to look." In contrast, the priest in another small town named after the Virgin looked at the pictures and expressed deep interest in Ramírez and

37
Martín Ramírez, *Untitled*, c. 1953
Pencil and mixed-media on paper
62 ¹/₄ x 24 in. (158 x 61 cm)
Collection of Jim Nutt and Gladys Nilsson

called the drawings beautiful. He noticed that they were not faithful representations of La Inmaculada, but they did maintain enough cogent references to her to signify the power of Ramírez's vision.

These images epitomize the way the charismatic artist creolizes and innovates. Sometimes, in a smaller or looser-knit community, those changes become part of the larger culture; sometimes they don't. The Virgins in Ramírez's work are a wonderful phenomenon. Coming from an orthodox folk culture, albeit one that was transplanted from its European roots, he took a long established symbol, that of La Purissima, and changed certain aspects but remained consistent in his own use of the image. Ramírez's Virgin is more of an earth mother; she is intimately connected with foliage and plant life while she stamps out the diabolic serpents who threaten the well-being of the globe. His major change, aside from foliating her vestments, is to eliminate the two cherub heads often seen on the globe as well. But anyone viewing the drawings from his cultural milieu will nevertheless sense the presence of those cherubs despite their absence. Those seeking the exact Virgin depicted in the drawings will search Mexico in vain, but we can examine the drawings to make a connection between Ramírez's Virgin and the actual Virgin, and to gain a better appreciation of his control and his ability to make the drawings speak. Such a comparison also generates intriguing questions: Why did he change her? Why eliminate the cherubs? What do the plants mean, if anything?

Without a doubt, searching for a literal portrait of the world in the drawings of Ramírez is, at best, arbitrary. Equally arbitrary is explaining all the inconsistencies in the context of mental illness. Underlying all this is the consciousness of the artist himself, for ultimately we must call him an artist, and in so doing we must accept his ability to change, interpret, remake, distort, and project the world. And because he is a vernacular self-taught artist we must learn, or at worst translate, the language he uses. There are many things about him we will never know, and his genius lies in the fact that this lack of knowledge in no way diminishes the grandeur and importance of his vision as expressed in his art.

Also to be explored are Ramírez's relationships with the animals that appear in the drawings. Los Altos is traditional ranchland and so it is no surprise that horses and their trappings are shown in such detail. Hunting is another important area, as this activity was critical to the local inhabitants' survival. The above-mentioned priest

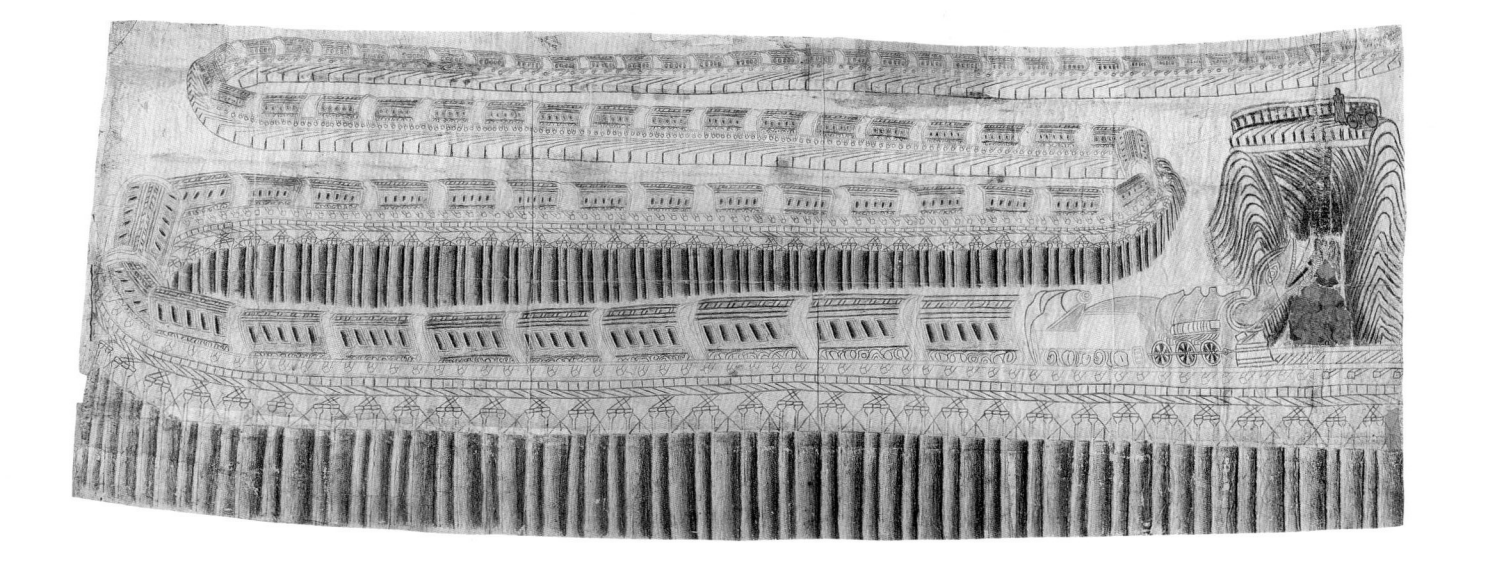

38

Martín Ramírez, *Untitled*, c. 1950
Pencil, crayon, and mixed-media on paper
33 ³/₄ x 84 in. (86 x 213.3 cm)
Collection of Jill and Sheldon Bonovitz

from the second church told me that the area used to be populated with deer and other game animals. I questioned him about big cats, because one of the drawings showed a tiger about to enter a cave. He responded that a nearby place now covered in concrete was once referred to as "The Hill of Tigers," a place well known to the old hunters.

Some of the older local people to whom we showed Ramírez's drawings of figures heading toward the hills on horseback said that rebels hid in caves of the nearby hills during the Cristeros Rebellion of 1926–29, a series of religiously motivated armed uprisings in central-western regions of Mexico in which Catholic clergy and laymen, or *cristeros*, opposed the anticlerical government in treacherous guerilla warfare. Some of those we spoke with said that their parents and grandparents brought the rebels food. Ramírez was a boy at the time of the rebellion, so many of his figures on horseback may well have been local cristeros.[13]

These examples indicate once again that the artist's stories are at least tentatively grounded in his native place and in Mexican Catholic culture. He was able to transform historical actualities into tangible art, and, despite his pathetic incarceration, shock treatments, and culture shock, he was still fully cognizant of the world he had left behind. Los Altos was the blood of Ramírez's art. It even shaped the language of his iconoclasm. He used the mores and imagery of his old life in his heroic attempt to locate himself in a more horrific new life, one that did not speak his language or understand his birthplace. It was another border, one he had to straddle rather than cross in order to survive (fig. 39).

Art making served an important amuletic function for him in the hospital. In an astonishing visual image James Durfee[14] recalled that some of the more violent patients frightened Ramírez, who would huddle under a table when he drew with matchsticks, unrolling his drawings section by section. He also told me that the drawings were not held together by mashed potatoes, as had been previously written, but by the morning oatmeal. Ramírez placed some of this food in a small pot that he had made. He dried the pot on the radiator and in it he crushed his colors in much the same way a ceramicist crushes his pigments for glazing. After moistening the colors with spittle he took

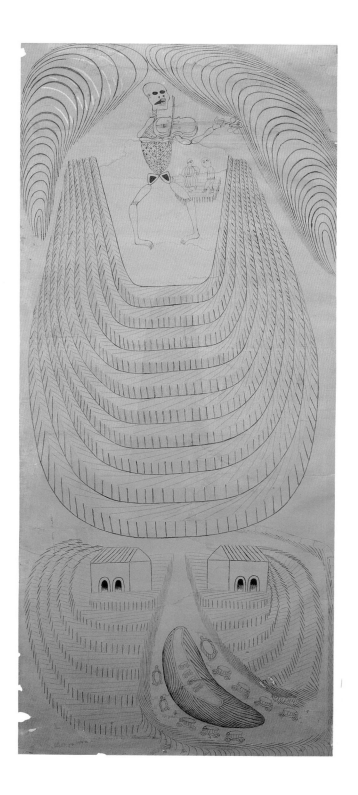

39
Martín Ramírez, *Untitled*, c. 1950
Pencil and mixed-media on paper
81 1/2 x 35 in. (207 x 89 cm)
Collection of Angela and Selig Sacks

matchsticks and dipped them into the colors and spread them on the paper.

Even in the hospital Ramírez was creolizing, inventing a means to express his message of home and his desire for relocation. How can we ever explain why he chose the medium of drawing and collage to do it? We are fortunate to have these pathetically limited glimpses into his life; between these images flits the phantom of this creative genius.

I blink as the big bells chime and notice that most evening strollers have already left the square. The birds are circling the shadowy trees, creating a raucous din that grows ever more cacophonous as the light fades. The bench where the man was sitting is now empty, and on the seat is the chewed clean cob of an ear of corn. We remember Martín Ramírez because of his drawings and the huge depth of worlds they contain. He is linked to many self-taught artists in that the images of his homeground and the yearning quality of his message and work were, like those of most masters, reaching for redemption in a forward-moving but difficult world. If it were not for his drawings he also would have left his space empty and anonymous, unnoticed under a limpid purpling sky and a spiral of birds homeward bound.

Notes

I wish to thank James Durfee, Annie Carlano, Joyce Ice, Cam Martin, Shari Cavin, José Bédia, Ido Hernandez, the International Folk Art Foundation, and the restless spirit of Martín Ramírez for their help and encouragement in this project.

1 The Los Altos aspect was first revealed to me in a letter from professors Jorge Durand and Douglas Massey.

2 Jorge Durand and Douglas S. Massey, *Miracles on the Border: Retablos of Mexican Migrants to the United States* (Tucson, Ariz.: University of Arizona Press, 1995).

3 The documents of the outsider field pick him up later when he was incarcerated at DeWitt State Hospital in Sacramento, California, where supposedly he began to draw mostly large, seemingly mystical vision maps of struggling self-location in an increasingly hostile universe.

4 When I began using the term *homeground* it was loosely based on an idea given by Grey Gundaker in *Keep Your Head to the Sky*. She has planted the seed of a concept that could be expanded way beyond the African-American. The book that inspired me is *Keep Your Head to the Sky: Interpreting African-American Homeground* (Charlottesville, Va.: University Press of Virginia, 1998).

5 Interview with James Durfee, 2001. All references to Ramírez's life in DeWitt State Hospital are from my conversations with Durfee, head psychiatric tech on Ramírez's ward for the last four years of his life. It was one of the great events of my research life to be contacted by Mr. Durfee and speak with him about his observations of the living man. Additional excerpts from my interview with him can be found in *Folk Art Magazine* (Winter 2002/2003).

6 Ibid.

7 Conversation with Victor Espinosa, 2001.

8 Ibid.

9 These facts cannot tell us when his idiosyncrasies or iconoclasm arose from his interior world to make him an artist. Only the drawings can potentially reveal the aspects of his life from which his visionary work rose.

10 Ibid.

11 Ibid.

12 John M. Ingham, *Mary, Michael and Lucifer: Folk Catholicism in Central Mexico* (Austin, Tex.: University of Texas Press, 1986).

13 Jean A. Meyer, *The Cristero Rebellion: The Mexican People Between Church and State, 1926–1929*, trans. Richard Southern (Cambridge and New York: Cambridge University Press, 1976).

14 Interview with James Durfee, 2001.

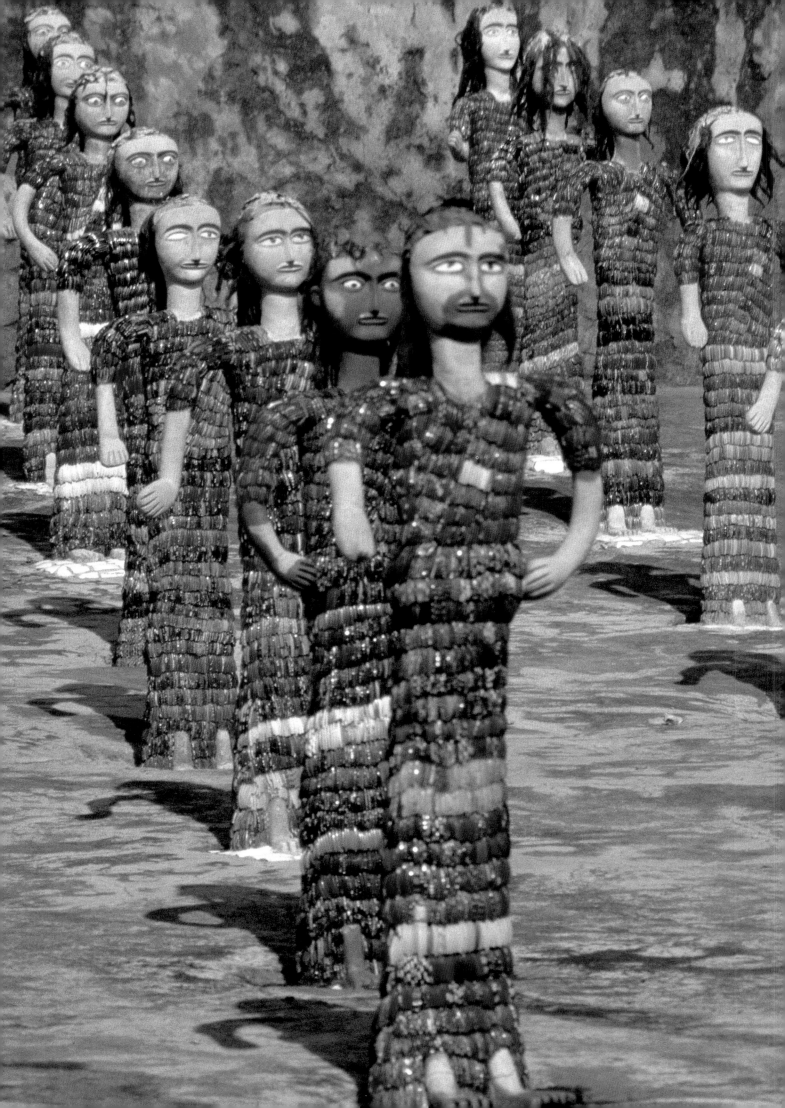

Nek Chand
Creator of a Magical World

John Maizels

Nek Chand Saini was born 15 December 1924 in the small Punjabi village of Barian Kalan.[1] Like everyone in India at that time, he was a subject of King George V of England, Emperor of India. He grew up in a fairly typical, semi-literate farming family, but even as a child he stood out. He liked to play with his handmade toys that he built from old pots, stones, and branches. He collected bird's nests, broken stumps, stones, and discarded household objects and kept them in a corner of the family home. He also played with soil, trees, and rivers. Like all the villagers, his family was poor and their home had no modern facilities, yet his childhood was an idyllic discovery of nature and creation.[2]

At age seven he attended a simple local school. It had no classrooms, paper, or pens, and the pupils sat on the ground outside under a shade tree. The school was quite a distance from his home, and for Nek Chand it meant a wondrous daily walk of discovery through forests and across a river. Each day he collected stones, pieces of wood, leaves, and other natural objects that caught his eye. He was often punished for arriving late for school and teased because he regularly tore his clothes while reaching into thorny bushes or climbing trees to retrieve new objects, but the dreamy child was untroubled by criticism.

He was very close to his mother, Janki, often preferring her company to that of his friends or his brothers and sisters. She introduced him to a traditional Punjabi folktale of a king living in his kingdom, and he always asked for her to tell him this story. He would go to sleep dreaming of having a kingdom of his own. The story inspired him to build a royal palace from sand along the banks of the nearby Kareer River, where his mother used to wash clothes. He became completely absorbed with his creation, forgetting even to eat. One day a friend kicked it down; his mother explained that a strong king must protect his kingdom from invaders. So he rebuilt his kingdom, surrounding it with a wall of stones and branches and enlarging it with palaces, gardens, courtiers, soldiers, and a king and queen. When his friend tried to attack his new kingdom Nek Chand defended it successfully and pushed him away.

At about this time Nek Chand came across a pile of broken glass bangles discarded under a stall at a local

PREVIOUS PAGES
Nek Chand
The "Queens After Bathing" set in Phase Two
(see fig. 42)

market, and he used them to make a small figure. When, at the age of twelve, he was sent off to his uncle's in Gurdaspur to attend secondary school, he left his bangle figure with his mother as a keepsake. He found city life perplexing and difficult compared with his easy rural existence and his private world of discovery and creation. Although homesick, he applied himself to his studies, including English, Urdu, and Farsi, and he returned home as often as he could. In 1943 he graduated from the Ghulam Deen Mangri High School with his matriculation certificate and returned home to a village celebration; in a mainly illiterate community his achievement was a special occasion for everyone.

Nek Chand followed tradition, as he was expected to do, and joined his father in working on the family farm. His new daily routine included rising early, working the fields, and tending the cattle. His creativity still exhibited itself, however, and he made a series of scarecrows—from discarded clothing, old pots, and sticks—that were unlike any seen before. These figures became well known locally and in many ways were an indication of things to come.

The 1940s were a volatile time in India with the growing movement to free the country from colonial rule, but with just the occasional newspaper finding its way to the village, most events passed by Barian Kalan unnoticed. However, even the most isolated area of the Punjab could not escape the turmoil and horror that would come. In 1947 the British pulled out but as a parting gift partitioned the country into separate Muslim and Hindu areas. In the resulting chaos ten million people lost their homes and became refugees as they were forced to move across the new borders. More than a million Indians lost their lives in vicious sectarian violence. Nek Chand and his family could not believe that they would lose everything but gradually realized that they would have to leave the land that had been theirs for generations. Nek Chand later recalled: "We lingered there hoping against hope that everything will be just the same as before but the time proved us wrong and we were among the last who left for Hindustan." The family left their land, home, livestock, and farm equipment and set out on foot, joining a long column of refugees heading for the new Indian frontier. After a grueling monthlong trek they reached the home of

Nek Chand's maternal grandparents in Jammu and eventually tried to settle in Gurdaspur, where they could manage only a subsistent existence.

Nek Chand decided to make his own way in life. Taking advantage of an Indian government scheme to employ refugees, he eventually found a post in the Public Works Department of the giant construction project for Chandigarh, the new capital city of what was left of the Punjab on the Indian side. The leader of liberated India, Pandit Nehru, was determined to make the new city a symbol of hope and progress. The world-renowned French architect Le Corbusier took charge of the planning for the city and, with a team of international and Indian architects, went on to complete his largest architectural project.[3]

Nek Chand's position was roads inspector, and he was responsible for organizing the construction all around the city. However, as he began his new job he received the tragic news that first his mother and then his father had died. Nek Chand was convinced that the agony caused by the splitting of the country had sapped their will to live: "Partition devoured them. Had there been no Partition I am sure they would have lived for many more years." (In 2001, during a visit to Lahore in Pakistan as part of a cultural event, Nek Chand returned briefly to his village for the first time since he and his family were refugees. He was recognized and surrounded in greetings by his former neighbors. He took back with him a small plant, soil in which to grow it, and water from the Kareer River with which to nurture it.[4])

Nek Chand settled in to his work, yet the pain of losing his home and his parents followed him. At the same time he was haunted by his childhood vision of a kingdom of his own. He began collecting stones and waste, just as he had done as a child. By the late 1950s he was roaming the Shivalik Hills outside Chandigarh, bicycling more than twenty miles a day in his search for stones that resembled people, animals, and gods or goddesses, stones that he believed had life within them. He took his finds to a small clearing he had secretly carved out in the jungle on the outskirts of the new city. In this little clearing he built a simple one-room hut that he used for storage and shelter.

His duties at the Public Works Department included supervising the city dump, which became a major

source of material for him. Twenty-six villages were demolished to make way for the mammoth capital city, and much of their rubble was deposited there. Among the things he salvaged from the dump was a well from one of these villages, and he transported it to his secret location. He also collected a vast array of waste from around the new city itself. Over many years he collected broken crockery from the new hotels. Factories became a source of discarded electrical fittings and broken ceramic baths. Iron foundries provided clinker. He even took the human hair that was discarded by the city's barbers. His childhood passion for broken bangles was revived with a vengeance, as he scoured village markets and fairs as they were closing, collecting thousands of these and other items. Bicycles were the main mode of transport in Chandigarh, and Nek Chand amassed a range of discarded cycle parts, including forks, seats, and handlebars, which were to become the armatures for his sculptures.[5]

He began building at his secret clearing by re-creating an image of his lost Punjabi home. He fashioned walls and arches to re-create a full-sized village street, and he placed stones set in concrete, representing human and animal figures, in regular rows along low, winding walls and in a series of intimate courtyards. For this work supplies of water and cement became of paramount importance. He collected liquid waste cement from a pipe factory about eight miles away using a large canister attached to his bicycle, and he also scavenged discarded cement bags on construction sites. From a municipal tank about a mile away he collected water in discarded empty oil drums and rolled them back to his hideaway. He also carried water in pots suspended from bamboo poles and made a large, corrugated iron tube that he strapped to his bicycle to hold the poles. He stored the water in a pond that he dug and which still exists today. In addition to using the water for mixing cement, he also used it to nurture hundreds of plants and trees that he had collected from around the city, gradually building up a whole nursery of rich foliage that provided shade for his ongoing toil and helped enable him to carry on in secrecy. The construction plans for Chandigarh did not permit unauthorized construction on government-owned land. Nek Chand feared that, if he were discovered, he would lose not only his

opportunity to create his kingdom, but also his job with the Chandigarh administration. To avoid attention when he scavenged he dressed as a poor laborer.

Chandigarh was constructed in organized phases, and Nek Chand borrowed this terminology to describe his own progress. Thus Phase One resembled a Punjabi village. His first sculptures were fairly crude figures, with cycle forks as armature for human legs that held thin bodies with round faces and pinched features. He practiced by making small animals, figures, buildings, hands, and faces from clay that he dug and then fired in the open air. As his skills improved he was able to model figures entirely out of cement. Adding brick dust and chalk to this mix as colorants, he made a series of groupings of religious figures based on the traditional images of Hindu temple culture. Apart from the cement figures, many of which had seashells for eyes, most of the sculptures were clothed in various transformed waste: broken glass bangles, pebbles, iron foundry clinker, feathers, human hair, broken bottles, pottery, and, most of all, mosaics of broken crockery (many of the figures had hats made from broken china bowls). The faces of Nek Chand's first sculptures were crude and stylized, with protruding eyes and mouths, in contrast with the serenity of the facial expressions of his later works (fig. 40).

Phase Two was to be a large sculptural environment of some two thousand figures. These would include kings and queens, women collecting water, classes of schoolchildren exercising, a court full of queens returning from bathing, a village wedding party in full swing, parades of soldiers, dancers, village maidens, priests, musicians, gods and goddesses, and beggars and saints. The later chambers that make up Nek Chand's Kingdom of Animals display include monkeys, bears, camels, cows, horses, and brightly colored peacocks, all clothed in mosaic, clinker, or broken bangles.[6] One chamber of figures led to another, with massed ranks of figures and animals set among giant pieces of broken mosaic from old bathrooms.

Nek Chand became increasingly concerned about what would happen to him and his creation. As his kingdom grew, covering more and more ground, it seemed that discovery was inevitable (fig. 41). In 1969 he attempted to make an appointment with the chief architect, N. M.

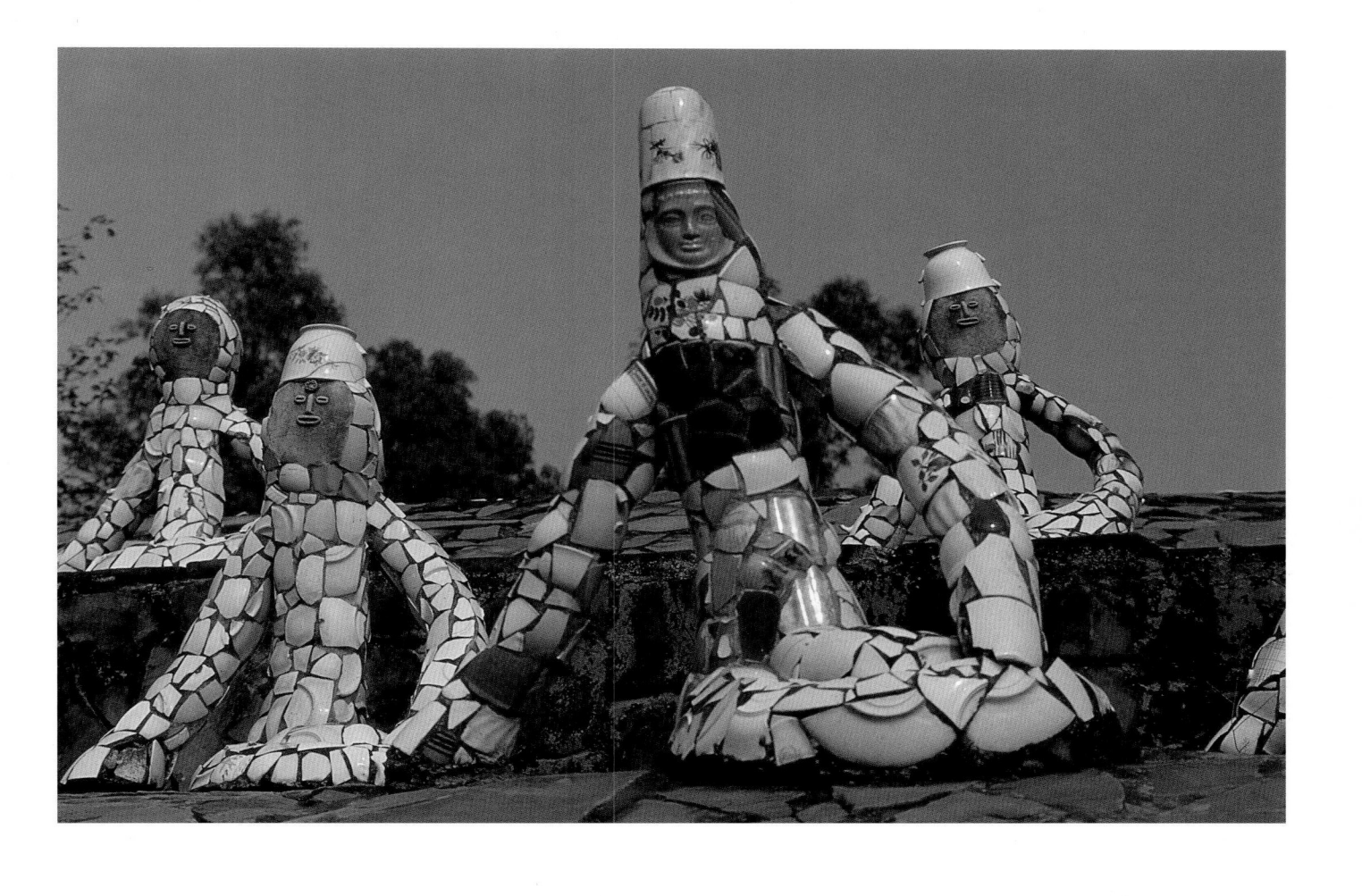

40

Group of broken crockery mosaic and cement figures;
these are among Nek Chand's earliest sculptures

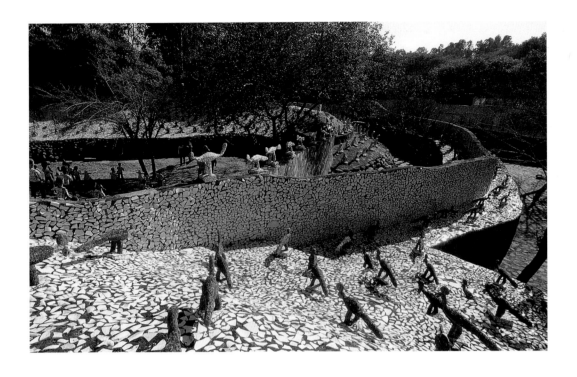

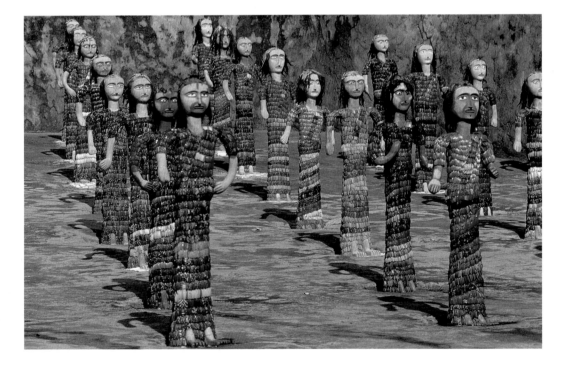

41

View across the sculptural Phase Two

42

The "Queens After Bathing" set in Phase Two

Sharma, who oversaw all building and planning projects in Chandigarh and the Punjab. Nek Chand finally persuaded Sharma to accompany him to his secret jungle creation, which was now surrounded by a high wall of old oil drums filled with cement and earth. To gain entry Nek Chand had to raise a barrier, and the chief architect stepped into a wonderland. He was overwhelmed by what he saw, but he also realized the danger that Nek Chand could face if he was discovered. Sharma recalled: "His fantasy world was on Government land, next to the great landmark of monumental buildings by the great master Le Corbusier, the Capital Complex. What Nek Chand had embarked upon was not part of the Master Plan and as such was unauthorised and illegal. At that period of time, no one could imagine the great creative mind of this humble genius who had no political or other support. I did not have the heart to go by the rules and advised him to continue his work in secret."[7]

When a government work party clearing the jungle in 1972 stumbled on Nek Chand's creation, Sharma would prove to be a staunch ally (fig. 42). The discovery caused a

sensation, and within days half the city came to see it. Critics within the administration insisted that planning rules be followed and that all of Nek Chand's world be demolished. Meanwhile, others rallied to Nek Chand's defense, aware that this was indeed an extraordinary creation. As the debate raged, people started to bring objects to Nek Chand to use in his efforts, and as support for his work continued to grow, the government ultimately relented. Many wanted him released from his roads inspector post so that he could concentrate on his creative work. Finally, in 1976 his creation was officially inaugurated and given the name the "Rock Garden," and he was upgraded to the position of "Director-Creator, Rock Garden" and was supplied with a truck and a workforce of fifty laborers. This enlightened reaction by government authorities was unprecedented and stands as a positive testament to the power of Nek Chand's creativity (fig. 43).

With his new labor force and status, Nek Chand was able to make rapid progress. He completed Phase One and then enlarged Phase Two into the huge sculptural

43

Birds placed along the tops of the walls

installation it is today. Using a small pumping station, he could now complete his first huge waterfall sculpture, along with bridges, gorges, passageways, and streams (fig. 44). He then embarked on the large-scale Phase Three, which one enters through a low arch leading to a deep gorge, which winds down to an even larger waterfall, and then to a wide open space with an amphitheater and a snaking arcade with giant swings. These arcades are a particular source of delight for visitors, as is evident by their whoops of laughter that fill the air. Visitors are not allowed to walk along the top of the arcades, but Nek Chand can occasionally be seen looking down and enjoying the pleasure that his work brings (fig. 45).

From 1976 to 1986 the Rock Garden experienced extraordinary progress, with the construction of high-domed buildings, two huge waterfalls, arcades and pavilions, and a model of Nek Chand's home village. His garden became famous throughout India and even appeared on postage stamps. He was awarded a Padam Shri, the Indian equivalent of an English knighthood, and Prime Minister Indira Gandhi paid him a visit. He traveled abroad for the first time, to an exhibition in Paris in 1984 and to another held in Berlin the following year.[8] Also in 1985 he brought more than two hundred sculptures to the Capital Children's Museum in Washington, D.C., and spent several months installing them in the entrance courtyard.

Despite Nek Chand's growing international reputation, the Rock Garden was facing severe problems at home. Changes in the Chandigarh administration in the mid 1980s saw many supporters retire or move on, and their replacements brought with them a different atmosphere. Nek Chand's Saini caste is not a high one, and in the jealous and petty world of government circles many resented that a lowly roads official could become so famous and revered. The Rock Garden offered them no opportunity for scams or lucrative deals, and so its financial support and workforce gradually began to dwindle. Finally, work at the Rock Garden ground to a halt. Then came the announcement of a government plan to build a road directly through the Rock Garden to the Capital Complex. Bulldozers were sent to the Rock Garden, but they retreated when they were met by supporters—including schoolchildren—who were clinging to its fortresslike walls. A

lengthy legal battle ensued, and, following Nek Chand's personal testimony to the Chandigarh High Court, his kingdom was protected from further invasion.

Still, with no further funding Nek Chand could make little additional progress. Then, in 1996, when Nek Chand left for a tour of the United States, all his staff was transferred to other posts, leaving the Rock Garden unguarded. One night vandals attacked and broke many of his sculptures. The damage was severe but limited. Nevertheless, Nek Chand was deeply pained, recognizing the attack as more than mindless vandalism. "This was not directed at the sculptures but at Nek Chand, as they very well know that my heart and soul lives in them," he said.[9] An international outcry followed, leading to the formation of the Nek Chand Foundation to ensure the preservation and conservation of the Rock Garden. The formation of the foundation led to a new pride in the Rock Garden within the Chandigarh administration and, consequently, considerably more financial support. In addition, several officials were arrested and charged with corruption, and Nek Chand's position in the government became more secure.

Stalled since the late 1980s, government funding for the Rock Garden is once again available, and Nek Chand can look to complete his creation. Currently he is finishing the high-domed buildings and pavilions of Phase Three, and he then plans to install sculptures as tall as sixteen feet in the large open area of this phase. Many of these figures have been installed already around the city of Chandigarh. In front of the railway station a group of giant figures greets arrivals, and even Chandigarh's army base, one of India's largest, has huge Nek Chand figures standing guard at the entrance. He delights in visitors' enjoyment of these sculptures and has also installed a large group of fun house mirrors to add to their pleasure.

Nek Chand has always been keen to work with brightly colored scraps of material, perhaps as a link to his original scarecrow figures, and over the years he has made hundreds of cloth figures. Like his concrete sculptures, they are constructed with metal armatures and tightly bound rags underneath a layer of material used for both clothing and features. Other figures are built up using hundreds of brightly colored small cloth balls; the features of these figures are less naturalistic than those of his "rag doll" fig-

44

The giant waterfall in Phase Three is powered
by a pumping station that sends rushing
streams and channels around the Rock Garden

45

Phase Three contains a snaking arcade,
with each arch sporting a family-size swing

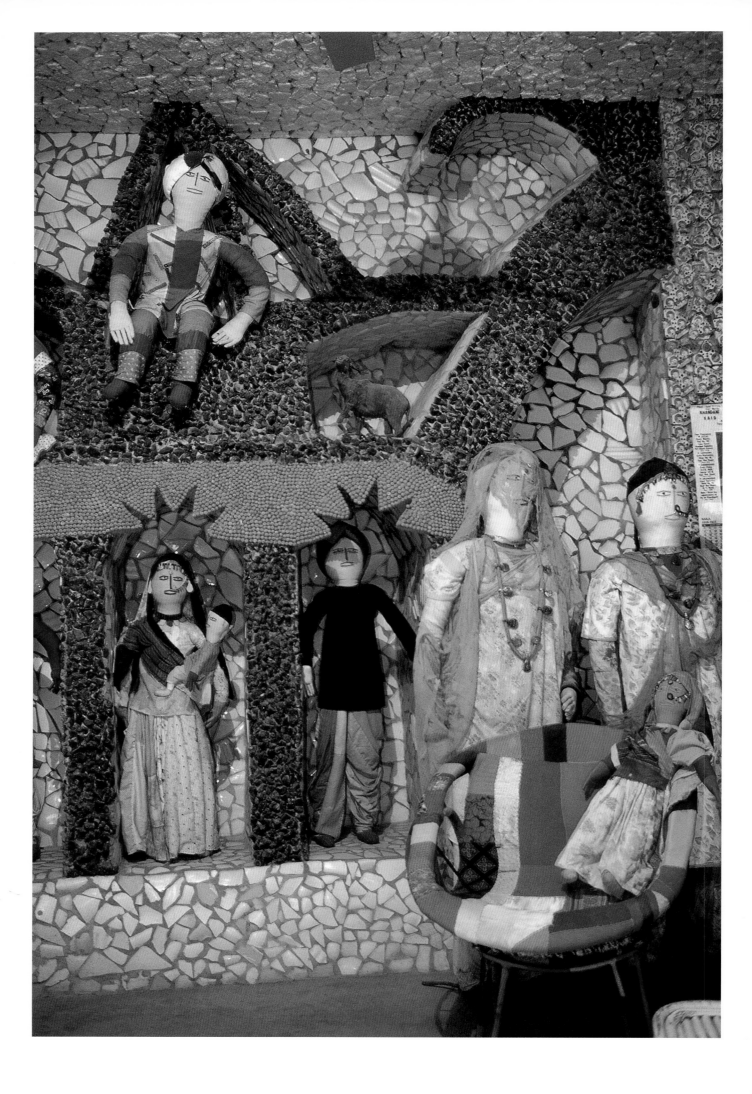

ures, and they more closely reflect the imagery of his stone sculptures, taking on the forms of birds or of two-legged torsos with large, colorful faces (figs. 46, 47).

These sculptures are not permanently installed at the Rock Garden but are brought out for display at events and festivals, including parades in which the sculptures are mounted on specially made trolleys that are pulled around the city by tractors concealed in large wooden casings. Many of the figures—men, women, and children—are dressed in typical Punjabi costumes and look like giant rag dolls, while others are more fanciful and imaginative in form, many coated in hundreds of small balls of vibrant cloth. Many of these cloth sculptures are kept in a building called the Guest House, which is hidden behind the

first of the giant waterfalls. This secret building was constructed by Nek Chand to house his guru and his disciples when they come to stay at the Rock Garden from their ashram in Rishikesh, on the Ganges River. Nek Chand is a follower of the Divine Life Society, a Hindu group whose philosophy stresses a love of fellow man and the leading of a pure life. The Guest House is covered in mosaic and is designed with niches for displaying sculptures. The walls are faced with electrical outlet molds, while the ceiling was constructed of pebbles embedded in concrete over timber shuttering, which was then removed so that the pebbles appear as if hanging (figs. 48, 49).

The year 2001 marked the twenty-fifth anniversary of the Rock Garden's official inauguration and public

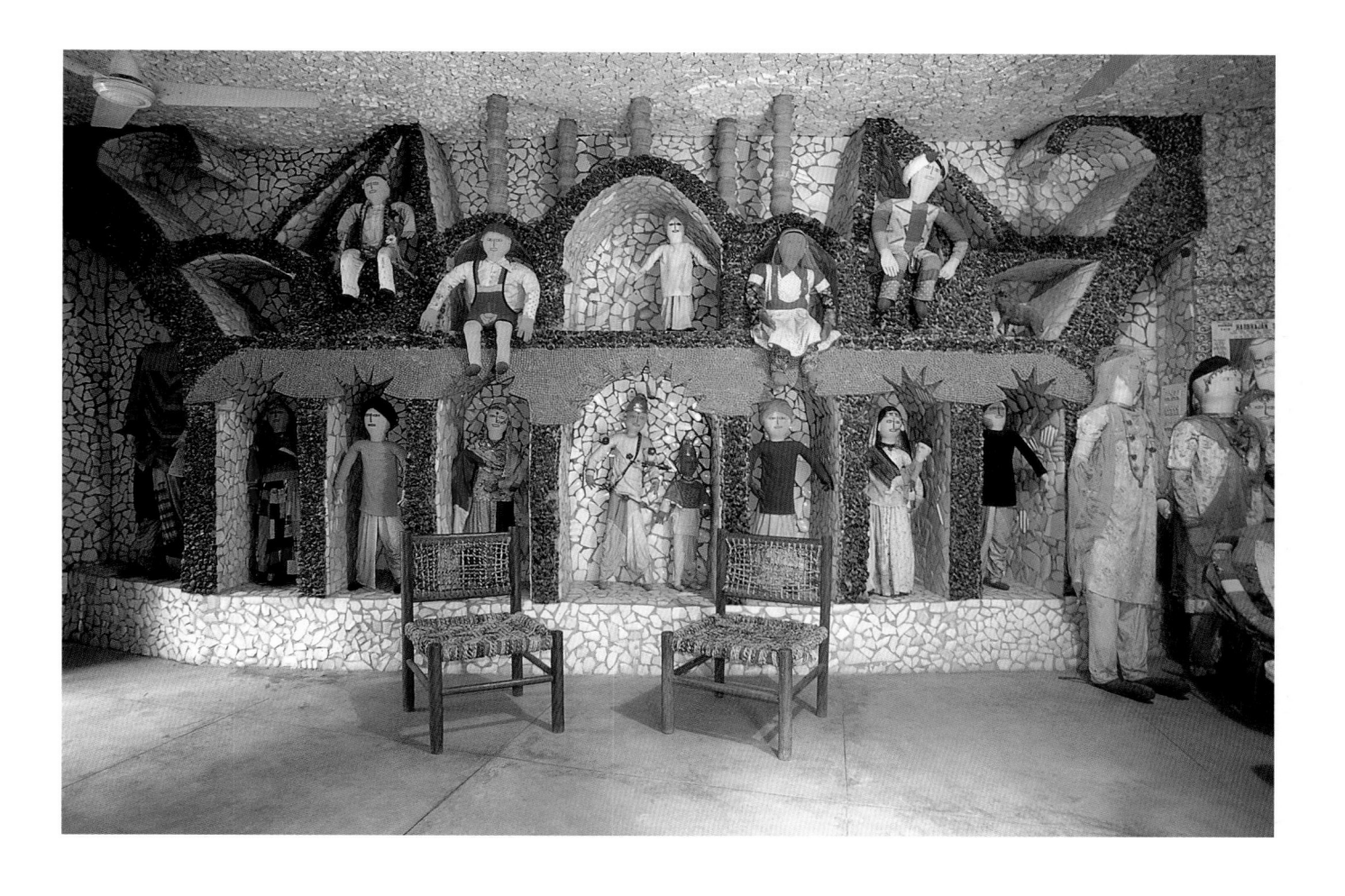

46 (opposite)

Cloth statues on display in the secret Guest House behind the waterfall

47

The main wall of the Guest House is constructed with niches and alcoves to store groups of sculptures

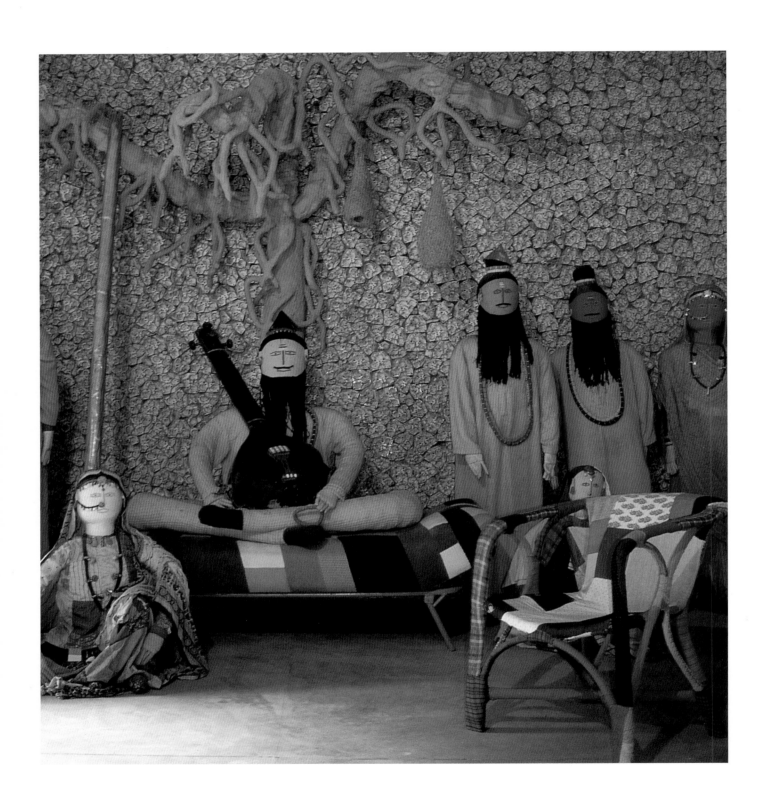

48

Cloth gurus are displayed at festivals
and ride around the city on large, open
trailers during celebrations

opening. A group of fifteen American and British delegates from the Nek Chand Foundation attending the celebration found themselves transformed into cloth figures and paraded around the city of Chandigarh. Dressed in orange robes and large turbans by Nek Chand's laborers, the delegates themselves stood waving from the top deck of a large, open trailer, while below them were a crowd of similarly clad cloth guru figures.[10]

Artist, architect, engineer, and dreamer, Nek Chand and his achievements are unique. His use of space is dramatic and astounding, contrasting small enclosed areas with vast open ones, deep gorges with rushing waterfalls. The endless variety of his sculptures, his use of every conceivable material, and the ever-growing scope of his architecture all contribute to the creation of one of the world's most extraordinary works of art. Today, Nek Chand's work is included in the collections of museums around the world, and he continues to travel to Europe and the United States for various exhibitions. Nevertheless, his calm daily routine at the Rock Garden continues as he moves toward the completion of Phase Three, the final part of his mammoth creation. And from high on the ramparts Nek Chand often looks down on his domain, his dream finally close to fulfillment.

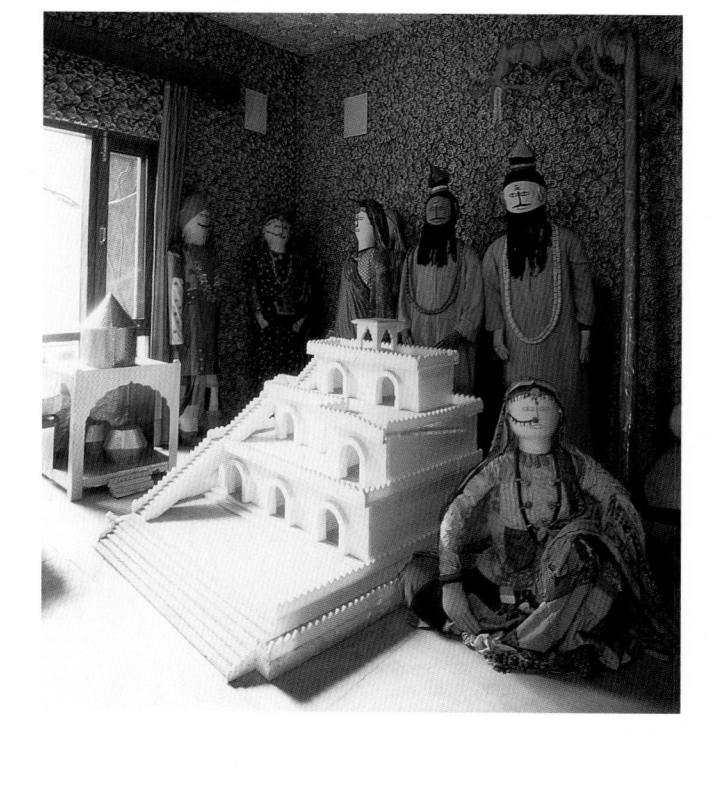

Notes

1 M. S. Aulakh, *The Rock Garden* (Ludhiana, India, 1986), 12.
2 I am indebted to Anita Negi for additional information on Nek Chand's childhood; on my behalf she interviewed Nek Chand in Punjabi extensively. Other information was provided during my conversations with Nek Chand in both the United Kingdom and in India.
3 Kiran Joshi, *Documenting Chandigargh* (Ahmenabad, 1999).
4 *Raw Vision*, no. 35 (Summer 2001): 16.
5 Bennett Schiff, "A Fantasy Garden by Nek Chand Flourishes in India," *Smithsonian Magazine* (Washington, D.C., 1984): 126–34.
6 S. S. Bhatti, "The Rock Garden of Chandigarh," *Raw Vision*, no. 1 (Spring 1989): 22–31.
7 M. N. Sharma, "Nek Chand, an Early Encounter," *Raw Vision*, no. 35 (Summer 2001): 28.
8 Ibid.
9 *Raw Vision*, no. 16 (Autumn 1996): 52.
10 Anton Rajer, "Rock Garden Silver Jubilee," *Raw Vision*, no. 35 (Spring 2001): 24–25.

49
The interior of the Guest House, with cloth figures on display

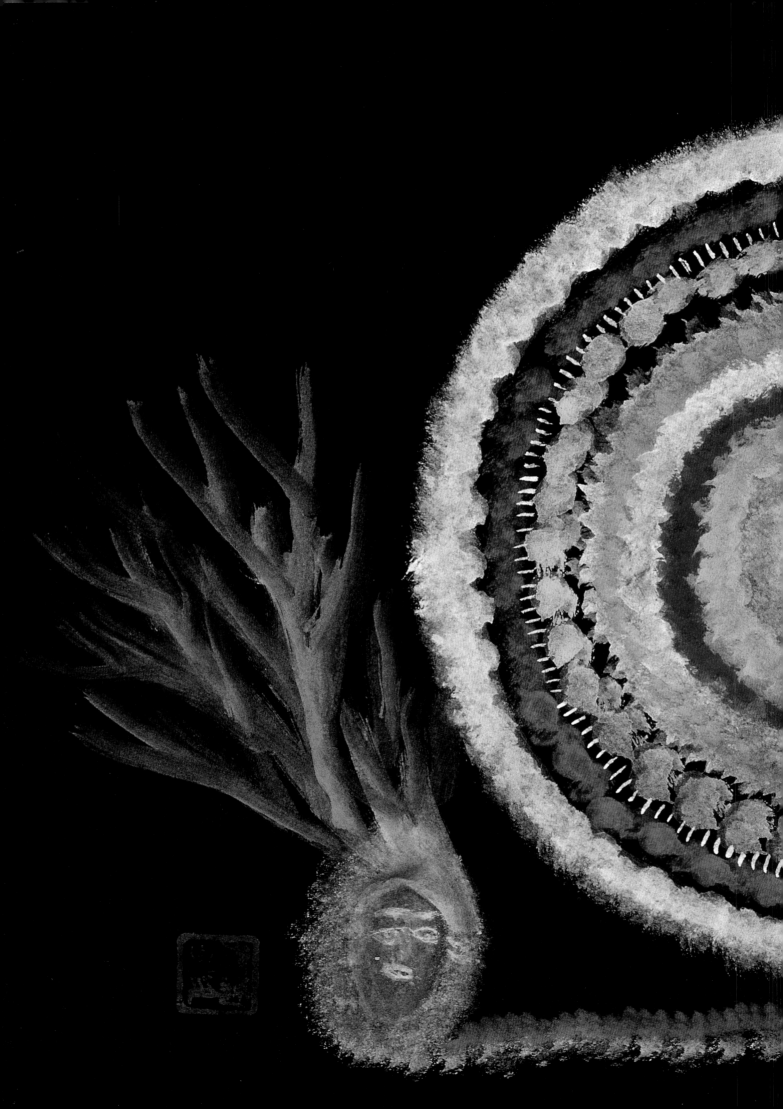

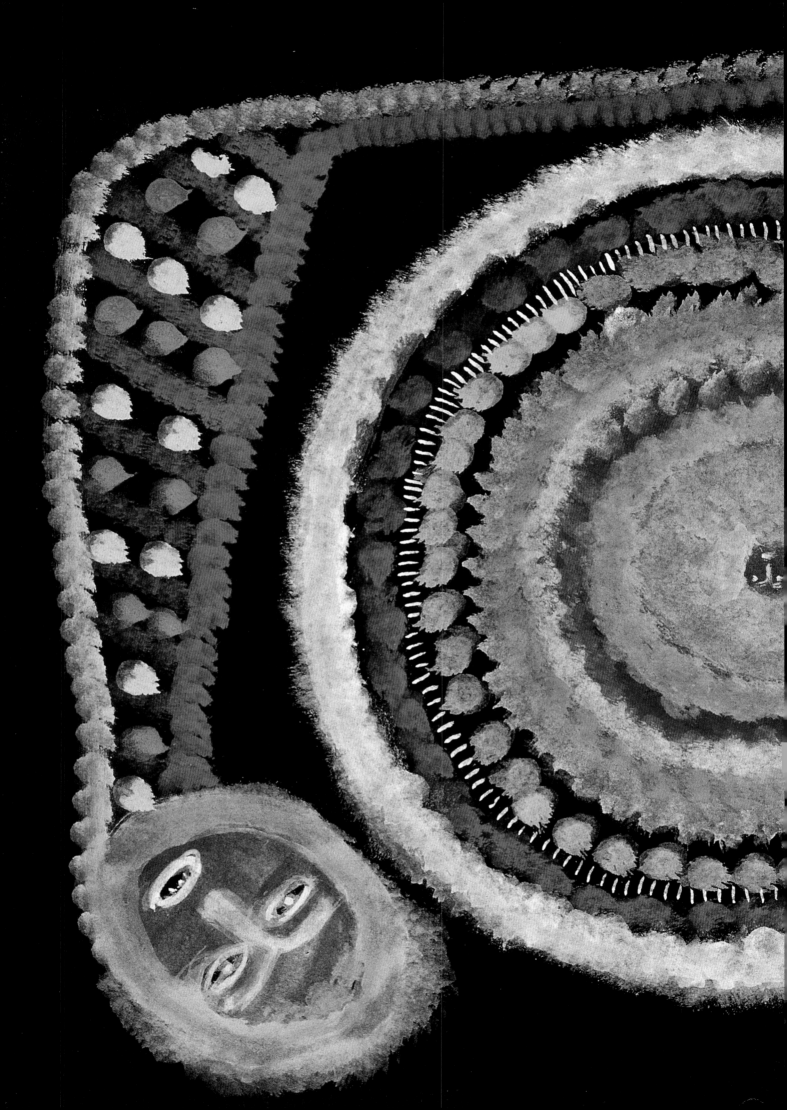

Hung Tung
Visionary King of Taiwan

Victoria Y. Lu

Taiwan, a small island of nearly thirty-six thousand square kilometers, is separated from the province of Fujian on mainland China by the Taiwan Strait. Many Han people migrated to Taiwan from China—most from the southern coastal areas of Fujian province—during the Ming (1368–1644) and Ch'ing (1644–1912) dynasties, bringing with them traditional Han Chinese culture. Prior to the Japanese occupation beginning in 1895, the society established by these immigrants was largely agricultural. But these Han settlers were not the first to land on the shores of Taiwan. The earliest inhabitants of Taiwan were the so-called Formosan aborigines, who migrated from the Pacific islands thousands of years ago.

Throughout its history Formosa—the name the Portuguese gave the island when they arrived there—has endured repeated foreign invasions. In the seventeenth century, both the Portuguese (1624–1662) and the Spanish (1629–1642) established temporary settlements on the island. The Dutch first took the Peng Hu Island in 1622 and then invaded Taiwan in 1624. They occupied the island until 1661. The fifty-year rule of the Japanese colonial government had a tremendous effect on Taiwan. Artistically, the colonial government promoted the study of Western-style oil painting and Japanese gouache painting through the sponsorship of the Taiwan Governor-General Art Exhibitions. Taiwanese academic artists—some of whom studied in Japan and France—imitated French-influenced Japanese styles, which included plein air, Impressionism, Postimpressionism, and Fauvism.

After the end of the Sino-Japanese War in 1945, civil war on mainland China led to the retreat of the Nationalist government to Taiwan and an influx of immigrants fleeing Communist rule. Nationalist control brought with it various changes and yet another wave of Han Chinese culture. In disputes over the content of Taiwan's orthodoxy, the Nationalists promoted traditional Chinese brush painting instead of Japanese gouache painting. The assimilation of Western and Japanese culture with Han Chinese culture in the twentieth century differentiated Taiwan from mainland China; the eclecticism of Taiwanese provincial culture cannot be summarily characterized by the traits of any given culture.

PREVIOUS PAGES
Hung Tung
Untitled, c. 1970
(see fig. 61)

During the 1970s the political liberalization move- ment not only gained stronger support from the native people, but it also awoke the public's interest in their indige- nous traditions. This led to the birth of a number of opposition political parties, which spurred political liberal- ization and awoke public interest in social and political rights. The era also saw widespread rediscovery of folk and local culture in literature and art. This movement, which evoked a sense of nostalgia, reflected a return to grass roots and was the first self-conscious wave of nativism in Tai- wan. This nativism movement of the 1970s occurred during Taiwan's most rapid period of economic growth. Artistically, this provincial nativism mainly took the form of stylistic realism, inspired by Western superrealism or photo-realism.

While soaring capitalism prevailed, a few artists and intellectuals conducted folklore research and field stud- ies, hoping to find self-assurance and fulfillment through their understanding of history. One such individual was Yen Shui-long (1903–1997), who showed a long-standing concern for Taiwan's folk art and spent years studying the cultures of the island's aborigines. Other such artists and scholars, including Sung Long-fei, Liu Chi-wei (Max Liu), Liao Shou-ping, Liu Wen-shan, Wu Hao, and musician Ming Li-kuo, found that folk traditions of Taiwan were not only derived from the dominant Han culture of the mainland immigrants but also infused with the aboriginal cultures of native tribes. In addition to the mixture of Han and aboriginal elements, there were traces of Japanese and Western cultural influences. Artworks influenced by these folklore elements shared a common characteris- tic: highly saturated color contrasts with little use of halftones. This stylistic tendency, which can also be seen in so-called primitive art and in children's painting, emphasized the loud, vulgar color and ordinariness of everyday life.

At the heyday of the provincial movement, the self- taught painter Hung Tung (1920–1987) was considered the greatest visionary artist of the island. He had at one time worked as a shaman. Hung Tung and his painting enjoyed unprecedented popularity in the 1970s. The frenzy he caused in the media led to increased public awareness of other autodidactic artists. Although the venerable painter Wuli Yuge (1901–1991) was already active by the 1960s,

Hung Tung's unprecedented emergence led the way for Wuli Yuge's and others' rise to prominence, such as Lin Yüan (1913–1991). The trend became further pronounced in the 1980s, as still more visionary and outsider artists emerged on the art scene.[1]

The absence of a theoretical foundation in the aes- thetics of Taiwanese self-taught art differs from the sit- uation in the West, where there exists a large and orthodox theoretical environment. Under the influences of many foreign cultures, some collective consciousness has formed through the interaction of geography, society, religion, and popular culture. The most important element is regional color, which is found in every category of Taiwanese naive aesthetic expression. Specifically, these categories include: aboriginal-influenced naive art, popular- and folk-culture-influenced naive art, Outsider and Visionary Art, and self-taught art by elderly artists.

Traditional and contemporary indigenous art styles coexist among Taiwan's aboriginal tribes. These groups arrived on this green and beautiful island as early as the Stone Age. Where they came from is still an open ques- tion, but they are generally thought to have migrated from islands in the South Pacific. Each of the various tribes has its own language, rituals, religious beliefs, and life- styles. They have quite sophisticated cultures and languages and are by no means a single ethnic group. Aboriginal art is rooted in daily life. Sculptures of human images are simple in style. Whether idols, totems, or ritual wares, these works tell stories, reflect the content of religious beliefs, and, with their geometric patterns, decorate space.[2] Aboriginal and aboriginal-style naive artists create their works from a more practical or religious-ritual perspective. They put minor emphasis on the pure aesthetics of form and care little about the expression of an artist's indi- vidual style or ideology.

Vernacular life and folk art is the spontaneous creation of regional culture. It did not inherit the official artistic tradition of the Japanese occupation era, nor was it influ- enced by the literati art of the mainland. It is the most representative category of Taiwanese regional art. The most spectacular aspect of Taiwanese folk art is its use of color. It does not conform to the mainlanders' traditional preference for simplicity and elegance, nor does it apply

the notions of harmony and contrast found in Western color theory. Rather, it has developed its own unique system of mishmash colors. Combined with various shapes, lines, and blocks, these colors naturally form splendid, lively rhythms of vivacious, festive joy.

Art by self-taught older artists is a product of the times. It is connected to various developments in Taiwanese history and economics. Wuli Yuge, Lin Yuan (b. 1913), and Hung Tung all experienced dramatic changes in the historical and political environment. Like most of their contemporaries, they grew up in a restrictive environment that did not allow them much access to education. Out of pure enthusiasm, in the 1970s this generation of elderly people began creating works that drew the attention and support of the younger generation. The trend came to the fore in the 1980s, when many "grandma" and "grandpa" artists came into the spotlight. Most of their works dealt with the memories of rural childhood.

Hung Tung was born in 1920 in a fishing village in a poor rural section of Tainan County. Orphaned at the age of three, he was raised by his grandfather and uncle. As a youth, Hung Tung worked as a shepherd to help support his family. Although he never received formal education, Hung was heavily influenced by a famous temple in his hometown, where he obtained most of his knowledge about religion and life. It is said that he even served as a medium for the temple at least once in his teenage years.

Hung Tung had been a typical fisherman, and he and his wife had five children. On November 4, 1970, shortly before his fiftieth birthday, he suddenly became enthralled with painting and decided to give up work and focus solely on art. For his already financially strapped family, Hung's decision came as an enormous shock. Not only did it mean the end of his income, it also added to the family expenses in the form of more than a thousand yuan for painting supplies each month. Hung begged his wife to allow him to pursue this new passion and in the end received the support of this kind and simple woman, who from that point on became the family's sole breadwinner. No one knows why this poor and illiterate village fisherman suddenly decided to sacrifice his modest livelihood and throw himself into painting. Even harder to understand is why rejection from the Provincial Art Exhibition did not

dent his ambition. Rather, he self-confidently replied that "his time had yet to come," sure that one day he would achieve great fame. Hung Tung's rise was accidental, yet somehow predestined. His fame demonstrated that his self-assurance was not undeserved. Though his work would ultimately cause reverberations throughout the art world, Hung Tung died alone. Like van Gogh, he was labeled insane—his brilliance recognized only after his death.

In 1972, Huang Yung-sung, art editor of *Echo Magazine*, together with the novelist Huang Ch'un-ming, visited South K'un-shen's Temple of the Five Kings (*Wu-wang miao*) birthday celebrations for the deity Wang Ye. While there, they stumbled on one of Hung Tung's scrolls hanging in the back of the temple. They took a few pictures of the work, and these were later featured in an English-language magazine. They established contact with Hung Tung, who invited them to his small brick house beside a fish farm to view watercolors and notebook sketches. A photographer from *Echo Magazine* then went to South K'un-shen to take photographs of these works. He then submitted the photographs to Kao Hsin-chiang of the *China Times*. Kao, in turn, contacted Ho Cheng-kuang, editor of the fine arts publication *Lion Monthly Art Magazine* (*Hsiung-shih mei-shu*), who developed a strong interest in Hung Tung. In December 1972 Ho took Li Hsien-wen, publisher of *Lion Monthly*, together with the artists Liu Ch'i-wen, Tai Pi-yin, and Ch'en Hui-tung, to visit the "crazy painter" of South K'un-shen. They were surprised to discover that he was not crazy at all but was simply so absorbed in his art that the people of the local community assumed he had lost his mind.

Li Hsien-wen's enthusiasm for Hung Tung's art led him in April 1973 to issue a special edition of *Lion Monthly* dedicated to the artist. This marked the beginning of Hung Tung's fame. In April 1975, Ho Cheng-kuang, founder of *Artist Magazine* (*I-shu chia*), in the course of preparations for the *Ch'ing Dynasty Tainan Exhibition of Famous Painters*, brought the photographer Chuang Ling and the folk art scholar Chuang Po-he to visit Hung Tung. They discovered on their arrival that Hung Tung had already turned the entire interior and exterior of his house into a work of art, covering the walls with murals and arranging his sculptures on the floor. Yet in contrast to

the public spectacle of his house, the eccentric Hung Tung refused Ho Cheng-kuang's requests to photograph. He behaved defensively and brought out only a few of his artworks to show his guests.[3]

In the autumn of 1975, Hung Tung, via an intermediary, asked Ho Cheng-kuang to prepare an exhibition of his work. This time he was exceptionally generous, bringing out more than three hundred pieces, which were shipped the following month to the offices of *Artist Magazine* in Taipei, where the photography and other preparations for the exhibition took place. Also during this time, architect and art critic Han Pao-te collected several of Hung's masterpieces. The exhibition of Hung Tung's paintings, held at the American News Bureau March 13–25, 1976, attracted close to ten thousand people each day. By the end of the exhibition, more than two hundred thousand people had seen Hung Tung's work, and the media reports that accompanied the exhibit made the artist famous throughout Taiwan.[4]

After the exhibition closed, Hung Tung returned to his home in Tainan and resumed his hermetic ways. Although curious visitors often crowded around his property, he kept his door shut, turned away guests, and, regarding his work as his life, refused to sell any of his pieces. This self-proclaimed "greatest artist in the world," despite the travails of poverty and disease, utterly ignored the market value of his art.

Hung Tung's wife, his ongoing pillar of strength and support, passed away in 1986. The bereaved artist followed her—some said that he starved to death—on February 23, 1987. In September 1987, Ho Cheng-kuang held a memorial exhibition for Hung Tung at the American Cultural Center. The exhibition featured works from the intervening ten years since the previous exhibition, and it once again stirred up a frenzy of media coverage. Yet this time the artist was already gone, and the difficult circumstances of his final years were cause for regret. Hung Tung's son, Hung Shih-pao, said of his father: "In painting, his [work] was himself, and he had his own circle of life. As long as he himself is happy, that's all that matters." Who can understand this reclusive master, who found the hopes and fears of human life in painting rather than in life itself?

Although Hung Tung worked for only some eighteen years, the number of surviving works is substantial. Ho Cheng-kuang has seen virtually all of Hung's work and estimates their total number to be around three hundred and seventy pieces.[5] The collector Chow Yü's estimate, including sketches and notebook drawings, is closer to one thousand. His work, I believe, can be clearly divided into two periods: first, the years before his discovery; second, the period after his exhibition in Taipei. The stylistic differences between these two periods are substantial and can at least be partially attributed to Hung's gradual accumulation of painting experience. His early work is characterized by its unaffected simplicity, while his later work, completed after Hung had already earned the status of "painter," reveals a sense of completeness and ambition.

Hung's early works were produced at his own behest. They directly reflect his personal environment, experiences, and memories. These works are imbued with a greater sense of freedom: the brushwork is roughly applied and unintentional, unlike the lines of his later works, which, laid down under the artist's tight control, possess a more stable sense of quality and decorative beauty, and conversely lack the childlike innocence of his early work. The consistent element of Hung Tung's style is found not in method or content, but rather in the almost religious revelations and mania of his own private spirit world. While it conveys some of the sensibilities of the mentally ill, the supernatural quality of Hung's painting is not something that can be adequately explained by words of the natural world. At the same time, his work frequently features a complex iconographic quality that cannot be readily interpreted as the typically complex composition of Outsider Art. It was this addiction to his creative self—these conversations with the world of spirit—that led some to find an explanation for Hung Tung in the vocabulary of insanity.

In assessing the legacy of Hung Tung, discussion often turns to two other late nineteenth- and early twentieth-century artists, France's Augustin Lesage (1876–1954) and Switzerland's Adolf Wölfli (1864–1930). Lesage was a coal miner in northern France. At the age of thirty-five he heard a voice foretelling his destiny as a painter. This revelation later led him to become a medium. His autodi-

dactic drawings and highly structural paintings full of detailed visual elements and vivid colors are similar to Hung's. They feature multiple geometric planes that together reveal a mystical (and incomprehensible) universe of strange birds and plants. Lesage frequently incorporated Egyptian hieroglyphs, and, like Hung's writing in Chinese characters, they existed as pictorial signs rather than as legible words.[6]

Wölfli was orphaned at the age of nine. Raised by cruel foster parents and plagued by failed romances, he adopted a deviant lifestyle that led to his repeated imprisonment and eventual confinement to an insane asylum, where he lived the remainder of his days. In the lonely, isolated world of the asylum he created more than twenty-five thousand pages of autobiographic works, together with more than three thousand illustrations, which he personally hand-bound into forty-five volumes. His works often feature complex, multilayered planes filled with letters, detailed iconographic symbols, and musical notes that puzzle the viewer's intellect and imagination.[7] A comparison of Wölfli's and Hung Tung's work is revealing. The former is permeated with the alternate world of an insane man, completely severed from our reality. The latter is that

of a spirit medium, standing, like Lesage, as a liminal channel between our world and the next. Wölfli's work frequently presents a suffocating, closed-off, and even frightening space, reflecting the contorted emotions of an imprisoned talent. Most of Hung's work, on the other hand, reveals an exotic and imagined Eden, like the innocent daydreams of a child.

Wölfli's art reads like a travelogue of the mental wanderings of his imprisoned mind. He did not set out to be an artist, was not interested in knowing what it was to be a master, and never predicted the honors and accolades that followed his death. By contrast, Hung Tung clearly perceived himself as a masterful painter and remained committed to his death to the notion that he would one day be the greatest artist in the world. Although Hung Tung was categorized, from the beginning, as an outsider artist, few considered, from a purely artistic perspective, his self-identification as a painter—which he himself entirely did from the outset of his painting career. Although he lacked formal education, he nonetheless earnestly pursued his own notion of what it meant to be a painter, regularly attending exhibitions in Tainan and even, on one occasion, seeking to apprentice himself to the artist Tseng

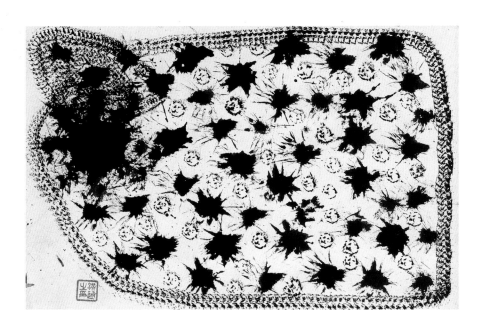

50

Hung Tung, *Untitled*, n.d.
Ink on paper, 15 1/4 x 21 in. (39 x 53.5 cm)
Collection of Yü Chow

P'ei-yao. Although the subsequent relationship between Tseng and Hung is unclear, Tseng apparently turned away his prospective student out of an intentional desire not to influence what he regarded as a unique artistic style.

Hung Tung's self-training was actually quite similar to that received by an academy student. He began with sketches, filling notebooks with simple images and symbols. Because he was illiterate, his characters read like pictures, drawn in much the same manner as the earliest pictographic ideograms of ancient China. Some of his sketches are almost entirely abstract, with highly varied line work that, though not always perfect, reveals considerable natural talent (fig. 50). In these experiments on paper, Hung Tung performed beyond all expectations, gripping the brush in both hands or in his teeth or his feet—and even using his penis—to apply the paint. He finished each of these works with his seal, just like a traditional Chinese ink painting.

The content of Hung's early paintings is relatively simple: small human figures with large heads and regular features, generally depicted alongside flowers, fish, and birds, much like children's pictures. Like Lesage, Hung Tung enjoyed filling areas of space with various patterns. His buildings are generally symmetrical, and his figures are almost always portrayed from the front. The absence of the balancing and connecting force of single-point perspective gives his work an extremely complex compositional quality. It is difficult to know where to begin looking at these packed compositions, the details of which demand a magnifying glass to see clearly. Featured in his first exhibition, *Niao-jen kuo* (*Birdman Country*) is the finest representative work of Hung's early period. The hanging scroll features a group of bird-headed people shown in profile, a subject not found in his later works. The upper section of the scroll contains a white inscription against a blue field, with the artist's signature in red. Another early masterpiece, dating to around the same period, is *Wang-ye ch'uan* (*Wang Ye's Boat*), which is drawn from local religious ritual and is expressed in the painting through an array of iconographic symbols. On the occasion of Hung Tung's first visit to Taipei, he presented one of his paintings to Cheng-kuang Ho and solemnly inscribed the work with Ho's name (fig. 51). In the upper section of the paint-

ing, Ho used the image of a bird as a symbol for his own soaring ambition.

Hung Tung appears to have understood the format of traditional Chinese painting. Because his illiteracy prevented him from understanding the inner meaning of Chinese literati painting, he simply adopted its external form—the hanging scroll. Hung frequently mimicked the silk mounting of a traditional hanging scroll by framing his compositions with small figures and other patterns, and at times even adding an inscription to the edge of his

51

Hung Tung, *Gift to Cheng-kuang Ho*, early 1970s
Ink on paper, 52 1/4 x 26 3/4 in. (132.7 x 68 cm)
Collection of Cheng-kuang Ho

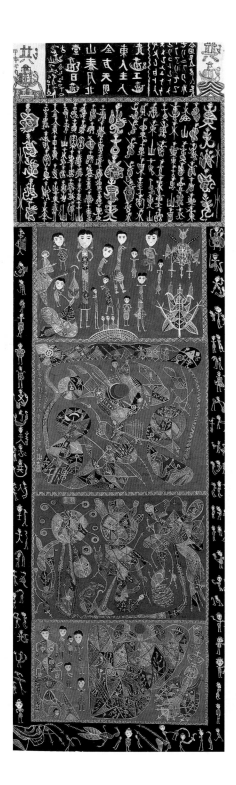

work. The painting *Ho shan shan* (*River Mountain Mountain*) and *Hsin ji chi hun* (*Exploring the Stars*) are classic examples (fig. 52). Hung Tung's works are difficult to date precisely, for even though they often feature a typical "Year XXX of the Republic of China"—style inscription, the writing itself, inscribed by an illiterate hand, is often nonsensical. The inscription found in the lower-left corner of *T'ien-t'ai shan-tzu*, which seems to read "Sixty-fourth year of the Republic of China," is a fine example. Although it is impossible to determine precisely the chronology of Hung Tung's work, the approximate dating of his oeuvre is not an entirely lost cause. A comparative examination of the April 1973 issue of *Lion Monthly Art Magazine*, the March 1976 special issue of *Artist Magazine*, and the September 1987 catalogue of Hung's memorial exhibition reveal a progressive improvement and maturation of Hung's technique. The modulation and relative wetness of the line work found in works from Hung's early period of self-study reveal the directness and unskilled quality of a child's painting. Yet as Hung Tung became more experienced, his lines became increasingly appealing, as is particularly apparent in his monochrome brushwork painting. The quality of the line work found in paintings such as *Hsi-yue* (*Pleasure*) demonstrates the finest results of Hung's intentional efforts to master the expressive potential of line.

Like any creative artist, Hung Tung experimented with different media and materials. His works include a few oil paintings, the technique of which, though not used in a manner substantially different from that seen in his other works, clearly alludes to Hung's interest in expressing what he perceived as modern artistic style. These works demonstrate that Hung was clearly cognizant of the fact that, in order to become the "greatest artist" of his generation, he needed to demonstrate skill in oil painting. His oil works are not altogether lacking in ability, as one can see in the half-automatic abstract style of *Hsiang-ye* (*Evening in the Countryside*) and *Hua shu jen jia* (*Family of the Blossoming Trees*) (fig. 53). Another of Hung Tung's oil works, *Ta-mu jen shan-shui* (*Big Eye Figure Landscape*), shows the image of a human figure with a body filled with smaller figures, together with an expanse of ground honeycombed with caves that are, in turn, filled with

52
Hung Tung, *Hsin ji chi hun* (*Exploring the Stars*), 1970
Gouache on paper, 56 1/4 x 16 1/4 in. (143 x 41.3 cm)
Private collection

more small figures. These underground figures are joined together with the surrounding environment to create a multilayered space. In representing the details of this composition, Hung successfully dealt with all manner of complex organic images using gouache and watercolors.

The popularization of painting themes, the expression of fairy tale–like feelings, and transformation of calligraphy into pictures and vice versa—these are the dominant directions of Hung Tung's work. Yet the artist's life was different from that of the masses; not only was he orphaned, but he also lived in the vicinity of the famous Wang-ye Temple, where he came into contact with an array of sculpture and decorative arts, religious ceremonies, and popular performances. Indeed, even the local fishing culture exerted an influence. Together, these forces imbued Hung's painting with strange forms and magical imagery. The painting *Ta-ch'uan ho fei-chi* (*Large Boat and Airplane*) demonstrates how Hung transformed personal experience into artistic expression (fig. 54). The work, which features a mechanized form transforming into a magnificent geometric pattern, was painted after Hung Tung

visited Kaohsiung, an industrial city in the southern part of Taiwan. Its depiction of a great ship is substantially different from the images of fishing boats and religious ceremonies found in Hung's earlier work, *Wang-ye ch'uan*, while the image of the plane resembles that of a child's toy. The work marks the beginnings of Hung Tung's mature period. The painting *Ta-tou wa* (*Big-Headed Doll*) reads like a fairy-tale, with Hung portraying the playful world of a group of part-man, part-animal spirits (fig. 56). The work may have been influenced by a temple festival and, judging from the style of its calligraphy, is likely an early work. In addition to Hung Tung's pictographic signature, his pictographic calligraphy and calligraphic pictures are sometimes stand-alone single pieces of artwork, while at other times they are combined with other styles. Hung made up his pictographic symbols purely for visual effect. He neither read nor understood any additional meanings in his writing (fig. 55).

Hung Tung was a simple country man who dealt with sexuality in a timid manner. The women in his paintings are differentiated by their hairstyles and dress, not by facial

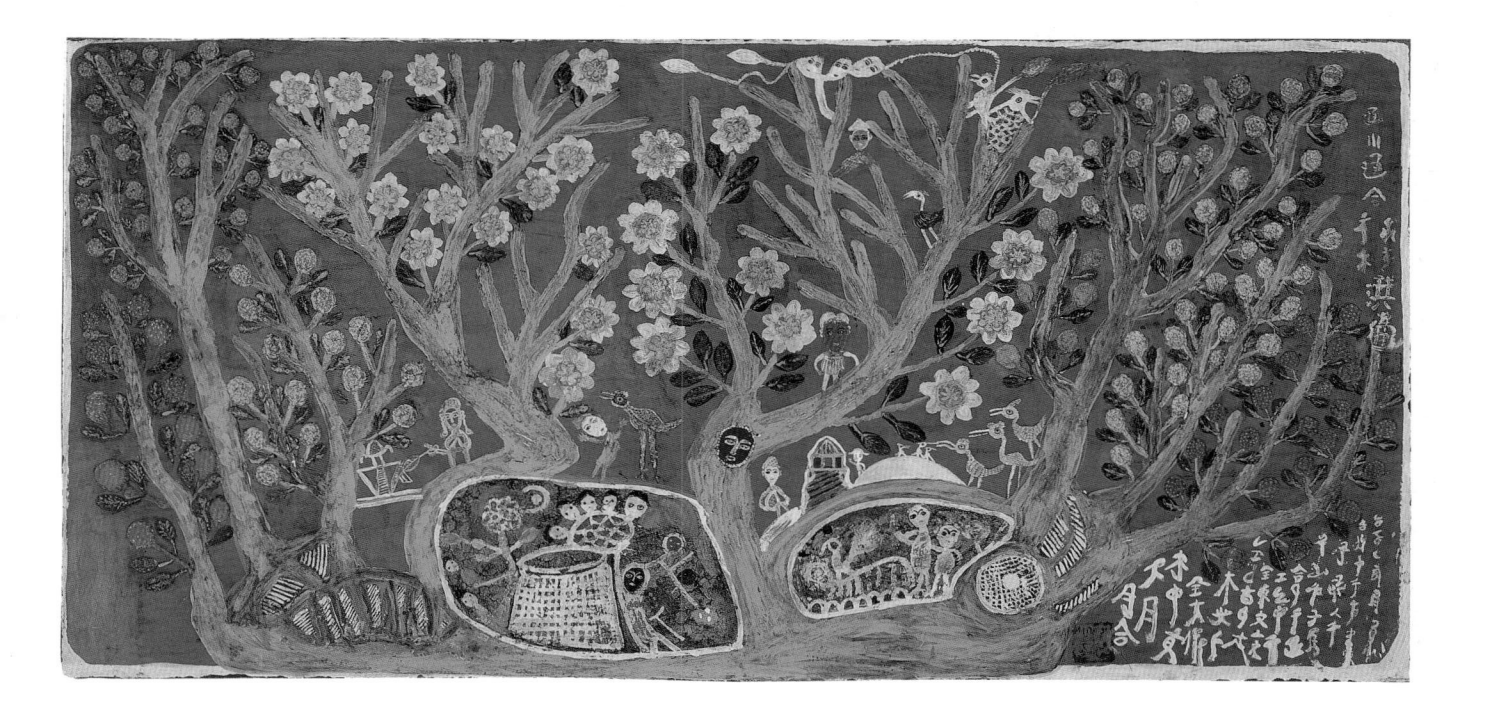

53

Hung Tung, *Hua shu jen jia* (*Family of the Blossoming Trees*), n.d.
Oil on Masonite, 23 ¹/₂ x 47 in. (59.5 x 119.5 cm)
Private collection

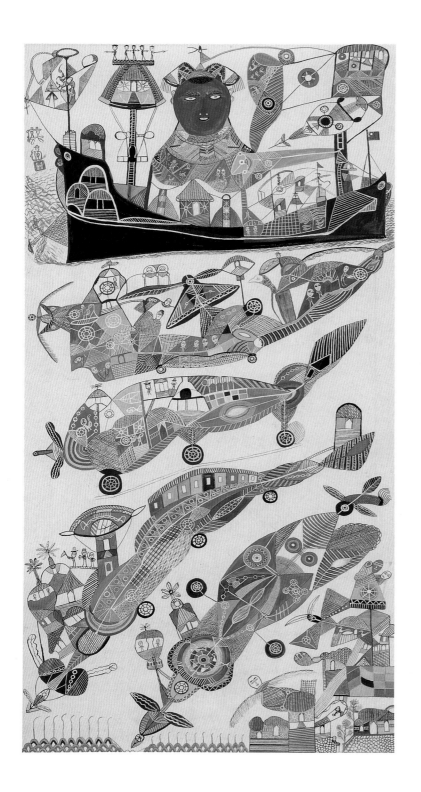

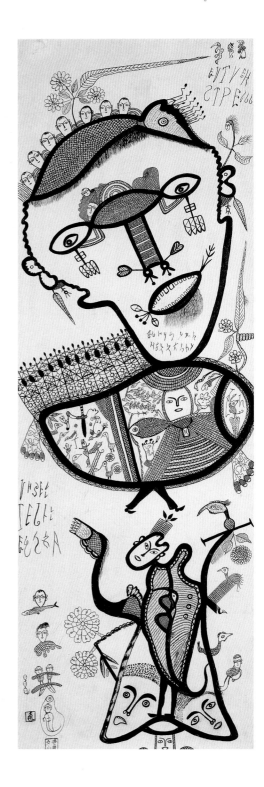

54

Hung Tung, *Ta-ch'uan ho fei-chi* (*Large Boat and Airplane*), n.d.
Gouache on paper, 53 1/4 x 26 3/4 in. (135 x 68 cm)
Hung Tung Museum

55

Hung Tung, *Untitled*, c. 1970
Ink on paper, 51 3/4 x 26 1/2 in. (132.7 x 68 cm)
Collection of Cheng-kuang Ho

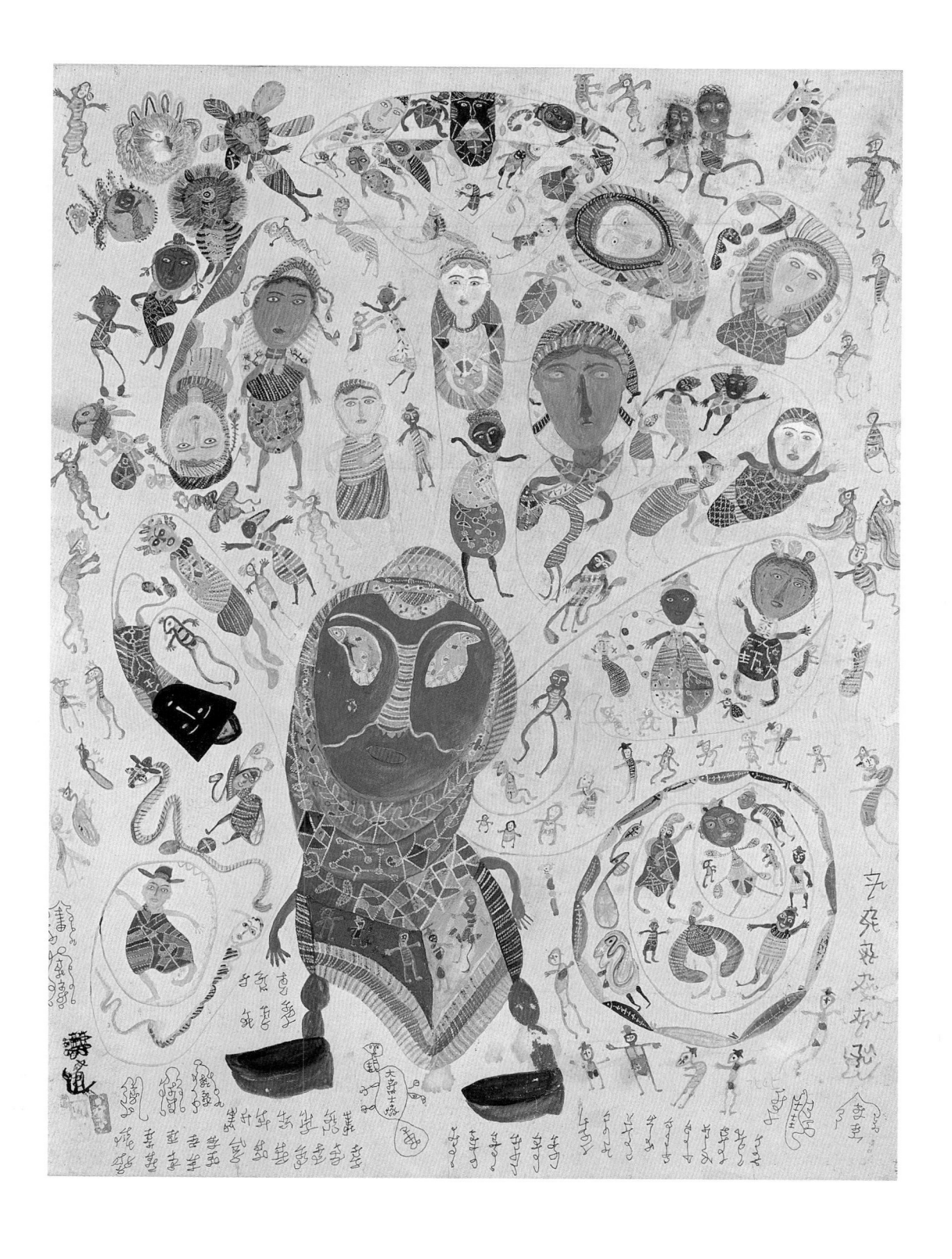

56

Hung Tung, *Ta-tou wa* (*Big-Headed Doll*), n.d.
Gouache on paper, 32 1/2 x 24 1/2 in. (82.5 x 62.5 cm)
Hung Tung Museum

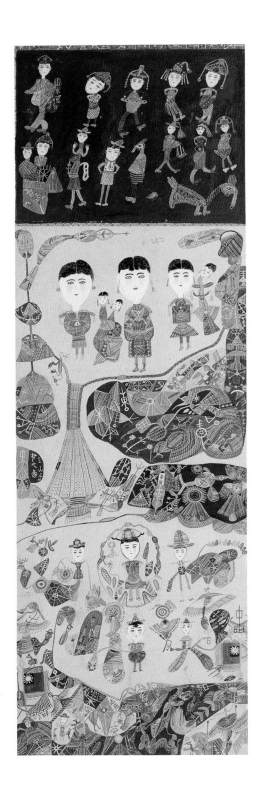

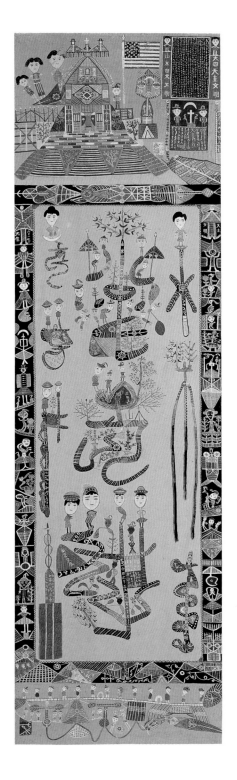

57

Hung Tung, *San mei-jen* (*Three Beauties*), early 1970s
Gouache on paper, 40¼ x 12½ in. (102 x 31.5 cm)
Collection of Yü Chow

58

Hung Tung, *Mei-kuo t'ien-t'ang* (*Heavenly America*), early 1970s
Gouache on paper, 60¾ x 17 in. (154 x 43 cm)
Collection of Yü Chow

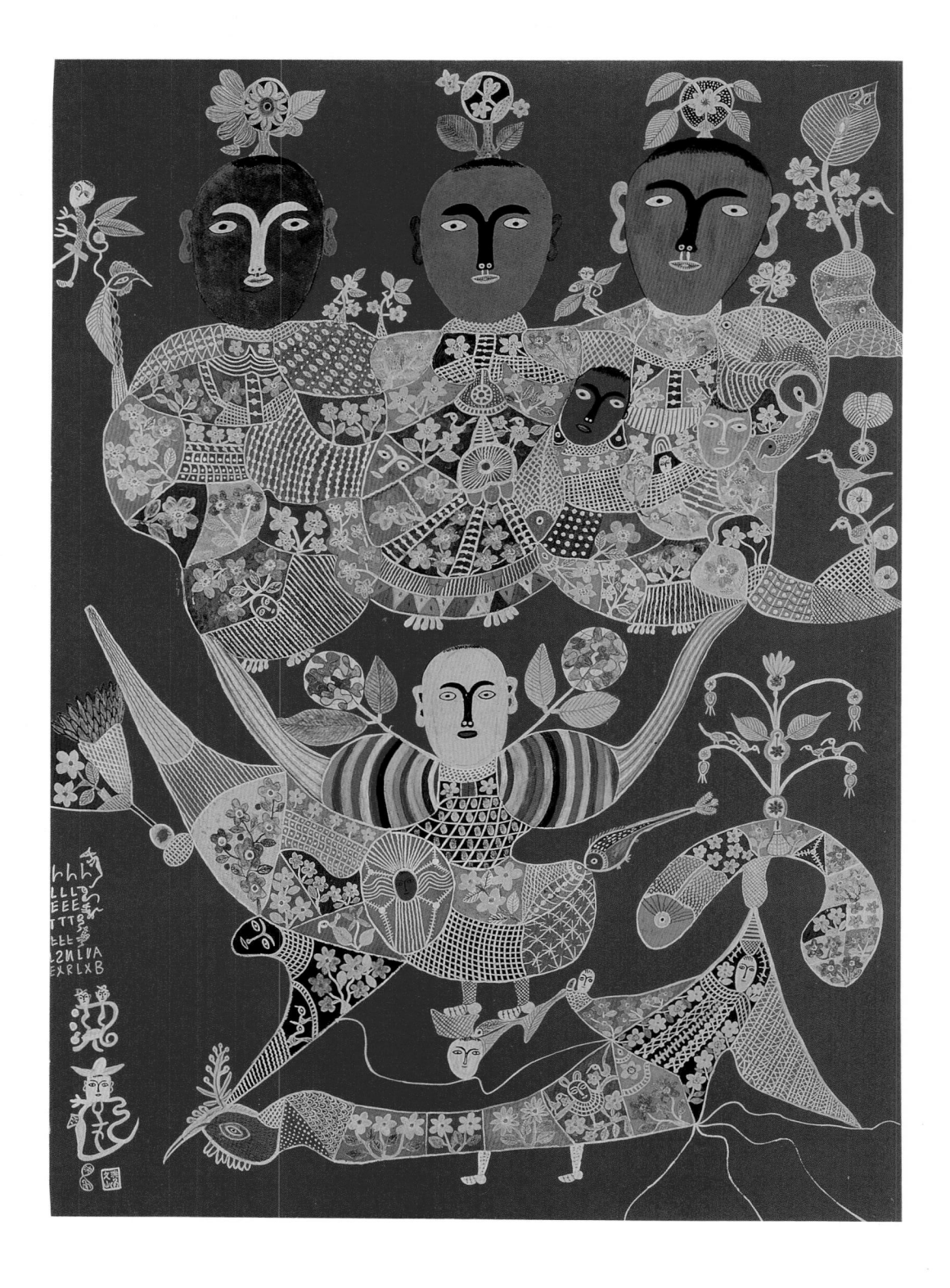

59

Hung Tung, *Lü-mien, lan-mien, hung-mien ho huang-mien shen-ming*
(*Green-Faced, Blue-Faced, Red-Faced, and Yellow-Faced Deities*), n.d.
Gouache on paper, 44 x 32 in. (112 x 81 cm)
Collection of Yü Chow

details or physical features such as breasts. These are not true women. Hung Tung's interest in female beauty is like the earnest appreciation of an audience for a performer on stage. The absence of sexual desire in Hung Tung's work emphasizes its childlike innocence and pure imagination. Even though Hung's life was plagued by hardship, his paintings are unrelentingly optimistic expressions of childlike sincerity. In *San mei-jen* (*Three Beauties*), Hung depicts a group of beautiful young ladies with powdered faces and children at their sides (fig. 57). Above and below the figures are many boys, girls, and small animals, as well as a few bird-people in profile. While some of the scene is illusory, the dominant theme remains the beauty and joy of life. This simple yearning for a good life can also be seen in some of Hung's other work, such as *Mei-kuo t'ien-t'ang* (*Heavenly America*) (fig. 58). The flag of the Republic of China, which features a white sun set against a blue and red ground, frequently appears in Hung Tung's work. However, after he began to paint, Hung made special trips to the American Cultural Center in Tainan to view exhibits, and so there can be no doubt that he was familiar with the Stars and Stripes. The American flag and churchlike buildings in *Mei-kuo t'ien-t'ang* demonstrate that Hung Tung was also familiar with the crosses found in Catholic churches.

The majority of Hung's works were painted on inexpensive scrolls, such as those used by ordinary citizens for marriages, funerals, and other common rituals. Hung used these scrolls because they were both affordable and convenient. In his later years, he particularly preferred ready-made red paper scrolls for their low absorbency, which gave the pigments a heavier quality and thus highlighted the painting's brushwork and composition. Judging from its line work, the painting *Lü-mien, lan-mien, hung-mien ho huang-mien shen-ming* (*Green-Faced, Blue-Faced, Red-Faced, and Yellow-Faced Deities*), which appears to depict temple images of Ma-tsu or Wang Ye, can be attributed to Hung Tung's later period (fig. 59). Many of Hung's later images feature fine monochrome outline (*pai-miao*) and colored brushwork, with neat and stable lines that are greatly removed from the highly modulated strokes of varying degrees of wetness found in his earlier works. The focal subjects of these works include plants,

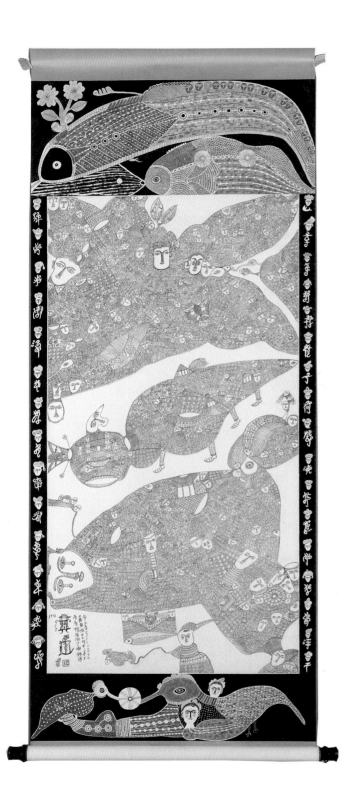

60

Hung Tung, *Shuang-yü jen-ch'in* (*Twin Fish, People, and Birds*), 1970s
Gouache on paper, 73 1/4 x 30 3/4 in. (186 x 78 cm)
Collection of Yü Chow

flying birds, geometric patterns, and human heads. By fusing these images together into a single dense composition, as seen in *Shuang-yü jen-ch'in (Twin Fish, People, and Birds)*, Hung, whether working in color or monochrome, fashioned a mature style that was far beyond what one would expect of a painter who never received a formal artistic education (fig. 60).

Hung Tung's life was like a roller coaster. At one time derided and believed insane for his obsession with painting, Hung was eventually heralded as a master, with admirers lining up for miles to view his first Taipei exhibition. Yet when the masses came to buy his paintings, he turned his back on them, retreated into his home, and hid in his work. The media gradually forgot him, and he sank into the depths of poverty. Regardless of how the world viewed him, Hung remained committed to the idea that he was a world-class painter. He knew he had ability, yet he also believed in ghosts and spirits and never denied the possibility that he was merely a vehicle for the spirits who were the true creators of his art. Who was Hung Tung? A man sick with mental illness? A spirit medium (fig. 61)? The product of his environment and upbringing? Or simply someone too different to be understood? As has been the case with other great talents, Hung's death caused the market value of his surviving works to skyrocket and elevated his reputation as one of the most important artists of twentieth century Taiwan.

Notes

1 Mi-jen Hong, "Art naif de Taiwan, évolution et actualité," in *17 Naïfs de Taiwan* (Taipei Fine Arts Museum, 1997), 35–36.
2 Chi-lu Chen, "General Characteristics of Formosan Aboriginal Art," in *Material Culture of the Formosan Aborigines* (Taipei: The Taiwan Museum, 1968), 367–68.
3 Cheng-kuang Ho, "Affirmation on Hung Tung's Art," *Artist Magazine* (March 1976): 38–41.
4 Cheng-kuang Ho, "Die Bilderwelt Hung Tungs," in *Taiwan: Kunst Heute* (Taipei: Taipei Fine Arts Museum, 1996), 183–84.
5 Cheng-kuang Ho, "Die Bilderwelt," 183.
6 Barbara Freeman, "Augustin Lesage," in *Parallel Visions: Modern Artists and Outsider Art* (Princeton, N.J.: Princeton University Press, 1992), 47.
7 Barbara Freeman, "Adolf Wölfli," in *Parallel Visions*, 74.

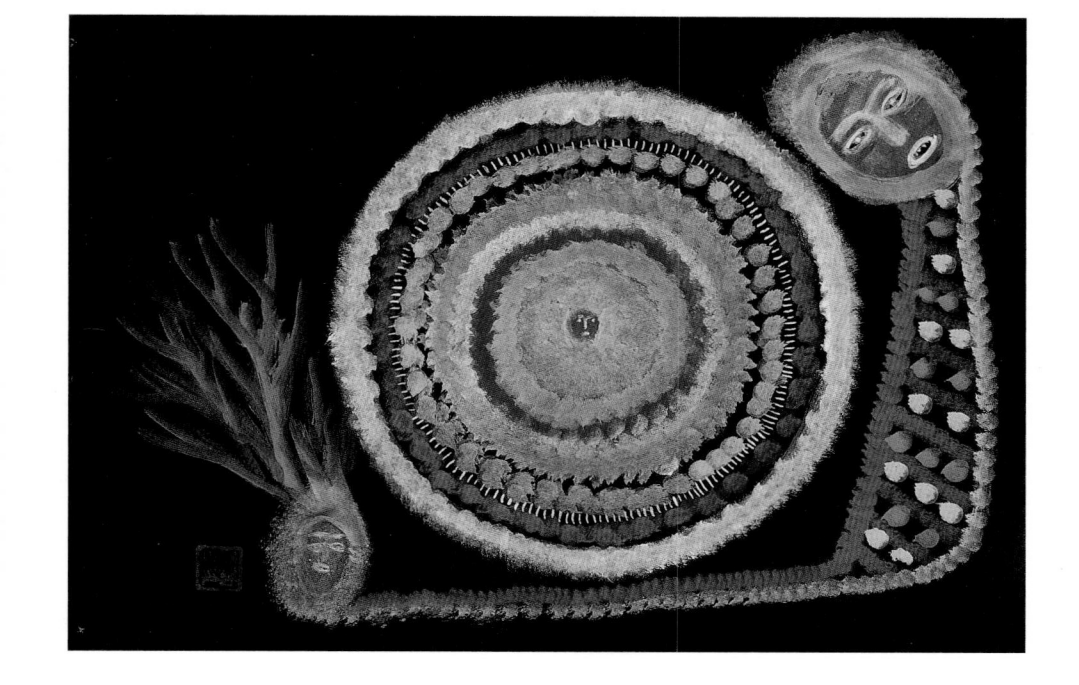

61

Hung Tung, *Untitled*, c. 1970
Ink on paper, 15 1/4 x 21 in. (39 x 53.5 cm)
Collection of Yü Chow

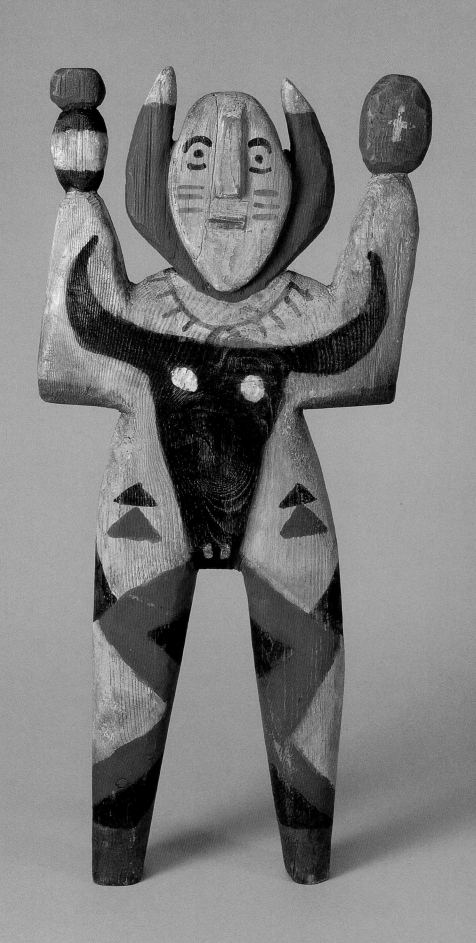

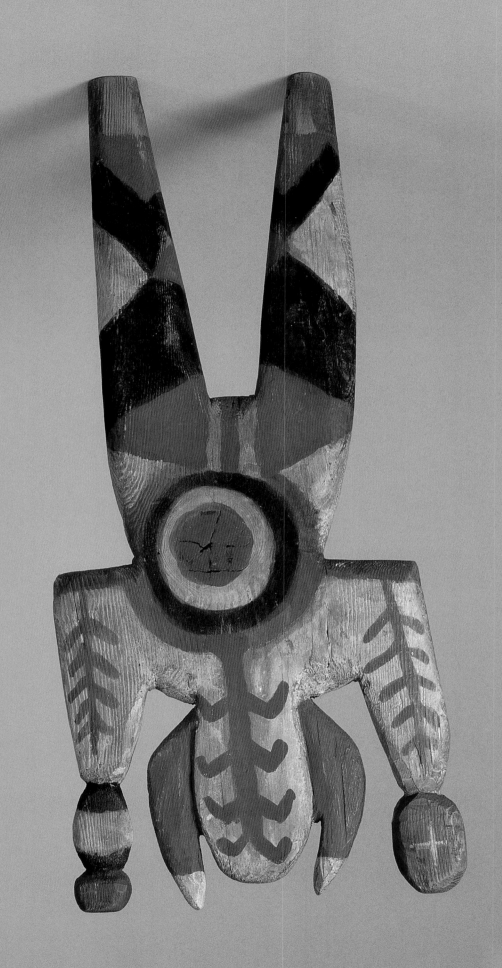

Charlie Willeto
Incantations, Transformations

Susan Brown McGreevy

The Navajos call themselves *Diné*, meaning "The People."[1] Since their arrival in the Southwest some five hundred to a thousand years ago, they have continuously and selectively adapted ideas and technologies from neighboring Pueblo, Hispanic, and Anglo societies, translating each influence into a distinctively Navajo idiom. Navajo arts were an integral part of everyday life. Objects were made for a variety of utilitarian and ceremonial functions, yet care and attention to the creation of beauty transcended necessity.

The Navajo worldview is unfamiliar territory for most Euro-Americans. Navajo life is guided by the fundamental precept *hózhǫ́*, commonly defined as "beauty," but in reality subsuming a complex set of related concepts: beauty, of course, but also harmony, order, health, balance, reciprocity, happiness, and goodness, conditions that were established in this world by sacred beings called the *Diyin Diné'e*, or Holy People. The state of harmony and beauty includes all animate and inanimate beings in the universe, because everything within the universe is interconnected.

The essence of Navajo creativity is defined by the central tenets of hózhǫ́. However, there is an inherent paradox imbedded in the Navajo ethos. On the one hand, each Navajo must strive to live a life based on harmony, balance, and reciprocity; on the other hand, the qualities of individuality and independence are highly regarded and encouraged. For example, in matters of artistic decision making, Navajos often say, "It's up to him (or her)." Thus Charlie Willeto's fantastical figurative carvings embrace a creative dynamic that is singularly Navajo: harmonious, even transcendent in concept; individualistic, even idiosyncratic, in design (fig. 62). The metamorphosis of Willeto's cumulative life experiences as a traditional Navajo into an unconventional artistic odyssey was an achievement of uncommon magnitude.

Setting

Along the highway between Albuquerque and Farmington, New Mexico, the physical landscape of ponderosa pine–studded mountains gives way to piñon–juniper woodlands and, at lower elevations, sagebrush flats. It is a land of rough-hewn textures; rugged mesas and jagged buttes march resolutely to the horizon. The back roads are punctuated by weird and fanciful rock formations, while rough

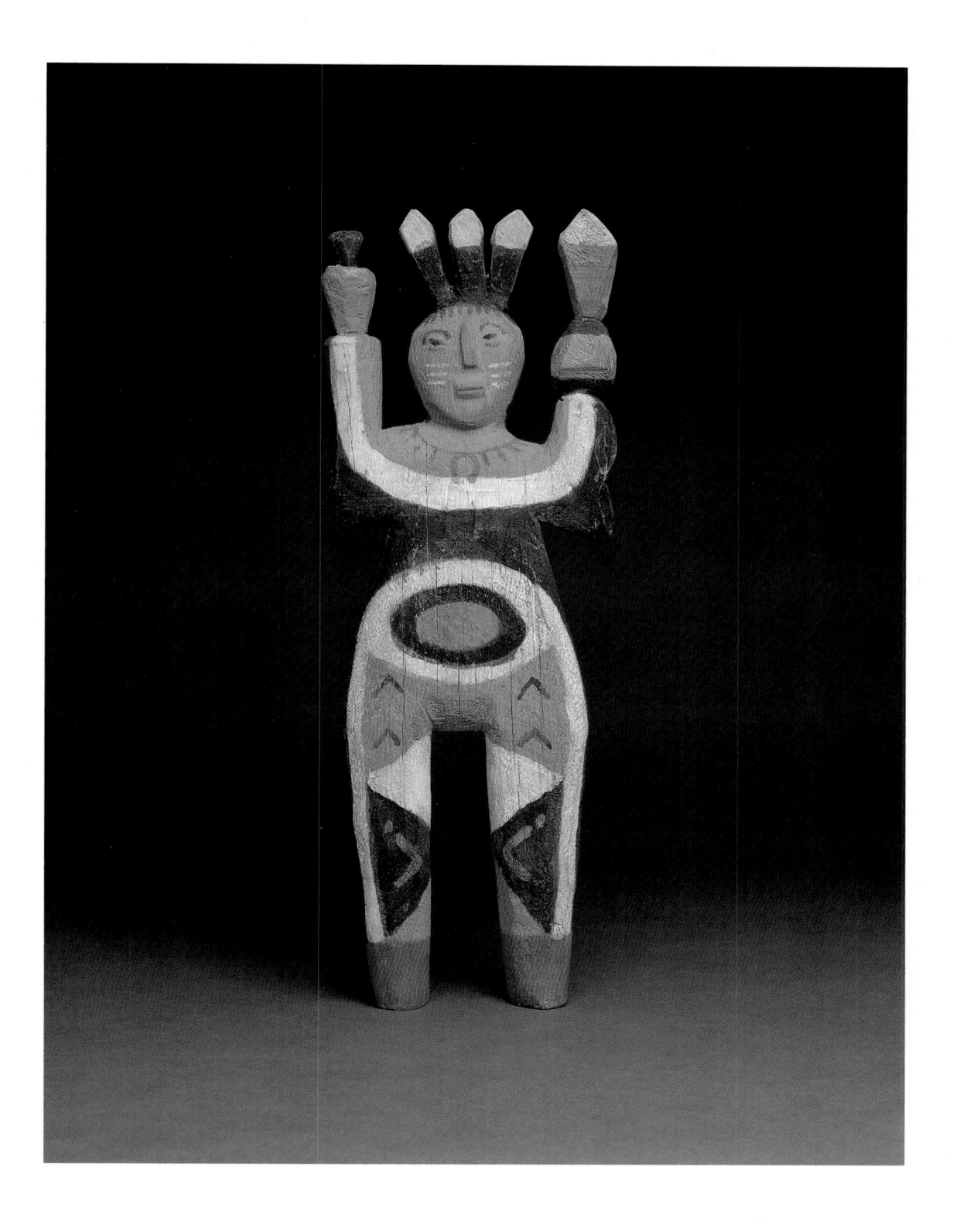

62

Charlie Willeto, *Standing Figure*, c. 1960–64
Painted wood carving, 16 1/2 x 4 x 1 in. (42 x 10 x 2.5 cm)
Collection of James and Judith Taylor, Santa Fe

terrain challenges the unwary driver. It is a place of wild and desolate beauty. The landscape also is profoundly culture-bound. The area surrounding the Nageezi area of the Navajo Nation is home to the legendary prehistoric site, Chaco Canyon. To the north is Gobernador Knob, birthplace of the most revered Navajo sacred being, Changing Woman, who created the four original Navajo clans and who symbolizes all changes inherent in life. For much of the year the region is an inhospitable place, hellishly hot in summer, brutally cold in winter—a land that would seem inimical to human settlement. Yet American Indian peoples have lived here for millennia.

There are Navajo dwellings called *hooghans* (hogans) hidden in remote and rocky canyons.[2] One of them was home to the remarkable Navajo artist Charlie Willeto (1897–1964). He was born in the small community of Ojo Encino, near Torreon, New Mexico. His maternal clan was *Tó'dích'ii'nii* (Bitter Water) and he was "born for" *Hashtł'ishnii* (Mud People).[3] Like many Navajo children of his generation, Willeto did not attend school but spent his days herding sheep, assisting with household chores, and absorbing knowledge about Navajo culture from his father, an accomplished *hataałii* (ceremonial practitioner or medicine man),[4] and from his mother, a medicine woman.[5]

Many long winter nights were spent listening to the elders tell stories about the origin of the Navajo universe, the creation of Navajo clans, and the template for proper behavior established by the Holy People. As one Navajo man related, "We keep our lives in order with the stories."[6] Thus throughout his early years, Willeto acquired an extensive knowledge of Navajo worldview, an epistemological foundation that would uniquely inform his subsequent careers as medicine man and as artist.

Ceremonial Life

When a Navajo person becomes ill, it is a symptom that harmony has been disrupted as a result of various internal and/or external etiologies. The services of a hataałii are engaged to perform the appropriate ceremony or to sing. During the ceremony the healing powers of the Holy People are invoked to restore balance and thus cure the patient. Many ceremonies include sandpaintings that serve several important functions: to summon the Holy

People; to identify the patient with the Holy People; and to absorb the illness. Sandpainting iconography portrays images of various Holy People and recounts details about the origin of the ceremony. The sandpainting is considered a sacred altar rather than a work of art and must be destroyed following the ceremony.

When ceremonies are correctly and completely performed, the Holy People must reciprocate by restoring hózhǫ, thus curing the patient. Because the complex and lengthy system of appropriate chants, sandpaintings, and other ritual practices is highly esoteric, the arduous acquisition of specialized knowledge that is prerequisite for any singer requires years of rigorous study with a practicing hataałii. Thus medicine men are considered the philosophers, ceremonial specialists, and intelligentsia of Navajo society. In his foreword to Trudy Griffith-Pierce's book *Earth Is My Mother, Sky Is My Father*, Pulitzer prize–winning Native American author N. Scott Momaday made this observation: "The complexity of Navajo cosmology is very great. To understand the structure of Navajo belief, one must see from the inside out."[7]

Willeto was a practicing Windway hataałii. This is a winter ceremony that can be held for nine nights or five nights, depending on the diagnosis of the illness and on the wishes and financial resources of the sponsoring family.[8] As conceived by the Navajos, it is *nítch'i* (Holy Wind) that gives "life, thought, speech and power of motion to all living things," thus the role of the winds is integral to Navajo worldview. During the ceremony, the Wind People are petitioned to counteract discord created by deleterious influences such as windstorms, lightning, and snakes, and to "restore one's power of movement, thinking and speech."[9] In general, a Windway ceremony is thought to be performed to cure headaches, paralysis, dizziness, eye diseases, and neck pains.

Willeto also practiced the Blessingway, the core ceremony that is imbedded in all other rituals. It is performed for the creation and maintenance of hózhǫ and for protection against harmful influences. When performed by itself, it can be held for many rites of passage: birth, a baby's first smile, puberty, marriage, construction of a new home—in short, any human activity that can benefit from blessing and protection. From time to time, Willeto also

participated in *yé'ii bicheii* dances, which are masked impersonator performances that are part of such major winter ceremonies as the Nightway, held to help ameliorate the symptoms of seasonal confusion, distraction, and depression, and the Mountainway, held to cure arthritis, mental illness, and gastrointestinal ailments.[10] An additional dimension of his ceremonial life was his role as diagnostician, principally a hand trembler and crystal gazer.[11] It is unusual, but not unheard of, for a singer also to be a diviner.

To become conversant with the mysteries of the Navajo healing arts, Willeto studied under two able medicine men: his father, Pablo Walito, and another Windway practitioner, Juan Bitonie. The two men were not only professional colleagues, they were also friends. Their relationship was to have portentous ramifications for Charlie Willeto's future; in 1944, they arranged a marriage between Willeto and Bitonie's daughter, Elizabeth, thus uniting two families of distinguished ceremonialists.[12]

Elizabeth was only eighteen at the time of the wedding, and Willeto was almost fifty; nonetheless the marriage lasted until Willeto's death in 1964. The couple had six children, only two of whom, Harold and Robin, survive today. Although the two sons work for a construction company in the nearby oil town of Bloomfield, New Mexico, both are talented, practicing wood-carvers, thus continuing and honoring their father's legacy.

By vocation, Navajo medicine men are loners. They routinely travel long distances to perform ceremonies in the hooghans of the families who require their services. According to his widow, Willeto was often away from home.[13] He frequently traveled fifty miles or more by horseback to perform the Blessingway or the longer, more demanding Windway. The services of Navajo singers are not provided pro bono; the form and amount of remuneration is established during a preliminary meeting between the patient, the sponsoring family, and the practitioner. Willeto customarily was compensated with goods such as blankets, baskets, and sheepskins, which in turn could be sold or bartered at local trading posts. On rare occasions he would be paid in cash. However, he was habitually concerned that his compensation was insufficient to support his large family, and so he supplemented his income

with a variety of part-time jobs: railroad worker, silversmith, moccasin maker, and, finally and most importantly, wood carver. Willeto clearly was a resourceful and versatile man.

Artistic Life

Objects in museum collections indicate that Navajos have been fabricating various types of wooden utilitarian objects for at least two hundred years. These include weaving tools, cradle boards, saddle frames, and children's toys. However, three-dimensional depictions of hieratic figures or human beings were considered a violation of certain sanctions established by the Holy People. Nonetheless, according to the Franciscan Fathers, "Dolls and images of some animals are at times carved of cottonwood for ceremonial purposes."[14]

In the short curing ritual known as the *'análnééh*, or remaking ceremony, stylized human or animal images are carved to remake the "life principle" of the being that is believed to be causing an illness.[15] After a remaking ceremony has been completed, the figure must be buried well away from the site of the ritual. Navajo artist Shonto Begay, whose father is a medicine man, offers an alternative explanation: "Illness dolls were used to trick away disharmony in patient. Then once the illness was 'locked' inside the doll, it was placed back into the earth."[16]

The ceremony is most often performed for a child or a pregnant woman. Willeto's first carving was in fact created for a remaking ceremony. According to his widow, a child became ill after seeing a dog run over by a car, and the family enlisted Willeto's professional services. Willeto carved a perfect little dog with turquoise eyes, and he then placed it on various parts of the patient's body. The life force of the dog was thus remade and connected with the patient. The child subsequently regained its appetite, stopped having nightmares, and was cured.

Willeto continued to carve small ceremonial figures of animals and people until it gradually occurred to him that he might be able to supplement his income further by carving images removed from ceremonial context. It was a transformative idea and the opening chapter of a pioneering artistic career.[17] Although Willeto was not the first Navajo to create figurative wood carvings,[18] his work represents a radical departure from any previous Navajo

art form. He had an open, inventive mind and a willing-
ness to take risks, to explore new artistic territories.

Willeto's work can be organized into three basic
categories: people, animals, and "spirit figures." The
origin of Willeto's carved figurative sculptures is a chroni-
cle of diverse influences as well as a tribute to his inge-
nuity and creativity. Although conventional wisdom suggests
that Willeto began carving in the early 1960s, his widow
recalls that he might have begun carving as early as 1955.
Whatever the actual date, his brilliant career began late
in life and was all too brief, ending abruptly with his death
in 1964. His earliest carved secular figures were simple
renditions of men and women wearing traditional Navajo
dress and often adorned with squash blossom or tur-
quoise necklaces and concha belts (fig. 63).[19]

Some images also occasionally featured a hairstyle
called a *chongo*, a chignonlike figure-eight twist that is
worn by both men and women (fig. 64). Although these carv-

ings reflect everyday dress, in demeanor and arm pos-
ture some suggest the human figurines, or "dolls," made for
the remaking ceremony. Other figures describe typical
scenes of Navajo life, for example, a weaver holding a bat-
ten and weaving comb (fig. 65). Willeto also made a
number of animal carvings. Some may derive directly from
his repertoire for the remaking ceremonies, but clearly
some are whimsical inventions. There are skunks, birds,
tigers, lizards, and snakes. According to collector and
artist Greg LaChapelle, the delightful image of a tiger jump-
ing through a hoop was inspired by a circus poster at
the Lybrook trading post (fig. 66).[20] Many later carvings
exhibit potent ceremonial influences. Some collectors
have called them "spirit figures" in recognition of their
uncanny, otherworldly affect (fig. 67).[21]

As Willeto's nephew, Paul Willeto, pointed out in
a paper presented at the 1996 Navajo Studies Confer-
ence, "Many of my uncle's carvings were mysterious and

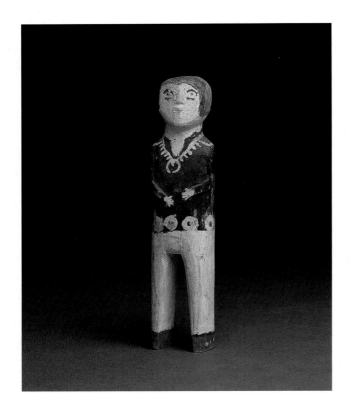

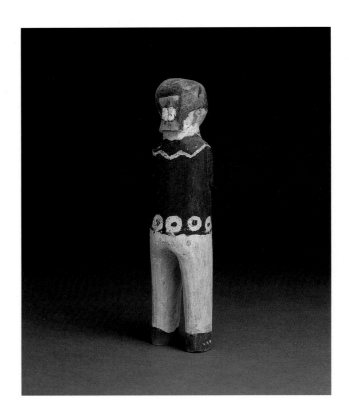

63

Charlie Willeto, *Navajo Man*, c. 1960–64
Painted wood carving, 8 3/4 x 2 1/4 x 2 in. (22.2 x 5.7 x 5.1 cm)
Wheelwright Museum of the American Indian, Santa Fe (1999.15.1)
Gift of Greg LaChapelle

64

Verso of fig. 63

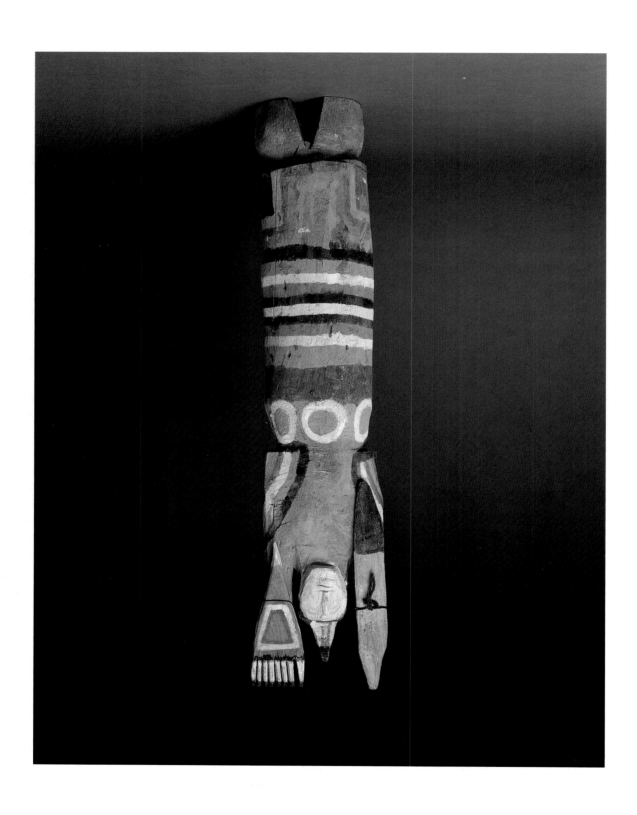

65

Charlie Willeto, *Navajo Weaver*, c. 1960–64
Painted wood carving, 36 x 8 x 6 in. (91.4 x 20.3 x 15.2 cm)
Collection of Bob and Lou Finley, Santa Fe

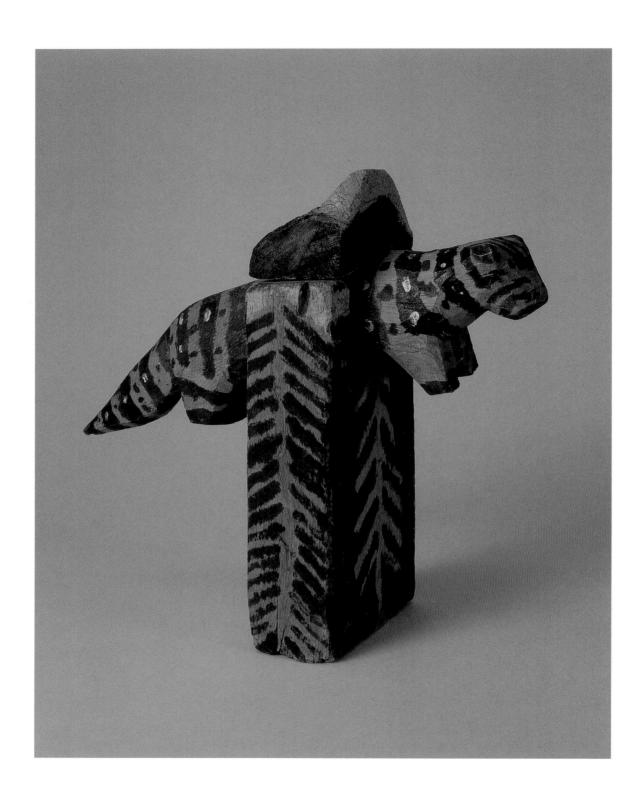

66

Charlie Willeto, *Tiger Jumping Through a Hoop*, c. 1960–64
Painted wood carving, 13 x 16 x 5 $^1/_4$ in. (33 x 40.6 x 13.3 cm)
Collection of Greg LaChapelle, Santa Fe

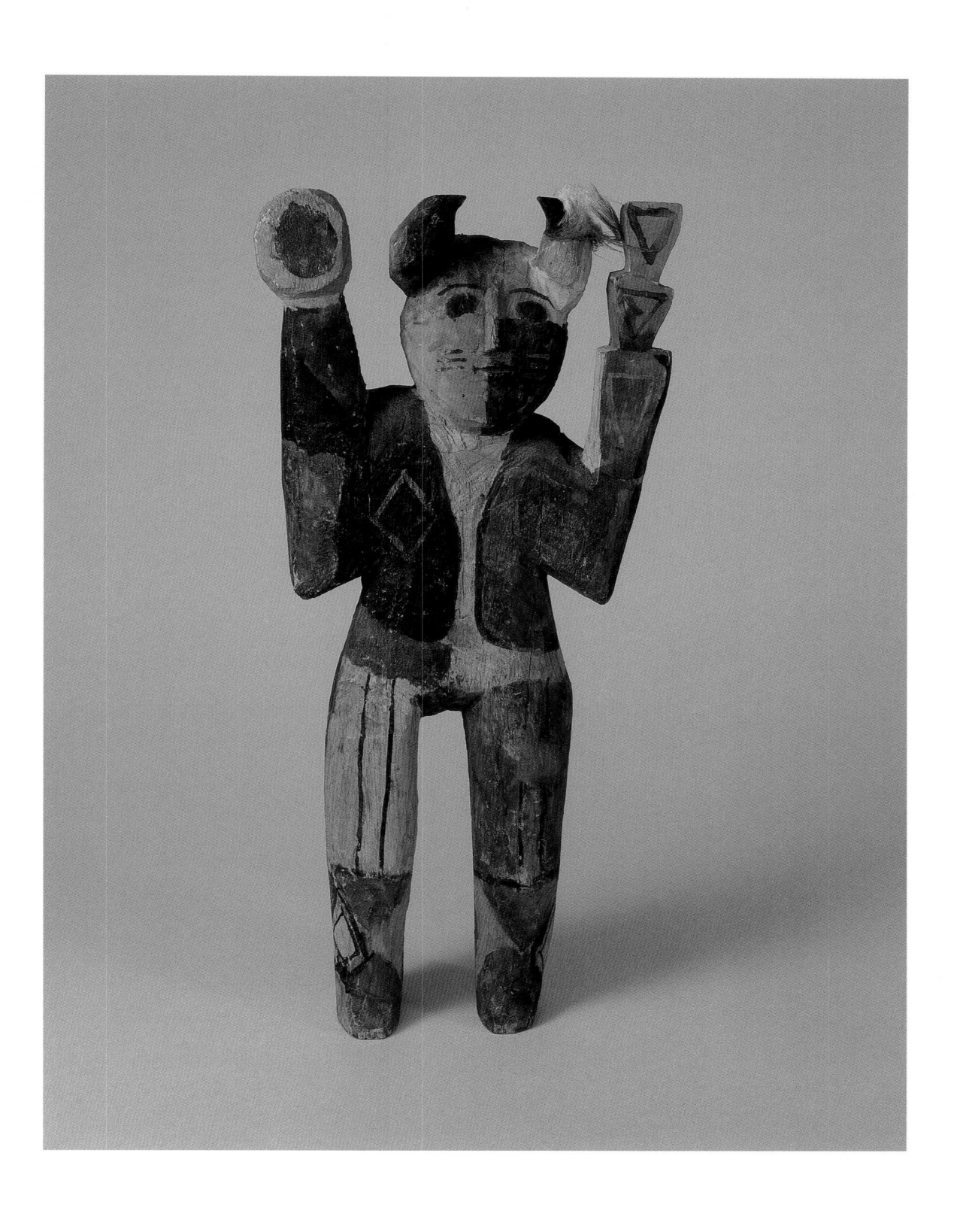

67

Charlie Willeto, *Spirit Figure*, c. 1960–64
Painted wood carving, 16 x 6 1/2 x 2 1/2 in. (40.6 x 16.5 x 6.4 cm)
Collection of Greg LaChapelle, Santa Fe

alien, causing strange feelings that no one understands." Although we cannot know with any certainty the meaning of Willeto's aesthetic symbolism, nonetheless it is possible to speculate about the influences that his ceremonial knowledge exerted. For example, the upraised arms of many of these figures suggest the posture of yé'ii images featured in sandpaintings, and, like the yé'iis, some appear to be holding rattles, spruce boughs, or other objects that are not easily recognizable.

Some spirit figures appear to be wearing face paint and/or masks or half masks (see fig. 67). As previously discussed, masked impersonators, or yé'ii bicheiis, are an important aspect of several ceremonies; however, Willeto's interpretations are highly stylized, capturing the essence, rather than the likeness, of these ceremonial beings. As Shonto Begay surmises, "I thought he [Willeto] must be very powerful to be able to make legends and stories tangible. I believe he had to be recognized and honored by the

spirits because his figures touch upon the stream of mystery within that is reserved for healing."[22]

Headgear appears in several styles. Single or multiple feathers are common embellishments, as they are in many yé'ii images in sandpaintings. There are several headdresses that may refer to the feather bonnets worn by Plains Indians, or perhaps they are meant to symbolize the eagle feather headdress worn by the most august male Holy Person, Talking God (fig. 68). In addition, horns are featured in several examples. The origin of these maverick appendages is rather enigmatic. One possible explanation can be found in the sacred image of *Ghǫ́ǫ́' 'Askiddi*, the Mountain Sheep God, a Holy Person who appears in some ceremonies and affiliated sandpaintings and is associated with fertility. It also is possible that the horns represent one version of the traditional warrior's cap adorned with feathers, abalone shells, and horns. In sandpainting images of various Holy People, horns symbolize power and authority, a ceremonial detail that certainly would have been familiar to Willeto as a Windway singer.

Details of attire demonstrate improvisations consistent with Willeto's inventive visual vocabulary. He clearly enjoyed dressing his figures in appropriate apparel. As previously noted, some of the painted styles resemble the everyday dress of Navajo men and women. Others derive from Navajo textile designs. Some patterns incorporate geometric configurations of varying complexity, while others contain shieldlike emblems. One particularly haunting image is a horned spirit figure adorned with a ghostly bull painted on its chest (fig. 69). The back of this figure is equally interesting, featuring a corn plant growing from a circular form, perhaps symbolic of the sacred lake depicted in many sandpaintings (fig. 70). The back-view aesthetic is not unique to this piece, as many other versos also contain iconographic images. Another astonishing carving seems to echo a mythical age when animals and humans were interchangeable beings. Thus the painted lizard is more than a decorative detail; shared corporeal space suggests that it has become one with the man, an artistic device that projects an eerie surrealism (fig. 71).

Willeto appears to have been particularly fascinated by owls, as he created many such examples (fig. 72). This departure in theme is perplexing because owls hold such

68

Charlie Willeto, *Standing Figure*, c. 1960–64
Painted wood carving, 18 x 7 x 1¹/₂ in. (45.7 x 17.8 x 3.8 cm)
Museum of International Folk Art, a unit of the Museum of New Mexico
Girard Foundation Collection

an ambiguous position in Navajo culture. On the one hand they play an important role in the origin narrative and hence are considered sacred; on the other hand some Navajos believe they are evil spirits and portents of death.[23] Willeto apparently was undaunted by potential controversy. His stylized owls stand erect, with large, hypnotic eyes that seem to scrutinize the world around them with surprise. The owls, although enchanting, also seem to hover on the periphery of a spectral empyrean.

Like Willeto's other figures, the bodies of the owls reveal diverse designs; some are painted in his usual palette of earth tones, but at least two incorporate green paint (see fig. 72). The most curious aspect of the owls is the addition of painted mustaches that often frame sardonic smiles. All owls have whiskers, but Willeto's interpretation is singularly anthropomorphic. Although the meaning, or perhaps symbolism, behind the fanciful adornments is cryptic, the mustaches nonetheless add a pecu-

liar kind of quirky charm to the birds. Perhaps that was his original idea. It also is remotely possible that Willeto might have seen a poster or other illustrative material featuring late nineteenth-century pottery figurines made at Cochiti Pueblo, as some of those male figures flourish very eccentric mustaches.

There were no high-tech inventions to assist Willeto in fabricating his carvings. He used whatever tools were available: axes, hatchets, hammers, saws, chisels of various sizes, and several different kinds of knives. He worked with scrap wood and used whatever paints he could find. Some paints he scavenged from the highway department, others were contributed by collectors. Occasionally he used his wife's rug dyes. Colors were applied deftly, although sometimes the quality of the wood caused the paint to blur or run. Most designs were painted in earth tones of brown, reddish brown, and black although, as previously illustrated, there were a few notable exceptions (see fig. 71).

69

Charlie Willeto, *Spirit Figure*, c. 1960–64
Painted wood carving, 20 x 8 1/2 x 1 1/2 in. (50.8 x 21.6 x 3.8 cm)
Collection of Greg LaChapelle, Santa Fe

70

Verso of fig. 69

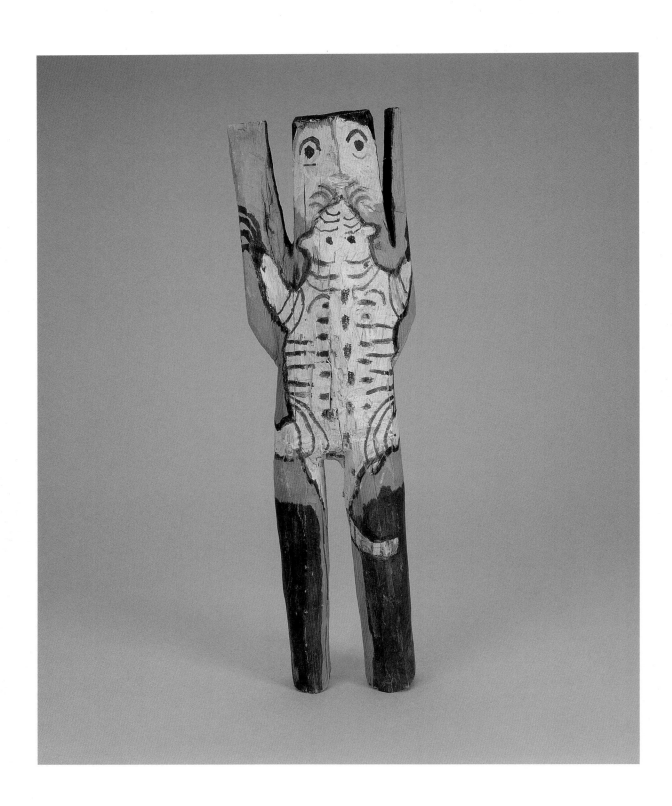

71

Charlie Willeto, *Lizard Man*, c. 1960–64
Painted wood carving, 61 1/2 x 19 1/2 x 1 1/2 in. (156.2 x 48.3 x 3.8 cm)
Museum of International Folk Art,
a unit of the Museum of New Mexico
Massey Collection

72

Charlie Willeto, *Two Owls*, c. 1960–64
Painted wood carvings
Left: 22 x 12 x 1 in. (55.9 x 30.5 x 2.5 cm)
Private collection, Santa Fe
Right: 22 x 11 1/4 x 1 in. (55.9 x 28.6 x 2.5 cm)
Wheelwright Museum of the American Indian, Santa Fe
Gift of Bob Ward (59/474)

The height of his carvings varied from five inches to more than five feet, often depending on available wood and paints but also, on occasion, influenced by artistic whim. Although Willeto lacked sophisticated tools, his touch was never tentative; rather his technique was bold and skillful. It has been estimated that Willeto carved more than four hundred figures, a prodigious achievement given the brevity of his career.[24] The quality of his work was not consistent, however, as it varied according to his mood, his health, and whatever else may have been going on in his life at the moment. It would seem that sometimes a muse inspired several brilliant works during a brief interval, but there also were dry periods when inspiration lay dormant.

The role of Willeto's wife, Elizabeth, was critical to his success. Not only did she provide emotional support, but she was also a carver and artist in her own right and so she often acted as her husband's assistant, painting and refining some of his carvings. Because her father was a medicine man and her mother a medicine woman, like Willeto she was a repository of deep ceremonial knowledge. This mutual background established a bond of like interests. Her knowledge also enabled her to make occasional sketches of yé'ii figures to serve as mnemonic devices for her husband's art. Now in her seventies, Elizabeth Ignacio is a warm and intelligent woman who is proud of her family's accomplishments.[25]

Early Collectors

With the establishment of trading posts on the Navajo Reservation during the late nineteenth century, barter for food, clothing, and other necessities became a viable economic strategy and part of the fabric of everyday Navajo life. When Willeto decided to supplement his income by taking his carvings to a local trading post, he was following in the footsteps of innumerable weavers, basket makers, and silversmiths. However, it is almost certain that no trader had ever encountered artwork as quirky as Willeto's. In fact, when he first approached the neighboring trading post at Nageezi, the trader there would have nothing to do with Willeto's carvings even though the family had been trading there for years. He next approached Jim Mauzy, the trader at Lybrook, a community about thirteen miles from Nageezi. The Willeto family had also

occasionally traded at Lybrook, so Mauzy was familiar with the tall, quiet Navajo man who would visit his store. Shortly after Willeto had left a few of his carvings with Mauzy in the early 1960s, Rex Arrowsmith, a trader who frequently visited the Navajo Nation to barter for and purchase Navajo rugs, jewelry, and baskets to sell in the store he owned in Santa Fe, visited Lybrook and noticed the figures. According to Arrowsmith, Mauzy thought that he would never sell any of Willeto's figures because they were so "odd and crude," but nevertheless he was willing to trade small amounts of groceries for the carvings.[26]

Arrowsmith also reported that Mauzy was concerned that casual Anglo visitors to the post, to say nothing of his usual Navajo customers, might find Willeto's work "disturbing and weird," and so he hid them in a back room and intentionally mislabeled their creator as "Alfred Walleto."[27] Mauzy took Arrowsmith into the inner sanctum, and the trader was sufficiently impressed with the work that he bought every carving that Mauzy had. Thus began the feedback that encouraged Willeto to keep creating.

During Arrowsmith's next visit to Lybrook he was accompanied by Greg LaChapelle, who was immediately drawn to Willeto's work. As he recalled, "I was very enthusiastic about the carvings. I instantly sensed the character and sensitivity with which these figures had been created."[28] This initial encounter was the catalyst for an extended period of collecting. The artist to trader to non-Indian art patron was part of an established and well-documented network that still exists and will no doubt continue to thrive well into the future. Today LaChapelle owns the largest single collection of Willeto's work. In 1976 he arranged for an exhibit of Willeto's carvings at the Wheelwright Museum in Santa Fe, the first of several displays of Willeto's work at that institution.

Arrowsmith purchased two large standing figures, each measuring about five and a half feet tall, that he placed outside his shop. When Herbert Waide Hemphill, Jr., an avid New York collector of American folk art, saw them during a visit to Santa Fe, he found them irresistible. Eventually the Hemphill Folk Art Collection of more than four hundred objects was acquired by the National Museum of Art, Smithsonian Institution, in Washington, D.C. Although the trail from a remote outpost on the

Navajo Nation to a prestigious national museum was convoluted and lengthy, the unorthodox and otherworldly figures of Charlie Willeto impressed many scholars, collectors, artists, curators, and gallery owners along the way.

Willeto himself became increasingly eccentric and reclusive. Perhaps he realized that the spiritual nature of his artwork, produced in secular context, might seriously alienate him from Navajo society and so he withdrew from it rather than risk painful ostracism. He also was concerned that his new artistic career could be potentially offensive to the Holy People, thus he arranged to have short blessing and protection ceremonies sung over him. Although he realized that his figures would end up in the hands of strangers, for Navajos it is the creative act that is transcendent; the aftermath is of lesser moment. From the beginning it was Willeto's intention that his carvings provide an additional means of provisioning the family's larder; however, the act of "commoditization" in no way diminished his talent for improvising or compromised his artistic integrity.

Although Mauzy's opinion that Willeto's carvings were "odd and crude" does not bear much weight today, Willeto's work remains enigmatic and mysterious. It would seem that Willeto was indifferent to the perceptions of the outside world; rather he invented a mythic world of his own, establishing an internal dialogue with a phalanx of outré personages, a clan of alter egos to keep him company. Willeto was a magician: his ability to transform inchoate chunks of wood into a fully developed figurative tradition was the signature of his genius. His work leaves an indelible imprint on eidetic memory.

Some authorities would argue that the vocabulary to analyze the "objects of others" is in a state of chronic confusion. Vernacular visionary art comes closest to describing the work of Charlie Willeto, hence his inclusion in this publication and exhibition. Willeto also can be classified as a self-taught artist because he did not attend art school, or any other school for that matter. Yet, within his own culture, his years of study to become a singer defines him as an intellectual. This cultural anomaly represents yet another example of the ambiguities inherent in our discourse. Without belaboring what has been wryly called "term warfare,"[29] it is clear that Randall Morris approaches

the crux of the problem when he observes, "It is we who must shape-shift. We must come to a new multi-disciplinary perspective not couched in Western-speak exclusively."[30]

But we are not there yet. While Willeto's work undeniably defies mainstream Euro-American artistic convention, it undeniably defies mainstream Navajo artistic convention as well. Totally original and iconoclastic, it nonetheless emerges from the deep interstices of Navajo culture, to be forged within the crucible of Willeto's audacious imagination. Unlike sandpaintings or yé'ii bicheii masks, Willeto's art is not explicitly sacred; rather his creativity embraces a less literal and more intuitive connection to a secret and sacred world, a world implicitly charged with cosmic energy. His singular vision is spiritually evocative, aesthetically potent, visually compelling. At the very least, the world according to Charlie Willeto reifies an authentic, numinous voice.

In 1976 the distinguished Navajo poet and painter Gloria Emerson saw the exhibition of Willeto's work at the Wheelwright Museum (then the Museum of Navajo Ceremonial Art). She took a few notes and put them aside. Several years later she found the notes among other accumulated poetry ideas. The notes became a paean. When she learned about this project, she offered to share it. It has moved me to tears.

Zigzag lines of the sunset fell into his mind and he awoke
 with a song.
His song became the rasping of a saw and a hammering and
 a chiseling.
In time, the forms walked out of his arms and lined themselves up
against the corral and the stuccoed side of his hogan.
His forms drank up all the colors of the landscape,
leaving the horizon gray on sage-gray.
Out there somewhere between Nageezi where they take it easy,
and Waafeno (Huerfano [Mesa]) . . .
Willeto, the wild man made things, strange things.
The things he made, a study in aberration, some called it.
Folks said he was crazy, or just plain lonesome.
Lonesome, lonesome, lonesome, to make new things,
adding to his growing clan of caricatures, of yé'iis, of cowboys,
 of owls.
Born for the wildness that coursed through the veins of an

artist on fire,

he made things from old boards, found things. He made crazy art.

Art to eat mutton ribs and tortillas by.

Or maybe commodity cheese and tortillas and camp coffee.

Out here in full view of the place where Changing Woman
 was made,

His clan stood waiting for something to happen.

Now his art hangs out there in a museum someplace in Santa Fe, N.M.

Notes

In expressing my appreciation to those who have helped me give birth to this essay, my initial thanks must go to the Willeto family: Elizabeth Ignacio, Harold and Robin Willeto, Deanna Garcia. Gloria Emerson in a few elegant phrases captured the essence of Willeto's artistic identity. Thank you Stephanie and (the late) John Smither, and my old friend Rex Arrowsmith. My thanks also to Tamara Pope Roghaar, curatorial assistant, Native Arts Department, Denver Art Museum; Tricia Loscher, exhibit and program director, Heard Museum North, Scottsdale, Arizona; Valerie K. Verzuh, collections manager, Museum of Indian Arts and Culture, Santa Fe; Wesley Russell, curator of collections, Roswell Museum and Art Center, Roswell, New Mexico; and Cheri Falkenberg Doyle, curator of collections, and Mary Katherine Ellis, collections manager, Wheelwright Museum of the American Indian, Santa Fe. Two other professionals deserve my thanks, Bruce Hucko, photographer, and Ronald P. Moldanado, program manager, Cultural Resource Compliance Section, Navajo Nation Historic Preservation Department. Additional thanks to Dick and Jane Cieply, Ray Dewey, Peter Fogliano, Eugene Frank and Gregory Baird, John Hill, Bud Jennings, Eugenie and Lael Johnson, and Judy and Jim Taylor. And a very special thanks to my good friends Leslie Muth and Annie Carlano.

1 Navajo orthography conforms to Robert W. Young and William Morgan, Sr., *The Navajo Language: A Grammar and Colloquial Dictionary* (Albuquerque: University of New Mexico Press, 1987).

2 The *hooghan* is the traditional circular, hexagonal, or octagonal Navajo dwelling. The door always faces east. All ceremonies must be performed in a hooghan.

3 The Navajos are divided into about eighty matrilineal clans. The primary affiliation is with one's mother's clan, with descent and inheritance recognized through the female line. One is "born for" the father's clan. Clan membership contextualizes relationships outside the immediate family and entails a complex set of reciprocities and obligations. A Navajo must marry someone who is not a clan relative. Clan relationships are so important that Navajos introduce themselves to each other by first using their clan names.

4 The Navajo word *hataałii* means singer or chanter in recognition of the complex repertoire of chant songs that accompany a ceremony.

5 Women cannot perform major ceremonials; however, many are talented herbalists, hence they are called medicine women.

6 Barre Toelken, *The Dynamics of Folklore* (Boston: Houghton Mifflin, 1979), 96.

7 N. Scott Momaday, foreword to *Earth Is My Mother, Sky Is My Father: Space, Time and Astronomy in Navajo Sandpainting*, by Trudy Griffin-Pierce (Albuquerque: University of New Mexico Press, 1992), xvi.

8 There are two interpretations of this ceremony, the Navajo Windway and the Chiricahua Apache Windway. Willeto performed the Navajo version.

9 James Kale McNeley, *The Holy Wind in Navajo Philosophy* (Tucson: University of Arizona Press, 1981), 1, 48.

10 The yé'ii constitute a special category of Holy People. To become a yé'ii bicheii, or masked impersonator dancer, a man must have had a Nightway or Mountainway performed for him.

11 When a person becomes sick, the first action he must take is to determine the source of the illness. Navajo diagnosticians employ various techniques: hand trembling and crystal gazing are among the most common.

12 Arranged marriages used to be common among the Navajos.

13 Willeto's widow, Elizabeth Ignacio, and the Willetos' two sons, Harold and Robin, and granddaughter, Deanna Garcia, were an invaluable source of information provided over the course of two visits with the family: Dec. 3, 2001, and Feb. 15, 2002.

14 Franciscan Fathers, *An Ethnologic Dictionary of the Navajo Language* (St. Michael's, Ariz.: Franciscan Fathers, 1910), 495.

15 Sam D. Gill, "The Prayer of the Navajo Carved Figurine: An Interpretation of the Navajo Remaking Rite," *Plateau* 47, no. 2 (1974): 62.

16 Shonto Begay, "Willeto's Tangible Mysteries," in *Collective Willeto: The Visionary Carvings of a Navajo Artist*, ed. Greg LaChapelle (Santa Fe: Museum of New Mexico Press, 2002), 1.

17 Although there was precedent for the conversion of sacred images into a secular iteration, Willeto likely was unaware of the circumstances. In 1919 the eminent hataałii Hasteen Klah (*Hastiin Tł'aii*, Navajo word meaning Mr. Lefthanded) wove his first sandpainting textile. He continued to create his "woven holy people" in spite of considerable opprobrium from ultraconservative Navajos.

18 The career of Clitso Dedman (1879?–1953) preceded Willeto's by about ten years. Dedman's work consisted of representational images of yé'ii and yé'ii bicheii figures. See Rebecca M. Valette and Jean-Paul Valette, "The Life and Work of Clitso Dedman, Navajo Woodcarver (1879?–1953)," *American Indian Art* 25, no. 2 (Spring 2000).

19 Turquoise has been an important gemstone in the Southwest since prehistoric times. It is a symbol of "Father Sky" and the all-precious commodity of water. Squash blossoms are Navajo interpretations of the pomegranate blossom trouser ornaments worn by Spanish men. The crescent-shaped pendant *nazhahí*, or *naja*, is an ancient Middle-Eastern symbol intended to ward off the evil eye. Both the naja and the concha, or shell-shaped ornament, were adapted from Spanish bridle accoutrements.

20 Greg LaChapelle's comments are from personal communications over several months.

21 The author has intentionally avoided the term *supernatural* because

many Navajos find it culturally inappropriate and intellectually inaccurate.

22 Shonto Begay, "Willeto's Tangible Mysteries," 1.
23 Apparently there is no prohibition among the Navajos against killing owls, because owl feathers are featured prominently in ceremonial attire and paraphernalia.
24 According to Arrowsmith and LaChapelle.
25 Ignacio does not speak any English. I am indebted to Harold and Robin Willeto and to Deanna Garcia for their help in translating.
26 Rex Arrowsmith's comments are from an Aug. 21, 2001, interview.
27 Mauzy's paranoia about keeping Willeto's identity secret may have been the origin of the Alfred Walleto pseudonym.
28 For a more thorough discussion of LaChapelle's recollections see his essay in *Collective Willeto*.
29 Charles Russell, ed. *Self-Taught Art: The Culture and Aesthetics of American Vernacular Art* (Jackson: University Press of Mississippi, 2001), 3. The expression *term warfare* was introduced by Didi Barrett in her essay of the same name in *Muffled Voices: Folk Artists in Contemporary America* (New York: PaineWebber Art Gallery, 1986), 4.
30 Randall Morris, "The One and the Many: Manifest Destiny and the Internal Landscape," in *Self-Taught Art*, 117.

Anna Zemánková
A Sublime and Sinister Art

Annie Carlano

It is not surprising that Jean Dubuffet's Collection de l'Art Brut includes the work of Anna Zemánková.[1] In these large-scale pastel drawings one sees many of the characteristics of "authentic" or "raw" art—often found in the work of artists working on the margins—isolates, mediums, the mentally ill, that he and André Breton and the surrealists admired and collected. They sought an art untainted by inhibition or by self-conscious concerns for fashion, an art that was spontaneous and original. Those qualities are beguilingly present in Zemánková's oeuvre. Like one uninterrupted thought poem, one graceful unfurling movement of dance, or the effortless flow of a stream, the art of Anna Veselá Zemánková is exquisite in its naturalness and unabashed sensuality (fig. 73). But Zemánková was not crazy.[2]

She was neither clinically depressed nor delusional, and it is unlikely that her extraordinary oeuvre was due to hormonal changes at age 50. She was self-taught. She was obsessive. She was diabetic. She was fat.[3] What Zemánková thought and felt about the art she created between 1964 and 1986 cannot be known. The remaining accounts of her life and the world in which she lived can assist in understanding her strange and ethereal artwork. While much of her oeuvre belongs to the realm of the mysterious and is both strong and moving on its own merit, an abundance of cultural clues—visual, legendary, and musical—offer insight into a more complete experience of the artwork. I will present a way of seeing the art of Anna Veselá Zemánková as the paradox it is: an expression of an intensely personal vision and a continuum of certain Czech cultural phenomena that reflect her experiences and interpretations of the world. Part dream and part reality, the art may have been created for herself alone, but its appeal is universal in its quiet, peculiarly unsettling, allure.

Anna Veselá was born in 1908 near the Moravian town of Olomouc, which for centuries had been a part of the Austro-Hungarian Empire. Moravia is a region of contrasts: bucolic, gently rolling hills in which were nestled villages that harbored traditional ways, mysticism, and a belief in "fairies,"[4] as well as cities of large buildings, monuments, and industry. Olomouc, in southern Moravia, is one of the latter. A small city in Anna's time, it has significant Gothic, Renaissance, and baroque churches and

later buildings of all types, impressive public sculpture, fountains, parks, and cultural institutions. Architects, painters, and sculptors came to Olomouc from Italy and the Germanic countries to create some of the most accomplished work of the region. As they commingled with artisans of Moravia, a distinct architectural and artistic style developed by the late Gothic period, a poignant south-meets-central-European-character, giving Olomouc its unique "look." Such was the setting for Anna's early life, a place full of tradition, history, and folklore. Born into a family of tradesmen, Anna had a relatively standard upbringing, notwithstanding the political disruptions of her youth. Moravia had been a battleground for centuries, with alliances and borders changing frequently. In 1918 the Czechoslovak Republic was formed, and Nazism would encroach soon enough. As she grew older, although she dabbled in painting and considered pursuing an art profession, her pragmatic parents encouraged her to pursue a career, and a life, that was secure.[5]

Obedient, she followed her parents' wishes, became a dentist, and married a dashing military officer in 1933. Motherhood and a succession of children followed. In 1948, the year the Communists took control of the government, the Zamanek family (the masculine form is used as the family name) moved to Prague, following the promotion of her husband to an army base there. They lived in an attractive, newer part of Prague, in an Art Deco corner building with large, streamlined balconies. She was a good mother and wife and would become an extremely entertaining grandmother. Family life was her milieu until around 1960.[6]

Spurred to create, *passionately*, for reasons she never shared, her mysterious new propensity delighted her family. Zemánková's son Bohumil, a renowned sculptor of his generation and member of the clandestine Prague intelligentsia, encouraged and supported her new obsession, providing large sheets of paper and pastels and tempera for her earliest drawings. At first her creations were clumsy in design and execution, but Zemánková labored incessantly to reach a point of artistic satisfaction, which manifested itself quickly in the artwork. While she did not speak much about her art, she was enthusiastic, exclaiming that she couldn't wait to express her new ideas.

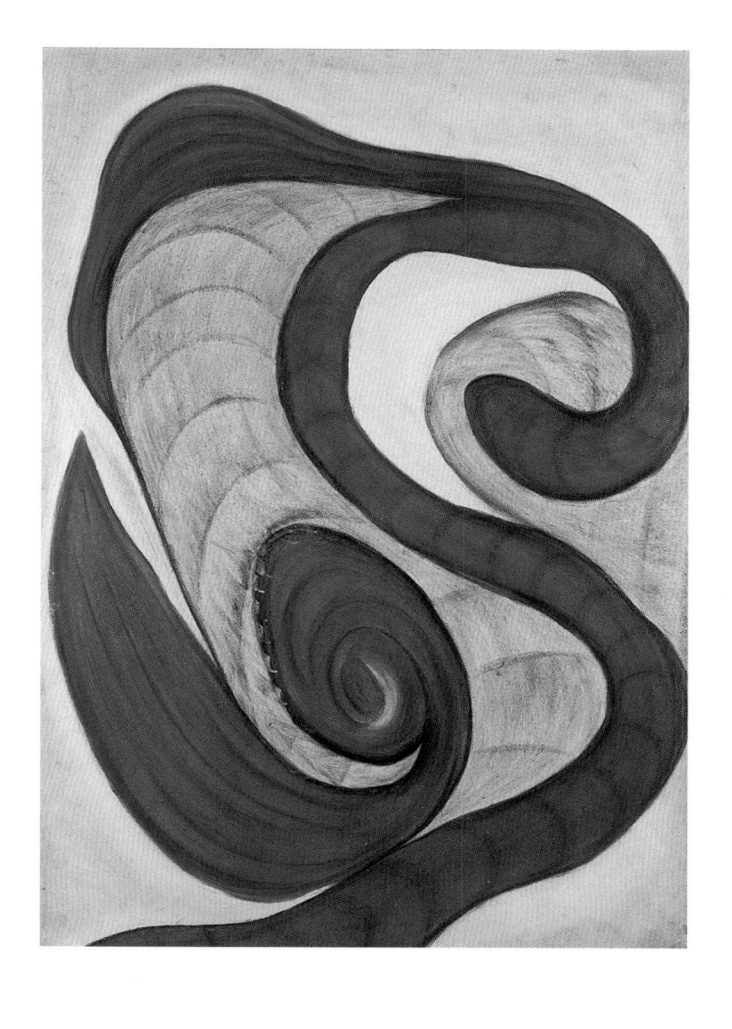

73

Anna Zemánková, *Untitled*, c. 1964
Oil pastel and mixed-media on paper, 33 1/4 x 23 1/4 in. (84.5 x 59.1 cm)
Zemánková Family Archives, Prague

This hint at a premeditated creative process is another indication that she was neither mad nor in a trance when working. It was indeed a time in her life when her personality changed noticeably, which probably had more to do with a midlife crisis than with a menopausal depression. Zemánková became increasingly mean-spirited, and her now retired husband spent his days gardening in the family's allotment near the castle to avoid contact with his wife. Eventually, a work pattern was established. Rising each morning at 4 A.M., she immediately went to the kitchen table to draw. Her predawn reveries evolved into large gestural compositions, spontaneous, lyrical, and near perfect in execution. These large-scale biomorphic,

evocative, "surreal" creations account for her early period, the first of four distinct phases of her artwork (figs. 73–75).

Zemánková's creative practice remained the same for each of these phases. At 7 A.M. she would make breakfast for her family, tend her balcony garden—her little piece of paradise—then proceed to her artwork, which would occupy her throughout the day. With confidence and precision, the finishing touches were applied without a second thought, erasures, or revisions. Anna Zemánková's process of making art was not exactly the same as those of the Spiritualist communities of Moravia and Bohemia, in which mediums created drawings through channeling spirits, but there is an uncanny similarity between their art

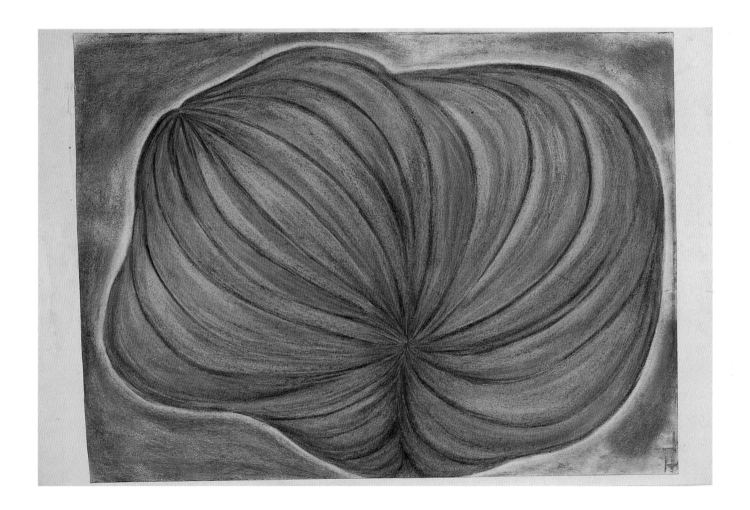

74

Anna Zemánková, *Untitled*, c. 1964
Oil pastel on paper, 23 ¹/₂ x 33 ¹/₄ in. (59.7 x 84.5 cm)
Zemánková Family Archives, Prague

and that of the second phase of Zemánková's oeuvre (fig. 76). In this phase, the grand scale and sweeping gestures have been replaced by watercolor and pastel paper half the size of that used in the first phase and on which she drew in a more complex, detailed, and accomplished manner. Most extraordinary, she began to manipulate the paper by delicately crimping it to create an embossed effect and adding a bit of naturalism. Bold in the first phase, she now created drawings that are fragile, atmospheric, and spiritual. Spiritualism has old, deep roots in the Czech lands and will be discussed below.

The ancient belief that the spirit lives on after death and that it is possible to converse with these spirits had been accepted phenomena and part of the local folklore for centuries. Swedenborg and the Swedes in the late eighteenth century, and much of the rest of Europe and the United States by the 1850s, repopularized these ideas. Beyond Prague, in the Bohemian and Moravian countryside, there existed entire communities of "Spiritists." One of these, Nová Paka, located in the Giant Mountains of north-central Bohemia near the Polish border, houses in its eponymous museum a large collection of drawings created by mediums of the twentieth century.[7] Striking in composition and theme are those works illustrating fruit, flowers, and vegetables from other planets. Channeling alien entities was a specialty of several individuals there, such as Jan Tóna, whose masterful pastel drawings have a tight, controlled quality, a lightness of touch, with gossamer, feathery details, delicately shaded forms, and soft contours. Meticulously rendered, they disregard scale; leaves are often several times larger than the fruit or vegetable depicted. His fantastical botanicals are accompanied by descriptive text, such as "Cherry tree from Venus" or "Eggplant from Mars."[8]

In figure 76 are some of the salient characteristics of such Czech mediumistic art that have caused several respected scholars to assume that Zemánková was in a trance or that she channeled her art. What appear to be two giant green beans hang gracefully from a central floral blossom, from which four strands of fantastic petal-cum-insect forms are attached. These petal/insect strands are raised and accentuated with dots of red paint. Integrated into these strands are intricate, minute spiderwebs. On the right, forty extremely fine lines, which appear as if seen through a mist, cascade down the drawing.[9]

The entire composition seems backlit, emitting a warm glow. From this same period, a winglike form (fig. 77) appears to harbor alien-looking creatures with white helmets and long pointy ears. Or does it? The fun and danger of this kind of para–art-historical analysis is that her works from this second phase are particularly rich in enigmatic minutiae. Sometime during this phase she created very small drawings, miniature versions of the larger drawings, in which the paper was manipulated more emphatically, with raised areas more pronounced and with some parts of the paper cut out (fig. 78a, b). The artist

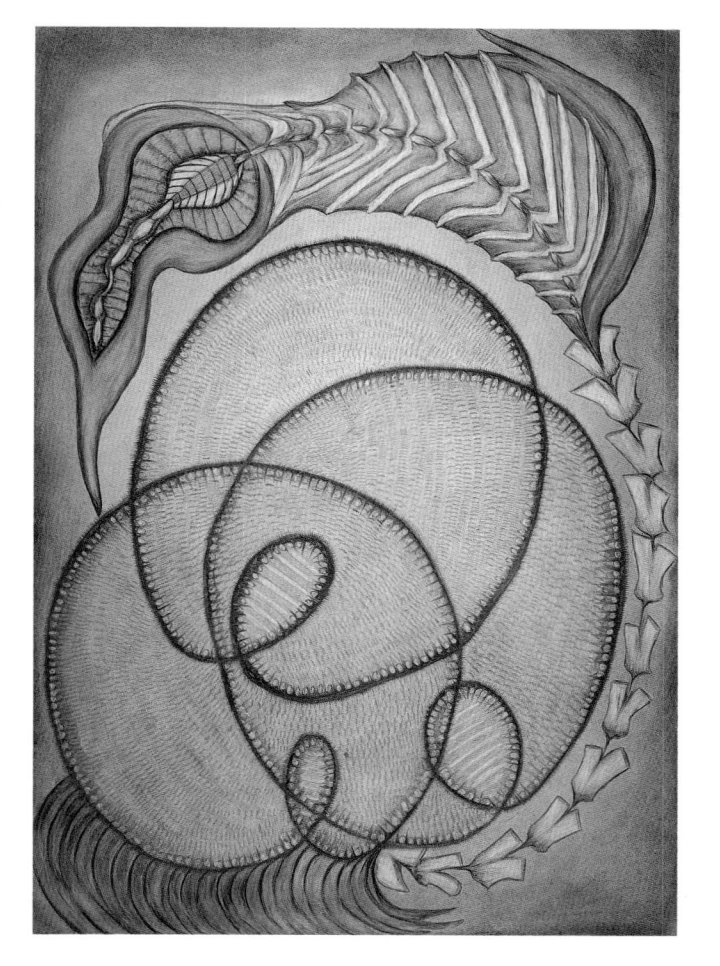

75

Anna Zemánková, *Untitled*, 1960s
Oil pastel on paper, 34 1/2 x 24 1/2 in. (87.6 x 62.2 cm)
Museum of International Folk Art,
a unit of the Museum of New Mexico
Gift of Thomas Isenberg

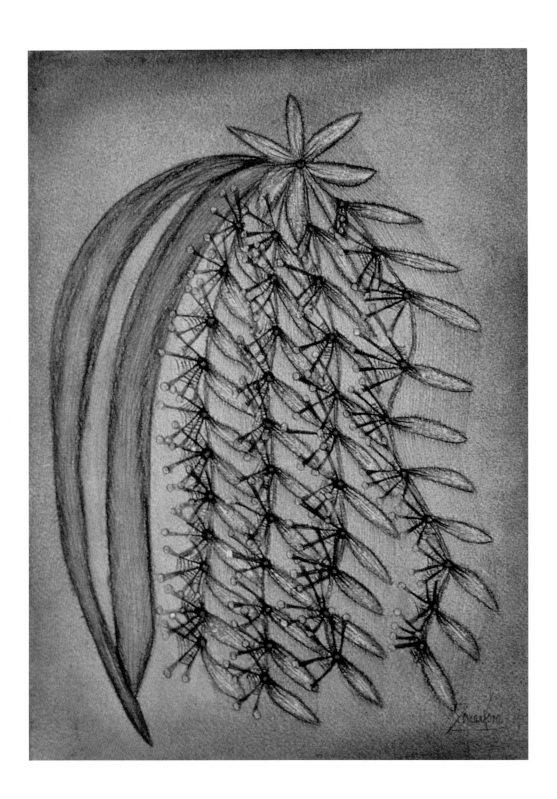

76

Anna Zemánková, *Untitled*, c. 1970
Mixed-media on manipulated paper, 12 x 8 ¹/₂ in. (30.5 x 21.6 cm)
Museum of International Folk Art,
a unit of the Museum of New Mexico
International Folk Art Foundation Purchase

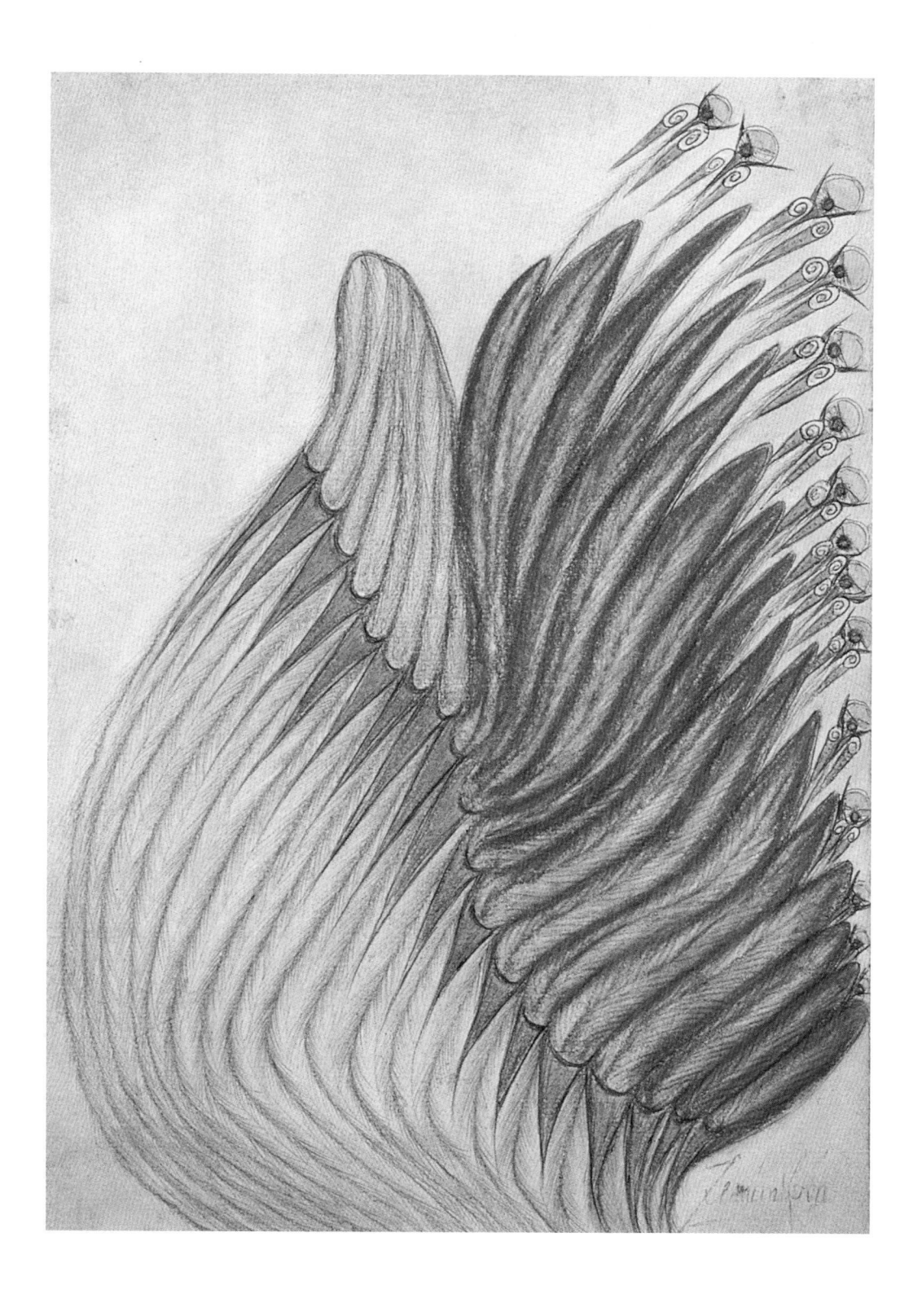

77

Anna Zemánková, *Untitled*, c. 1970
Oil pastel on paper, 12 x 8 1/4 in. (30.5 x 21 cm)
Museum of International Folk Art,
a unit of the Museum of New Mexico
Gift of Thomas Isenberg

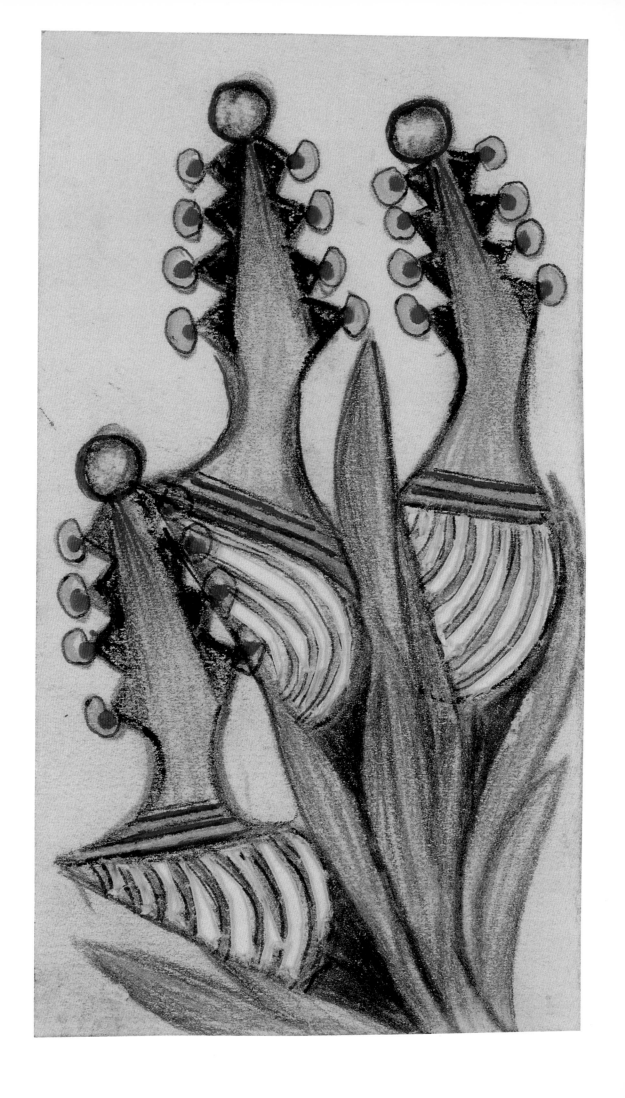

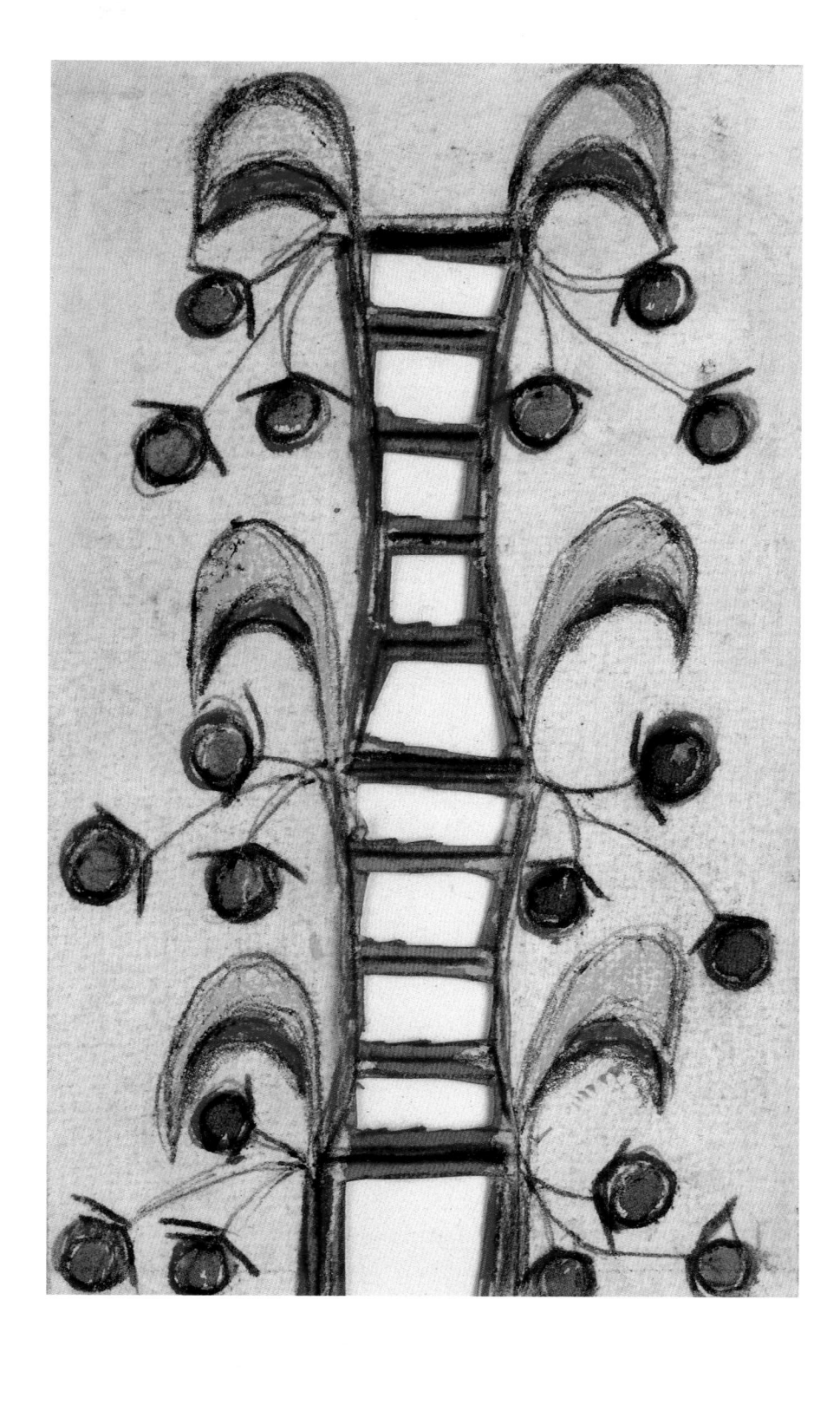

78a, 78b

Anna Zemánková, *Untitled*, 1970s
Cut out and manipulated paper miniatures,
each 3 x 2 in. (7.6 x 5.1 cm)
Museum of International Folk Art,
a unit of the Museum of New Mexico
International Folk Art Foundation Purchase

continued making these small visionary works throughout her life. Occasionally these "minis," as they've come to be called, were ornamented with applied spangles, beads, or tiny rhinestones. Whether or not she channeled, we do know that during the 1960s, like many people at the time, Zemánková was keenly interested in outer space, from cosmonauts to the possibility of life on Mars.[10]

The Czech Republic has been a cauldron of the occult since the Middle Ages, but it was during Hapsburg rule when such activities flourished with decadence to the point of exploitation and corruption. All three segments of society, Czech, Germans, and Jews, belonged to this tripartite of the occult. The charming Golden Lane, now a tourist attraction, was home to the alchemists. Giuseppe Archimboldo (1537–1593), first under Ferdinand I and, later, under Emperor Rudolf II, proved to be the perfect court portrait artist for this setting, as his composite depictions range from the bizarre to the grotesque; he was an artist-alchemist who turned pieces of decaying fruit, vegetables, and insects into meticulously realistic portraits. Archimboldo was called back to Prague by Emperor Rudolf II. When Rudolf II moved his court to Prague in 1583, the city quickly became "an academy of the occult."[11]

Magicians, alchemists, and astrologers were brought to the castle almost immediately to satiate the sovereign's taste for spiritualism, transmutation, and fortune-telling. Others, such as John Dee and Edward Kelly, showed up uninvited at the castle gate to offer their services. The latter mesmerized Rudolf by conversing with spirits in a magic mirror given to him by the archangel Uriel. Kelly, known as the "Engelender," was appointed Imperial Counselor for his secret remedies that kept the emperor's hypochondria at bay. Kelly's knowledge of the black arts impressed the ruler, who had a salient dark side: among Rudolf II's vast collections included freaks of nature and odd *naturalia*, such as monkey brains in jars. Not surprisingly, Kelly bought the house of Faust, that most nefarious charlatan of all time. Located in the former cattle market, now Charles Square, the site was the premier venue for the black arts, and it teemed with seedy characters. Built around an eerie rock was a cross for illegal executions: the fallen bodies were thrown down a trapdoor into the netherworld, which housed a labyrinth of under-

ground torture tunnels. The legend of Faust, the sorcerer who flies over Prague on Mephistopheles transformed into a winged horse, inspired the Czech romantics and has become a part of every child's informal or formal education.[12]

Rudolfine Prague also included the Rabbi Jehuda Loew ben Bezalel and the golem legend, which still resonates with Jews and non-Jews alike. According to the folklore, this very erudite rabbi, who was not even a part of the cabalistic circle, created the wicked monster of clay that walked the streets of Prague, terrorizing the innocent. The golem became a character in Czech literature and puppet dramas, permeating Czech pan-cultural life and adding to the already haunting aura of the Jewish quarter and the Jews—the "other," segregated as they were at the time.[13]

Such macabre histories and stories, in their egregious bleakness, cannot help but weigh upon the psyche of all who inhabit Prague. Add to this a political history that has rendered the Czech lands a bloody war zone, leaving turmoil and change in its wake. For these reasons, the Czech persona understandably is commonly characterized as maudlin, pessimistic, and saturnine. A gray, wet climate and, under communism, black or charcoal-colored building facades add to the grim portrayal.[14]

As a counterpoint to this darkness, the urban planning of Prague, its splendid diversity of forms, its human scale, and the omnipresence of the river and the hills, envelop the individual with intimacy and rhythm. Paradoxically comforting and confining, the environment makes one feel both protected and nestled, or claustrophobic. Kafka, one of Prague's German literary luminaries, wrote in *The Trial* about the labyrinth of rooms, narrow corridors, closed quarters, noises, stench, and oppressive density. He himself lived in several picaresque locations in Prague, including his family's apartment next to Tyn church, where wafts of incense, as well as Christian services, filled the home. On his own he occupied a small place at #22 Golden Lane (which was alchemist row) in dark, boxlike, cramped quarters. Prague is a city where even the most mundane daily tasks are an adventure; crossing bridges, ascending and descending stairways and hills, and navigating narrow alleys and vast squares, where walls of tiny stones or solid masses flank the pedestrian and where pavements are uneven and in places unstable. Pat-

tern and texture abound: giant mosaics are created by expanses of terra-cotta rooftops, and rough-hewn stone complements smooth-painted architectural surfaces. The softness of flowers, leaves and lawn, and public gardens combine with these buildings in one organic whole.

Despite the fact that Prague is architecturally encyclopedic in domestic constructions, churches, and palaces, it is the baroque that gives the city its overall character. The seventeenth and eighteenth centuries saw extensive building and the redesign of earlier facades. Later, Art Nouveau, cubist, and Art Deco architecture continued the undulating and sculptural nature of the built environment. Inside and out, Prague is a pulsating city, full of curves, spirals, and rhythmic ornamentation, often in the form of repetition of a single motif. Baroque and neobaroque details are ubiquitous and form an active design vocabulary: chevron patterns of carved wooden entry doors, snail-like finials in and on churches, and spiraling columns, volutes, and domes adorn public and religious buildings. Not unlike Borromini and Bernini's Rome, the heart of Prague beats in an undulating wavelike motion.

This same type of dynamic, sinuous baroque form is prevalent in Zemánková's oeuvre (fig. 79), usually in the form of stylized botanical compositions but also in abstractions (see figs. 73, 74). Curvilinear and lyrical, these artworks curl and unfurl in a single repetitive rhythm. Zemánková's constant interest in the spiral[15] motif, which here is incorporated into a plant's tendrils, is hypnotically reminiscent of sound, the kind Angelo Maria Ripellino heard when walking on Nerudova Street in the Mala Strana, describing its "sedative-like musicality."[16]

Evocative of rhythm, sound, and melody, the art of Anna Zemánková is, in a few rare instances, literally about music (fig. 80). In this drawing of a giant treble clef set into a dreamy background, the intuited becomes overt. Another drawing[17] depicts bars of music incorporated into a larger floral and abstract design, almost disguised, in an Escher-like manner in which the viewer's perception of positive and negative determines what is seen. One familiar with the Zemánková mythology is preconditioned to hear Mozart in her work, but that would be limiting. Although it is true that the artist enjoyed classical music— she listened to it on the radio as she created her art-

work—she preferred "strong" musical pieces, and her favorite composers were Beethoven, Bach, and Dvořák. Not surprisingly, she also liked jazz, particularly Charles Lloyd. Zemánková was certainly unfamiliar with Kandinsky's theories of "painting music" or with her compatriot Kupka's theosophical harmonic artwork, in which color harmonies and overlapped shapes follow musical progression. Still, much of her work, like that of modern artists such as Paul Klee, has these same qualities.[18]

The third phase of Anna Zemánková's prodigious oeuvre is the "textile/bricolage"[19] mixed-media works. Dating from the early 1970s, they are astoundingly unique, combining pastel crayon, passementerie collages, needlework, crochet, and macramé (fig. 81). At first glance they appear to be ebullient creations from the 1970s Fiber

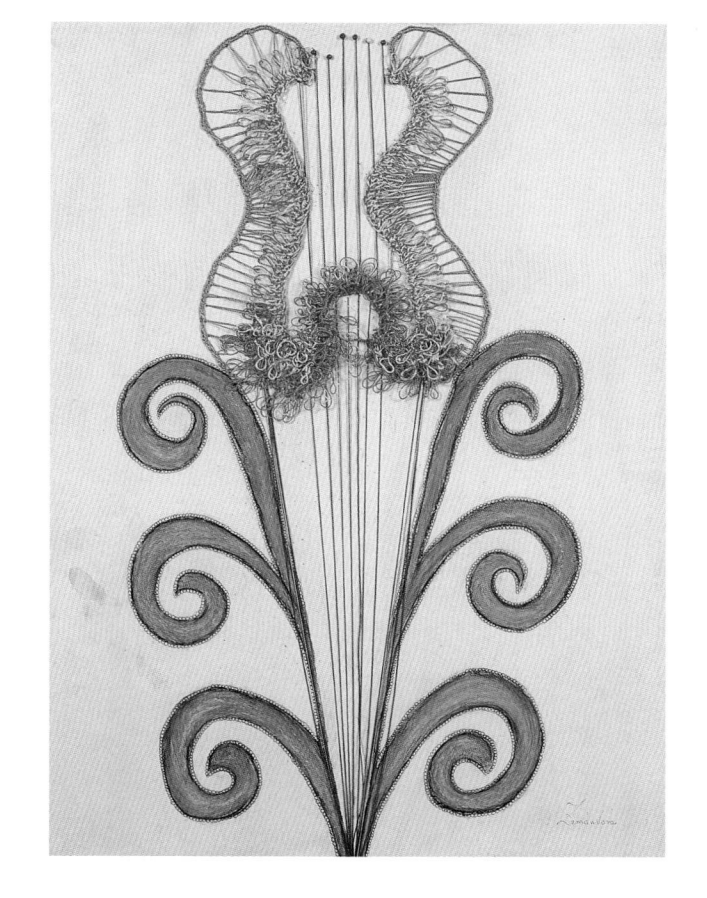

79

Anna Zemánková, *Untitled* (detail), 1970s
Silk thread, oil pastel, and mixed-media on paper,
overall dimensions: 34 3/4 x 24 1/4 in. (88.3 x 61.6 cm)
Zemánková Family Archives, Prague

Art movement, but they were made in ignorance of the outside art world. These exuberant artworks have more to do with the traditional Moravian textiles and costumes the artist grew up with, and with the furnishings and dress fabrics that surrounded her adult life, rich as they were in color, vaguely Viennese patterns, and surface ornamentation.[20] They represent the most fascinating intersection of her personal and artistic lives. To decorate her Prague home, Zemánková made embroidered lampshades and pillow cushions.[21]

She was a doting grandmother, and for her grandchildren she made lots of offbeat presents. For her granddaughter Terezie, she crocheted hats and purses of brightly colored synthetic straw, which would seem quite

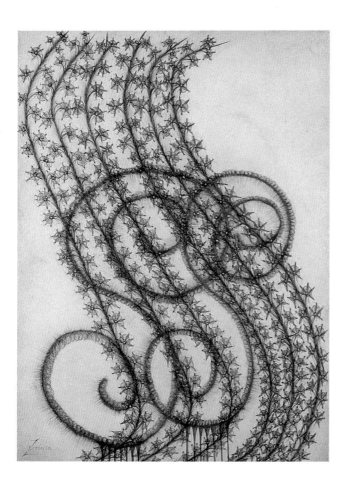

strange to a little girl.[22] Moravian schoolgirls of Zemánková's generation received an incredibly extensive education in the needle arts, from knotting to lace techniques, and although Zemánková had no interest in such things during most of her adult life, the advent of her grandchildren ignited her interest in domestic textile arts.[23]

In these textile/bricolage works we can see the *art brut*, or outsider artist, tendency to construct art literally out of materials at hand. Instinctively, Zemánková gathered thread, beads, and cloth to use with store-bought art supplies. In a display of items associated with sewing and so-called woman's work, it is interesting to look at them in a group with those of other female outsider artists who use various types of textiles in their oeuvres. The art of Madge Gill of England and Jeanne Tripier of France, along with that of Judith Scott of the United States, share a gutsy expressionistic quality that challenges our notion of sweet, dainty doilies or perfectly knitted sweaters as the highest level of achievement of woman's needlework.[24]

Zemánková's textile/bricolage artworks are the most graphic examples of the yin-yang nature of her oeuvre, because they are at once both flat drawing and sculptural textile work, because they are sublime and sinister, and because they are her most feminine and her most masculine. In figure 81 the loose, gestural drawing style of the golden leaves is the antithesis of the exacting tedious stitching and beadwork of the floral blossom. Well designed and masterfully crafted, this specific example is perhaps the artist's finest textile/bricolage creation. Its sophistication surpasses that of most examples of textile art by other outsiders or mainstream fiber artists.

Beyond these three major phases of Anna Zemánková's artwork are anomalies. The black and white miniatures she made just before her death in 1986 were crude but befitting elegies. Her early experiments with materials and techniques, such as adding cooking oil to her paintings, which resulted in a strange viscous golden-brown patina, are another. Without a doubt, the most exceptional of all is the wood square and twine room divider she invented around 1970 to separate her kitchen from the dining area of her home (fig. 82). Sometimes not even paper was available in the art supply shop; one time the only paintable surfaces for sale were pieces of plywood.

80

Anna Zemánková, *Untitled*, c. 1970
Oil pastel on paper, 24 3/4 x 17 3/4 in. (62.9 x 45.1 cm)
Private collection, New York

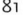

81

Anna Zemánková, *Untitled*, 1970s
Oil pastel, silk thread, and mixed-media on paper
34 3/4 x 24 1/4 in. (88.3 x 61.6 cm)
Museum of International Folk Art, a unit of the Museum of New Mexico
International Folk Art Foundation Purchase

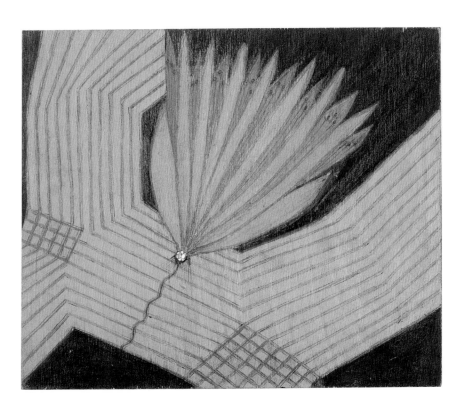

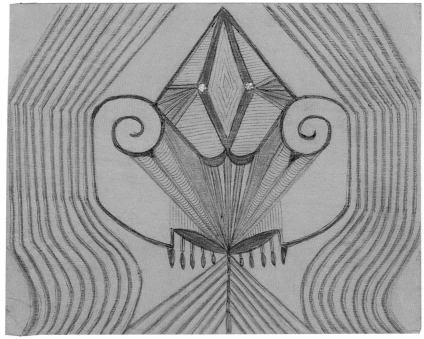

82

Anna Zemánková, *The Wall* (details), c. 1970
Tempera and mixed-media on plywood, each 6 x 7 in. (15 x 18 cm)
Zemánková Family Archives, Prague

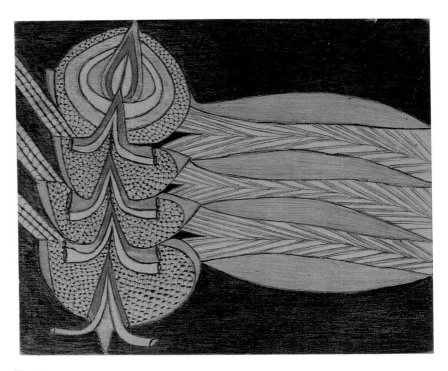

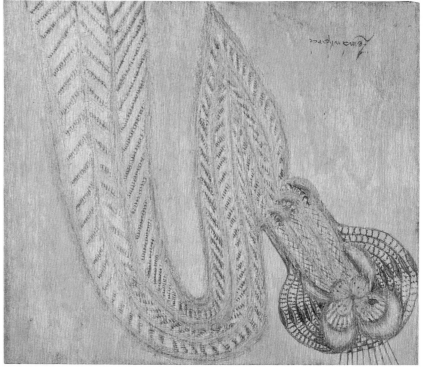

Zemánková immediately saw in the ordinary wood squares an entire "wall," as she described it, and enthusiastically began to paint each one. Individually and collectively, these small paintings display superb patterns. Combining both the geometric and rational as well as the organic and emotional, these compositions are arresting in the dynamic—overlapped, overlaid, receding, projecting—organization of the motifs, and radiating energy of the lines. They are not unlike the best of Viennese design circa 1900, the fabrics of Hoffmann and Moser, or the erotic sensuality of Klimt's stylized female forms in their use of the checkerboard and plant forms, and the predominance of black.

Not as small as the miniatures Zemánková made over a twenty-year period, the biomorphic abstractions of the wooden squares are the most jewel-like patterns of her oeuvre. More detailed, more complex, and more delicately embellished than most "minis," the wooden squares attest to Zemánková's extraordinary skill at rendering the minute monumental. There are no extant photographs of the "wall."[25] It must have enlivened the Zemánková home, providing a sense of both winter garden and artsy decor.

The art of this visionary, created under mysterious circumstances, for the sheer joy of the act, must be taken seriously nonetheless. Making sublime and sinister drawings, crochet, collage, and interior furnishings without parallel, Anna Veselá Zemánková was an exceptional artist. Prodigious and dexterous, self-taught and self-aware, otherworldly and of the world, her oeuvre belongs to the history of the best art.

Notes

1 Information from conversations with various members of the Zemánková family, June 2001.

2 From the earliest Czech publications to the most recent French texts about the art of Zemánková, she has been described as having a variety of mental disorders, being a medium, and possessing supernatural powers. Arsén Pohribny has written, most recently in *Oinirické vize Anny Zemánková*, that Anna Zemánková told him about two distinct paranormal experiences in a 1964 interview. First, she had the ability to descend into her inner organs, and second, through "transpersonality" she

once became a plant herself. According to family members, both accounts are fictional. *Oinirické, vize Anny Zemánková*, exh. cat. (Olmouc: Muzeum umení Olmouc, 1999).

3 Anna Zemánková was overweight most of her adult life, and at midlife she was particularly obese. She developed diabetes, and her bad temper possibly was caused by insulin imbalances, perhaps exacerbated by the onset of menopause. This hypothesis has yet to be confirmed, even by Anna's physician son. Other than the theory that a physiological illness spurred Zemánková to produce her extraordinary artwork, it is also possible that, as with many self-taught artists, Anna received a calling for reasons for which a rational explanation does not exist.

4 Information from Zemánková family members.

5 These early paintings did not hint at any special talent. For two color reproductions of these landscapes see *Oinirické*, 11.

6 Various family members provided dates from 1960 to 1966. However, Zemánková had an open-house exhibition, common in Prague under communism, at the Gate Theater in 1964, for which a printed invitation exists in the family archives. This indicates she began making art that year or earlier.

7 I am grateful to Dr. Alena Nádvornková and Terezie Zemánková for arranging this visit, and to Dr. Bařina, director of Nová Paka, for his kind hospitality. There is a growing interest and study of mediumistic art in this country and in Europe as manifested in recent exhibitions and publications. For more information consult *Art spirite médiumique et visionaire: Messages d'outre monde*, exh. cat., Halle Saint Pierre (Paris: Hoëbeke, 1999), and *The Spiritual in Art, Abstract Painting 1890–1985*, exh. cat. (New York: Abbeville Press and the Los Angeles County Museum of Art, 1986); with specific regard to Outsider Art, see Roger Cardinal, "The Art of Entrancement: European Mediumistic Art in the Outsider Domain," *Raw Vision*, no. 2 (Winter 1989–1990): 22–31.

8 Sadly, there are no publications of the mediumistic drawings at Nová Paka museum at this time. For a color reproduction of Jan Tóna's "Cherry Tree" see *Tschechischer Surrealismus und Art Brut zum Ende des Jahrtausends*, exh. cat. (Vienna: Palais Palffy, 2000), 40, and for a brief biography of Tóna see *L'art brut tchèque* (Paris: Halle Saint Pierre, 2002), 92.

9 In this second phase of her work, Zemánková's drawings are on 12 x 8 in. water color/pastel paper, which has a slightly bumpy surface, making tiny delicate markings particularly challenging.

10 Family interviews, June 2001.

11 Angelo Maria Ripellino, *Magic Prague* (London: Picador, 1995), 88.

12 Ibid., pt. 1, 1–151.

13 The best source of information in English is Madge Pemberton's translation of Gustav Meyrink's *The Golem* (New York: Dover Publications), 1976.

14 The original pastel colored facades of the eighteenth-century building facades were black and grimy by the mid twentieth century. It was not until after 1989 that they were restored to their original splendor. Some of these in the Mala Strana and on Kampa Island, subject to yet another flooding of the Vltava in spring 2002, were seriously damaged.

15 In the family archives are several other drawings in which the spiral dom-

inates. In one of these, two delicate spiraling lines are the only markings on the paper.

16 Ibid., 163.

17 Aze 76. This is the inventory number of the work, a part of the estate of the artist, held by Cavin-Morris Gallery, New York. I must express my deepest gratitude to Shari Cavin, who first introduced me to the greater depths of Anna Zemánková's oeuvre and who facilitated most of the research carried out for this article. I have benefited greatly from our conversations over the past few years.

18 Information from family members, who also noted that the artist often listened to talk radio. Much of Zemánková's drawings are imbued with a spiritual musicality, for example, her use of overlapping transparent circles and the egg form. Artists working in the greater Spiritualist traditions have made similar compositions. See Maurice Tuchman, "Hidden Meaning in Abstract Art," in *The Spiritual in Art*, 47–61.

19 This name was coined in an email conversation between Terezie Zemánková and the author in May 2002.

20 The needlework and lace patterns of Moravian regional dress are among the most elaborate and beautiful of all folk costume. The embroidery is known for its exquisite naturalism, with depictions of flowers and woodland fruits having a particular charm. The bobbin laces of the region, on dress or furnishings, are made with meandering loops. Regional dress is decorated with needlework in a wide array of colors, from pale pastels to deep, warm hues, and with motifs that are filled with several different colors and shades. For more information on the textiles and dress of Moravia see, Antonín Václavík and Jaroslav Orel, *Textile Folk Art* (London: Spring Books, n.d.). Regional dress influenced high fashion and antifashion in the Czech lands, much as peasant styles influenced the fabrics and fashions of the Wiener Werkstaette. See Eva Uchalová's *Czech Fashion 1870–1918, from the Waltz to the Tango* and *Czech Fashion 1918–1939: Elegance of the Czechoslovak First Republic*, both published by Olympia in cooperation with the Museum of Decorative Arts, Prague (Prague, n.d.). The relationship between Viennese decorative art traditions and those of Bohemia is well known. See, for example, *Art Deco Boemia 1918–1938*, exh. cat. (Milan: Electa, 1996).

21 For a black and white illustration of one of these lampshades, taken with the artist in her home, see *paní Zemánková*, exh. cat. (Chebu: Galerie vytvarného umění v Chebu, 1990), 2.

22 Conversation with Terezie Zemánková, June 2001.

23 A review of pattern books of Moravian and Bohemian schoolgirls from 1900 to 1935 revealed a larger repertory of needle arts than in other continental European countries. Much gratitude is extended to Eva Uchlová, curator of textiles, and Kostantina Hlavackova, curator of twentieth-century costume and textiles, Museum of Decorative Arts, Prague, for allowing me to study the museum's extensive holdings of embroidery and books.

24 Geneviève Roulin, late curator of the Collection de l'Art Brut, Lausanne, wanted to do an exhibition of textile work. It is now the idea of Terezie Zemánková to initiate an expanded version of her project.

25 The "wall" was installed at the Olomouc exhibition in 1999, and it will be installed in the Vernacular Visionaries exhibition.

Carlo
Beyond "Polenta and Bones"

Caterina Gemma Brenzoni

To retrace Carlo Zinelli's artistic journey is an opportunity to open our minds and let ourselves be drawn—enchanted—into another world. In this world the artist's choice of visual elements is unclear, as is his message—yet we can grasp their artistic relevance and the spontaneity of his expressive search. We can, in fact, assert that Carlo—as he is generally known—was an artist in every sense of the word, in spite of his diagnosed mental illness. We must also consider his role within *art brut* but not confuse him with this movement. Carlo Zinelli had no known pictorial training before he was committed to a psychiatric hospital and thus virtually isolated from the outside world. His works appear to us as a revelation: the first sign of a feverish and visionary creativity and the expression of a cryptic world of recurring symbolic marks. It is also the expression of a highly personal, poetic universe free of the influence of contemporary or past artistic movements.

As the French artist Jean Dubuffet said, one must believe that artistic potential exists in every individual, albeit often in a dormant state. Other than Carlo, there are numerous cases of individuals with no formal artistic education yet in whom a creative process ignites, apparently spontaneously, and feeds on an extraordinarily rich artistic production. One can guess that Carlo's artistic ability was stimulated by his illness and by his particular way of tapping into the deep layers of the unconscious, revealing the imbedded information through a complex vocabulary of figures and symbolic marks and using a rich, varied palette. His are images that strike a visceral chord: even if many symbols recur literally hundreds of times in his art, they are forever combined in different, ordered ways, as though to indicate a hidden code or rhythmic vocabulary. It is fair to ask, however, why should we persist in trying to interpret these beautiful works? Surely, Carlo's art speaks of his direct experience, of his life in the country, and of the Second World War. I will examine his history and his illness and interpret his words via analysis of his works, because every madman who grunts is the oracle of Delphi who speaks and yet doesn't speak. But in the end, beyond human and psychological experience, Carlo will elude any clear explanation because he belongs to art and to the history of art.

PREVIOUS PAGES
Carlo
Untitled (detail), 1957–58
(see fig. 83)

Carlo Zinelli was born in Italy July 2, 1916, in San Giovanni Lupatoto, near Verona. His father, Alessandro, was a woodworker, and his mother, Caterina Manzini, was a housewife who died in 1918 after bearing seven children. Carlo, the sixth child, went to school until third grade, and then at age nine he went to work as a farmhand for a family in a nearby town, returning home occasionally for holidays and other visits. His playmates were a friend named Silvio and a small dog whose death would affect him deeply. In 1934, at eighteen, Carlo left the country — perhaps regretfully — for Verona, where he worked in the municipal slaughterhouse. During this period we know of his interest in music and the episode, as recounted by his younger sister, in which he decorated the family's kitchen walls with a theme of flowering branches and birds. He painted along the perimeter of the room with the *battitura del filo* technique, in which stiff pieces of wire dipped in paint are used to strike at a wall, leaving a graphic image. Although he finished his obligatory military service in 1936, two years later he was recalled to the eleventh regiment of the Trento alpine battalion.

The following March, under circumstances that are still unclear, he volunteered (perhaps as a stretcher-bearer) for the Spanish civil war. There his schizophrenic personality completely revealed itself, and after only two months he was sent home and placed on medical leave until June 1941, at which time he was admitted to a military hospital and declared unfit for service. From 1941 to 1947 Carlo was hospitalized periodically following episodes of antisocial, incommunicative, and aggressive behavior. In April 1947 he was definitively committed to the San Giacomo alla Tomba psychiatric hospital in Verona with a diagnosis of paranoid schizophrenia. After ten uneventful years spent in near-total isolation, Carlo was admitted, along with some twenty other patients, to the painting atelier created by the Scottish sculptor Michael Noble and by Mario Marini, a physician-psychiatrist, who were later joined by the sculptor Pino Castagna. Their atelier was to become one of the most important of its kind in Europe, where psychiatric patients could freely paint or sculpt without any interference with their expressive choices. Carlo used tempera paints and colored pen-

cils and often worked for eight hours a day, a routine that made him calmer and more manageable.

In 1964, after his works had been exhibited outside the atelier and had achieved a certain notoriety, Carlo came under the care of Vittorino Andreoli, a young psychiatrist, and the hospital's director, Cherubino Trabucchi. By this time he also had attracted the attention of art historian Arturo Pasa, who collaborated on the first monographic study of the artist for the publications of the Compagnie de l'Art Brut. From 1969, when he was transferred to the psychiatric hospital's new location in Marzana, near Verona, until his death from pneumonia on January 27, 1974, Carlo painted much more infrequently, perhaps because he was disoriented by the move and deprived of the special atmosphere of the San Giacomo atelier.[1]

Carlo chose to convey his life experience through painting, which functioned as the mouthpiece for his soul and his feelings. His is a spontaneous, true, and instinctive art that evokes both doubts and profound reflection. His oeuvre comprises roughly nineteen hundred paintings, of which seventeen hundred are catalogued and one hundred fifty are lost (fortunately, we have photographs), as well as a few sculptures.[2] This enormous body of work was created on simple white sheets (35 x 50 cm and, later, 50 x 70 cm or 70 x 50 cm) using various combinations of media: tempera paints, colored pencils, and collages with cigarette packages, candy wrappers, leaves, and flowers. At first he painted on only one side of the sheet, but later he used both. As early as 1957 the first figures appear on the backs of certain works; this trend becomes more frequent beginning in 1960 and ultimately is a constant feature from 1962 to 1968. These two-sided works should be seen as continuous from one side of the sheet to the other, almost a single narration without caesuras or linguistic leaps — a reading that is supported by the absence of margins or frames on the sides.[3] Carlo generally used pure colors, rather than mixed hues, to depict his subjects, and he added extra water to the pigment he used for his colored backgrounds. We also know that he was extremely possessive of his brushes and wore them down to the last hair.

We have no evidence that Carlo drew while in elementary school, but we do know that, during his youthful period in the city, he made small drawings on odd pieces

of paper and occasionally on postcards that he sent to his sisters. In his wallet, on the back of two photographs of young women—a fond description was written on each—were drawings of military emblems and a strange bird, both signed by Carlo and dated 1939.[4] In these few scraps of evidence, certain elements of what would become his expressive vocabulary are already present: the juxtaposition of figures and writing, figures repeated four times, and figure-silhouettes. There is also a photograph, from 1936, of a handsome young man in a pose that is both somewhat dandyish and bohemian. This contrived, rather theatrical image is hardly consistent with the idea we have of a poor, culturally isolated Carlo.[5] Carlo left to serve in the war—and went mad in order not to kill—soon after this photograph was taken.

Amid a general climate of interest in nonofficial and nonacademic art forms (Outsider Art), the 1940s saw art therapy emerge as a strategy for psychiatric rehabilitation in England and the United States, and it soon spread to many countries with important psychiatric and psychoanalytic traditions. Art therapy eludes precise categorization, yet it falls somewhere within the various innovative approaches to treating handicap and illness. Using the tools of art, it attempts to allow patients to paint spontaneously and work freely to express their creativity, without the need for any exhortation to activate memories, fantasies, or narrative plots. Italian psychiatry boasts a noble history in this area: the first such studies date to the second half of the nineteenth century and were conducted by the Veronese doctor Cesare Lombroso (in 1882 he published *Genio e follia* [Genius and Madness]), who also formed an important collection in Turin of works by mentally ill artists.

Opened in 1957, the atelier of the San Giacomo psychiatric hospital in Verona was one of the first centers for art therapy in Italy. Its success depended largely on the presence of the two prestigious artists mentioned earlier, the sculptors Michael Noble and Pino Castagna, whose efforts were supported by the psychiatrists Mario Marini and Cherubino Trabucchi. The center supplied sheets of white paper, colored pencils, graphite, and tempera paints; although the materials used by the artist-patients were rather minimal, everyone could freely choose among them without interference. The atelier thus had

a unique atmosphere, similar to that of a Renaissance workshop, which undoubtedly encouraged the participants to express themselves without the rigid controls so typical of psychiatric institutions at the time. In addition to the coordinators, San Giacomo had an exceptional nurse, Mario Mengali, loved by all for his ability to communicate with the patients.

Two years later a conference on psychopathic art was organized in Verona and featured various experts in this field. As part of this conference the organizers mounted a contemporaneous exhibition at the Galleria d'Arte Moderna and included works by Carlo and other atelier artists, as well as pieces by Gaston, Wölfli, Aloïse, and others. Additional exhibitions were organized in Verona and elsewhere in Italy and documented by such writers as Dino Buzzati and Alberto Moravia.[6]

Carlo, who had no artistic education but who possessed a manual dexterity (as demonstrated by episodes from his youth), began painting immediately when given paper and tempera, and he was effectively animated, or, rather, re-animated. The spontaneity of Carlo's expressive search calls for an artistic and technical analysis of his paintings, produced without interruption from 1957 to 1974, and an examination of the various stages of his activity, divided into four periods to clarify the developments, the constants, and the changes.

The chronological classification of Carlo's work is possible largely because of the atelier nurses' diligent practice of dating the majority of his sheets, although errors might have been introduced into this system, and many drawings were not dated.[7] Overall, however, these notations indicate that after a slow beginning Carlo painted frenetically, completing many works in the course of an eight-hour day. The apex of his production was in the 1960s, both qualitatively—from 1962 to 1965—and quantitatively, with an output that included some two hundred thirty paintings by 1967.

Carlo's first paintings date to 1956 and are mostly on paper, while two are on thin canvas mounted on cardboard. These early works contain many of the themes that recall his personal history and that will recur in the later paintings: figures of men and women, or of animals, painted with the tip of the brush and generally small in scale,

that seem to tell the story of his life in the country (fig. 83).
According to the sculptor Pino Castagna, in the years
from 1957 to 1959 Carlo also experimented with ceramic tiles,
of which no trace remains, and terra-cotta sculptures.

The paintings from 1957 to 1962 are filled with minis-
cule figures and objects in complex compositions that
frequently include writing. Sometimes his subjects are dis-
persed without apparent spatial organization, while other
times they are arranged in horizontal or vertical sequences,
or in an arch shape. It is important to remember that these
works are signed by Carlo, who was perfectly aware of
his artistic achievement. In these works, repetition and
stereotypy create a *bourrage*, or filling of the space, in which
increasingly stylized figures and objects are juxtaposed

83

Carlo, *Untitled*, 1957–58
Tempera on paper
13 3/4 x 27 1/2 in. (35 x 70 cm)
Collection de l'Art Brut, Lausanne, Switzerland

and superimposed, their transparence at times revealing the subjects underneath.

Carlo's works through the early 1960s, both small format (35 x 50 cm) and, later, somewhat larger (50 x 70 cm), are characterized by pale colors on a white background. He applied paint by using the brush as though it were a pencil, and also by a quasi pointillist technique. The larger figures are clearly outlined and filled with infinite tiny dots, laid down with the brush in myriad colors, resulting in a vibrating effect that suggests constant motion.

Briefly between 1959 and 1960 the delicate brushwork is particularly enriched with fields and squares of homogeneous color, and the personages become silhouettes; these seemingly immaterial figures are arranged one after the other in a vertical or horizontal sequence along a straight line. There are both human figures (such as Carlo's so-called woman-mask seen from the front) and objects (such as the boat), as well as animals, both real (insects, birds—perhaps blackbirds or pigeons—or dromedaries) and imaginary; in all of these works a sense of the grotesque prevails. At times the white, or sometimes colored, ground is nearly empty, while in other works it is again filled with a thick scattering of minor elements that form a backdrop to four distinct figures depicted in infinite variations. These paintings clearly focus on the central figure, with four other figures of men, women, or other subjects arranged around it: black figures against a white background, or colored figures on a white background filled with tiny images. During this period the quaternion prevails, with black shapes (men, women, objects) placed on either a white or a brightly colored homogeneous ground. Carlo's choice of background hues reveals an extraordinary eye for color, as he has progressed to an ampler and chromatically richer pictorial style than was evident in his earlier work. Larger, often hollow figures float in the middle of the sheet, surrounded by extremely stylized, neomorphic threadlike elements that Carlo referred to as the "matches," painted in bright, contrasting colors, and, beginning in 1960, as the "little priests." Round forms and empty squares are in an ongoing dialogue between full and empty, and at times colored rectangles become small paintings within a painting. These works do not include writing, and the production from these years is uneven (fig.

84). In this period Carlo's behavior, like his painting, was dominated by an obsession with the quaternion, as well as by a fixation with numerical repetition and mysterious rituals.[8]

Between 1960 and 1962, briefly and seemingly out of the blue (although hinted at in his youth) Carlo began making collages using cigarette packages, candy wrappers, daisies, and cotton swabs attached to the sheet with tempera paint. At times these objects form a part of the pictorial narrative, while at other times they alone fill the space. These collages seem to be an attempt to go beyond the limits of the tempera technique and to return to the time when Carlo gathered many "useless" objects, such as candy and cigarette wrappers, from hospital rooms and park areas, where he also filled his pockets with dead birds and insects, and with pieces of wood, leaves, and stones. The precarious state of conservation of these paintings is evident; many have gaps in which only small areas of color are now visible, the result of the loss of collaged elements (fig. 85).[9]

The next works are characterized by dense fields of colored spheres, either scattered or in ordered groups and arranged around one or more central figures. They also occur within the contours of human figures, animals, plants, or inanimate objects. These circles first appear within figures and then, as though scattered by an explosion, they are everywhere on the sheet, creating a whimsical effect. The pure color of the first period gives way to mixed hues; at times the gradations are delicate, while other works include two or more bright, sharply contrasting colors (fig. 86).

Beginning in 1964 the use of colored grounds returns, as does decorative writing, integrated with fewer figurative elements. The writing, in pencil and in both cursive script and block letters, now assumes an ornamental and aesthetic weight, while toward the end of 1965 numbers, letters, and words with autobiographical references (incorrectly spelled or in Veronese dialect) also appear. These are distributed either around the figures, following their outlines, or elsewhere on the sheet.

In approximately 1965 Carlo overcame the quaternion, and the figures now take on a more assertive role. Kneeling figures and crosses are placed here and there, and the representation of a recurring divinity becomes less fright-

84

Carlo, *Untitled*, 1964
Tempera on paper
27 1/2 x 19 3/4 in. (70 x 50 cm)
Fondazione Culturale Carlo Zinelli, Verona

ening. Even the colored ground takes on a more important formal role. Overlapping, deftly applied colored strips form the backdrop for geometric shapes such as squares and circles; these in turn are surrounded by narrative writing. With this vibrant palette, Carlo created elegant chromatic juxtapositions, at times sharply contrasting, yet always harmonious. The paintings of this period, between 1964 and 1967, are the strongest of his career (fig. 87).

Between 1966 and 1971 the white background again prevails, as do black figures organized around a larger, central figure. The number of subjects is now reduced: hieratic figures, the alpine soldier, the horse or mule, and the boat are often the protagonists, while startling imaginary figures persist (fig. 88).

85

Carlo, *Untitled*, c. 1962
Tempera and cigarette wrapper collage on paper
13 ³/₄ x 19 ⁵/₈ in. (35 x 50 cm)
Collection de l'Art Brut, Lausanne, Switzerland

The delicate brushwork with dryer colors carries the narration, while the writing penetrates the spaces and surrounds the figures, yet also becomes the absolute protagonist: certain works, in fact, are filled exclusively by continuous, painted script. The writing style ranges from miniscule characters to huge, almost unrecognizable letters in black or, at times, in a rich array of reds, greens, blues, yellows, oranges, and browns. Various words, often with repeated letters, again appear in both cursive script and block letters, sometimes accentuated by the brushwork (fig. 89). At times, the sheets in which writing dominates are further embellished with asterisks that are formed with densely applied brush marks. Until 1967 the paintings are characterized by a strong emphasis on color. Beginning in

1968 there is a return to the dense bourrage. Large figures are circumscribed by dotted bands that form a kind of frame, with branches in the middle containing tiny figures shown seated or leaning on these frames (fig. 90). Even though the volume of his production diminished from 1969 on, until 1973 Carlo continued to explore the decorative aspects of color, which he laid down in homogeneous fields using delicate, densely applied pointillist marks. On the other hand, the organization of the various images slowly reverted to a horizontal, and somewhat listless, formula. As to technique, beginning in 1967, and more frequently from 1969, Carlo favored tempera and graphite; his final works mix tempera and wax crayon with black and colored pencil, which created a new, paler chromatic effect (fig. 91).

86

Carlo, *Untitled*, 1963–64
Tempera on paper
19 3/4 x 27 1/2 in. (50 x 70 cm)
Fondazione Culturale Carlo Zinelli, Verona

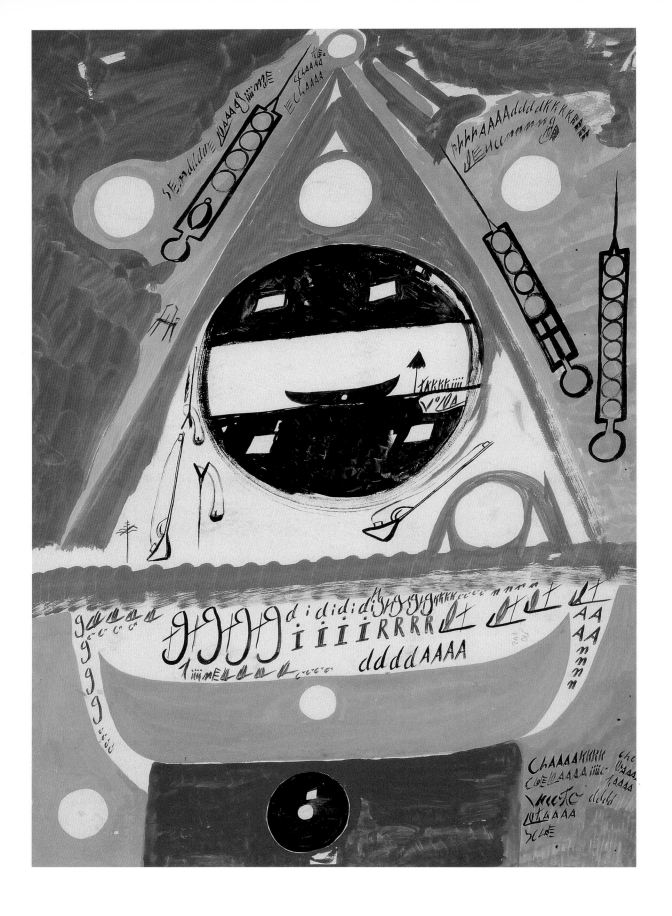

87

Carlo, *Untitled*, 14 September 1965
Tempera on paper
27 1/2 x 19 3/4 in. (70 x 50 cm)
Fondazione Culturale Carlo Zinelli, Verona

88

Carlo, *Untitled*, 1967
Tempera and graphite on paper
27 1/2 x 19 3/4 in. (70 x 50 cm)
Collection de l'Art Brut, Lausanne, Switzerland

89

Carlo, *Untitled*, 1968
Tempera on paper
27 1/2 x 19 3/4 in. (70 x 50 cm)
Private collection, Verona

90 (opposite)

Carlo, *Untitled*, 28 May 1968
Tempera and graphite on paper
27 1/2 x 19 3/4 in. (70 x 50 cm)
Williams Collection

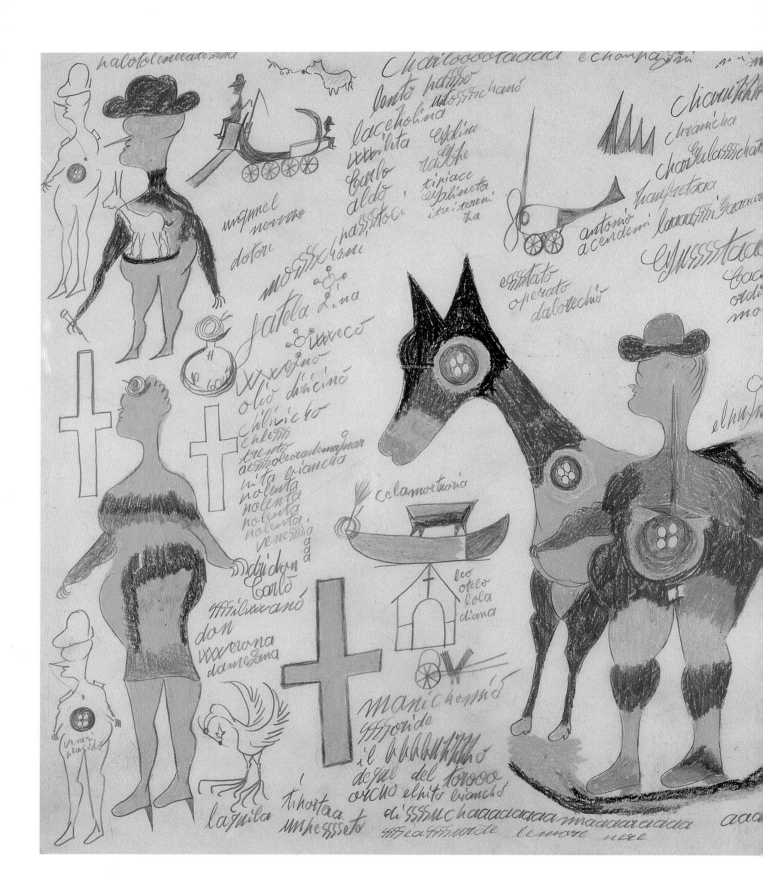

91

Carlo, *Untitled*, 20 February 1970
Wax crayon and graphite on paper
19 ³/₄ x 27 ¹/₂ in. (50 x 70 cm)
Fondazione Culturale Carlo Zinelli, Verona

What is the meaning of Carlo's art? One method for understanding his work is to consider it a language and to analyze it according to the criteria of content and form. It is clearly an enigmatic art, of which we can comprehend the constituent elements but not their overall meaning. The world it represents is constant, from the beginning to the end, even if new stylistic elements and neo-morphisms appear over time. The artist's attention to detail is always precise, and the outlines of the various images are clearly defined. For a certain period he progresses from a formidable number of subjects to just a few, until he arrives at the obsessive use of the quaternion.

Carlo's preferred subjects are, without doubt, animals: an infinite variety of birds, domestic animals, exotic species (serpents, crocodiles, giraffes, leopards, and the rare dromedary), goats, wild boars, porcupines, insects, and mice. Many of these creatures have been interpreted as having implicit sexual significance. Somewhat less frequent are representations of fruits and vegetables (apples, pears, carrots, figs, and cherries), and flowers and other plants. From his youth, Carlo exhibited a clearer sensitivity to nature than to his relationships with other people. His body of work constitutes a veritable bestiary and herbarium, with imaginary creations such as star-shaped fish and cats, perforated horses and donkeys, animals with long hair, and wildly concocted plants and flowers.

In addition, Carlo painted a multiplicity of everyday objects: shoes, bags, hats, eye-glasses, pipes, bowls, beds, tables, chairs, stools, ladders, and boats. More than any other object in the second period, boats become the protagonists in paintings that depict four of them against a colored ground. Bundles of hay, carts, plows, and pitch-forks refer to his life in the country, while the numerous crosses and pickaxes are linked to his terrible memories of the war. Mechanical objects also appear frequently; among these are rifles, tanks, airplanes, propellers, trains, bicycles, wheels, pointed objects, knives, keys, matches, and syringes.

The human figures—men, women, and children—are always in motion, delineated as solid shapes and generally drawn in profile but in rare instances frontally; in these cases the figures become monstrous masks (woman-mask), at times deformed with one or two long noses (called "pinocchio"), huge noses, heads with horns, large heads or abnormal bellies, wings, or three legs. A number of female figures, or "ballerinas," recall Carlo's youth, when he was a passionate dancer and music enthusiast. There are also figures reclining on beds or tables, seated solemnly on thrones, or kneeling in adoration. Stylized phallic symbols are also depicted. Far from static, these works give the impression of constant motion and of a deep restlessness.

We can distinguish the neomorphic "matches," interpreted as human figures that walk or lean against a chair, and the "little priests," interpreted as butcher's hooks, perhaps expressing an obsession with sex or a fear of blood and transformed into men. The men, or little priests, are arranged in a row and seem to be engaged in a solemn procession. We must also consider Carlo's use of numbers—at first many—and then the quaternion: four people, four boats.[10] And, finally, there are the words with autobiographical references (misspelled or in dialect), penned in cursive script or block letters, with letters that are repeated as many as four times. These words and phrases are the same as those that Carlo muttered and repeated like a prayer while painting: "end of the world," "bread rolls," "money," "box of matches," "polenta and bones," "it will become more beautiful," "*pater nostro*," and others that are clearly connected to his past, but also to the present and to where he lived. These formal components are essential to the understanding of the expressive and effective weight of the message, as well as the author's intentions and choices. At times there are compositional schemes: the vertical or horizontal scansion of the forms, or the repeated use of two large, inverted figures engaged in a spectacular duet. The surprising stylization of the figures perhaps reflects the influence of the Giacomettian Noble; the Scottish sculptor adored Alberto Giacometti's work and owned two sculptures that may have captured Carlo's imagination.

Combinations of geometric figures appear frequently, as do geometric-linear drawings, decorative compositions, and magical or allegorical representations. The paper is completely filled with motifs in *horror vacuii* fashion. The repetition of images creates a ritualistic atmosphere, an instinctive, playful toying with order, decoration, imitation, symbolism.

Carlo has been labeled a brilliant draftsman.[11] His paintings convey a general flatness; a sense of volume and perspective foreshortening are absent. Two-dimensional forms are negated in the three-dimensionality of circles or stars that create internal vacuums. These synthetic forms seem to be lit from behind—thousands of figures that empty the space rather than fill it. These are surreal apparitions. The broad theme of sexuality has been read into many figures and scenes, but it is not the predominant or exclusive theme.

We generally no longer accept the premise that these works can be critically judged on the basis of personality and certain traits of the unconscious that can be deduced from the artist's biography, even though in Carlo's work many of the recurring parameters of schizophrenic painting are certainly present: *perseveration*, or the frequent and repetitive appearance of drawings, symbols, and identical themes; *bourrage*, or drawings or sketches without a prefigured order and whose aim is to fill the sheet without leaving any empty space, perhaps as a defense against *horror vacuii*; asymmetry, or mirror imagery, the exasperated search for symmetries or, rather, the will to repeat them; *pseudo-occult symbology*, the presence of religious, magic, sexual, and political emblems, applied with a precise logic to various personages. Carlo's art expresses a great dynamism that contrasts sharply with his apparent shutting down and lack of drives. It is both art and madness, deviance and its sublimation, contradiction and social revolt —and all expressed in a private delirium.

Carlo's work is an inexhaustible source of surprises that occur within a coherent and singular language. Thus, the division of his production into four periods is strictly a research tool. Within his corpus, there are no deliberate copies of images, even though his subjects are recurrent and many of the same figures and objects are recognizable in many works. As previously observed, Carlo's paintings do not exhibit signs of hesitation or second thoughts; rather, they form a kind of epic tale, which develops around certain themes in order to seek and discover possible solutions and meanings. His work progresses from a disordered approach to a complex and ordered mode that mixes figures with writing to achieve equilibrium. The pictorial narrative passes from one side of the sheet to

the other. Only the chromatic choices vary, becoming at times intensely vibrant and harmonic.

Carlo's paintings evoke cave paintings, or frescoes from ancient Mediterranean civilizations whose populations migrated from one region to another yet left visual evidence of their story. Like these illustrious archetypes, the stories narrated by Carlo are many, and they extend to a world beyond the borders of the paper, beyond the madhouse, where the protagonists travel in infinite tales. Modern culture, which has so readily embraced "primitive art," African art, and Asian art (especially Japanese), is particularly primed to acknowledge and embrace Carlo's work. His paintings resemble those of the past, when painting and writing were integrated, visible-legible like an illuminated manuscript. Paradoxically, Carlo is author of a kind of modern illuminated page. His themes and recurrent figures oscillate between the distant past, represented by his life in the country; the more recent past, represented by his war experience; and the present, represented by hospital life. Carlo develops these themes according to varied compositional structures, which are occasionally juxtaposed in an antithetical fashion, almost like an alphabet that is organized according to a personal grammar. It has already been suggested that Carlo's personal language is analogous to a poetic and musical language, in which the distinct compositional structures reflect certain styles of singing or musical accompaniment and can, in any case, be read as expressive richness.[12]

It is difficult to establish a relationship between his states of mind and the forms and colors he used, even if his toying with the gestural modulation of forms, the intensity of colors, and the more or less percussive compositional rhythms may be seen as a narrative, at times happy and sweet, at other times the tragic tale of a man who has suffered.[13] In Carlo, however, the struggle between health and illness is not evident, as it is so clearly in one of the most important documents of nineteenth-century humanity, the correspondence between the van Gogh brothers. Does creativity annul the absurd boundary between the healthy and the sick?

A fundamental challenge for humans is to communicate, to have the spoken word. The person who cannot meet this challenge is exiled to a figurative ghetto. Con-

sequently, a silent and reserved means of expression, such as painting, can take hold in people who are otherwise unable to express themselves, to communicate their identity. With this in mind, it would be interesting to discover if Carlo painted a self-portrait among his many strange figures, as this would signify a first step toward self-recognition. He did include his signature on many paintings, and on one work he featured it against a vivid, purple background (fig. 92).

There is always a distance between the viewer and Carlo's works, even if his images communicate, tell stories, elicit emotions, and induce us to try to identify with him and to understand why his subjectivity is never solipsistic, but rather transcendental. One's life experiences are in reality part of a universal pool of a common and fundamental constitution that is expressed differently in every individual, yet at the same time possesses a specific regularity that allows us in some way to enter into contact with the artist.[14] However, we must try to read, and thus understand, Carlo's writing. His is a musical writing, with a formal structure, that expresses fragments of poetry and poetic phrases, prayers, rhymes in dialect, and popular sayings. Sometimes the paintings consist only of variously combined written words, while in other cases they feature a vortex of words that seem to scream out. The linguistic expression resembles that of the forms, almost like that used in baroque lyric poetry or by the futurist poets. We must not think, however, that Carlo didn't want to communicate with words; rather, there was a kind of block between the word and his vocal expression, a scission between a phantasmagoric life and reality, and the images and color somehow filled this chasm. As stressed earlier, for Carlo art represented a sort of catharsis and salvation, an oasis for he who found himself in the desert.[15] We want to believe this, for it would also mean that Carlo was happier because of the art therapy.

We know that at times Carlo declaimed with a resonant voice in an incomprehensible language of his own and jabbered to himself and to mysterious companions.[16] On rare occasions he formed complete sentences, of which the most famous remains his reply to a journalist who, while visiting an exhibition, asked him the meaning of his work: "Se non sei cretino, guarda" (If you're not an idiot, look).[17] We ask ourselves what Carlo saw in his isolated environment and if his surroundings interested him. Some say that the wall that had risen around him broke down at times, but it is difficult to establish whether, when faced with past and present modes of artistic expression, he was in some way aware of these, and aware of being part of a collective history made up of figurative references and technical knowledge.

We can, in any case, define his search as a solitary one, one that was also an exploration of technique as expressed in his calculated and, within the first year, masterful mixing of colors to produce new hues and tonalities. The schizophrenic rupture of the codes of communication and the consequent distortion and disassociation from the surrounding world, from oneself, and from one's own physical being: to what does this lead? What power do human creativity and expression hold? Does illness perhaps allow artistic genius to emerge? Are art and creative experience capable of activating generative processes, even in the most serious forms of psychosis?[18]

Carlo emerged as a dominant personality within the San Giacomo atelier, and the young psychiatrist Vittorino Andreoli introduced him to Jean Dubuffet in 1963. Following this meeting, and despite initial reservations, his work became part of the collection of the Compagnie de l'Art Brut, leaving behind his relative anonymity, and in 1966 an issue of the *Cahiers* was devoted to Carlo. I will not attempt to cover the history of art brut here, but a brief aside is necessary to understand Carlo's place within its context. Both the first monograph about the work of a mentally ill artist, *Ein Geisteskranken als Künstler: Adolf Wölfli*, published in 1921 by the physician Walter Morgenthaler (1882–1965), and the revolutionary 1922 work *Bildnerei der Geisteskranken* by Hans Prinzhorn (1886–1933), acknowledge the artistic production of mentally ill patients and thus inaugurate the period in which such works became more widely known and were viewed without prejudice. Prinzhorn's work influenced the Dada artists, the surrealists, and the followers of the Bauhaus, including such artists as Max Ernst and Paul Klee, who considered the art of the mentally ill an important source of inspiration. But it was Jean Dubuffet (1901–1985) who systematically disassociated the art of the "crazy" from any

92

Carlo, *Untitled*, 1963
Tempera and blue ink on paper
27 1/2 x 19 3/4 in. (70 x 50 cm)
Collection de l'Art Brut, Lausanne, Switzerland

psychopathological consideration and who made the public aware of the aesthetic and intellectual richness of this work. In 1947 Dubuffet, along with André Breton, Michel Tapiè, and others, founded the Compagnie de l'Art Brut. The collection that Dubuffet and the Compagnie formed beginning in 1945, and that was later transferred from Paris to Lausanne in 1976, continues to be the object of study and research, with new works added despite a constant oscillation, shared by Dubuffet, between a desire for independence, indifference, and opposition to official recognition. Even if art brut remains tied to the specificity of its inventor in a precise moment in time, the bet is still on.[19] In 1949 Dubuffet gave the art of madmen, also known as "degenerate art," the name *art brut* to distinguish it from *art culturel*, thereby isolating the art of the psychically disturbed and seeking out an art free of any social compromise. Carlo and other artists stand apart from the history of painting; this separateness has to do with the mental institution and its lack of awareness. The isolation of the "outsider" is both physical and historic. Art brut is a bridge between separate realities.

Much has been written about the opportunity to consider the art and artistic productivity of the mentally ill as an expression of the illness, in order to arrive at a definition of psychopathological art. Today, however, but also as early as 1907 with the pioneering essay *L'art chez les fous* by Marcel Réja (pseudonym of Dr. Paul Meunier), critical thinking rejects this definition and excludes the possibility that schizophrenic art exists. One can, rather, speak of an "irregular" art, born outside the usual currents and channels, yet studied by psychiatrists, appreciated by art historians and collectors, esteemed by the market, and worthy of our profound respect. Carlo, like Wölfli and Alöise, was affected by psychic disturbances, and their respective work was fed by an interior universe that tormented and suppressed them but also rendered them capable of positive feelings and perhaps made them happy. The ability to express the reality they perceived cannot always be seen as artistic quality, yet the art produced by Carlo during an eighteen-year period is engaged in both the psychic dimension and the aesthetic—after all, he demonstrated a remarkable talent in a situation that is clearly psychotic.

What strikes a chord and transports us to a high aesthetic plane are the refined chromatic combinations of tempera, diluted and laid down with decisive strokes in the backgrounds of his paintings. This brilliant pictorial sense, charged with meaning, brings him close to the generally recognized mainstream abstract art. We must also acknowledge the extraordinary richness of his narrative and distinguish it from that of other artists, without trying to interpret or give forced psychoanalytic explanations to the images. There is general agreement today that the art brut phase was fundamental to Carlo's public recognition and insertion in the *non culturel* movement, but now he belongs to history.[20]

The infinite questions raised by Carlo's paintings are ultimately replaced by an implicit spell. We, the viewers, are kept at a distance and have no other choice than to allow ourselves to be transported by Carlo the artist, and to share an affirmation by Dubuffet: "True art is always there, where you least expect it . . . it is what gives us back the exact, total truth about things," and it is, finally, a road to insight and knowledge, a way to learn the truth.[21]

Notes

This essay was translated by Ceil Friedman. I wish to thank the Fondazione Culturale Carlo Zinelli and its president, Alessandro Zinelli, for facilitating my research.

1 V. Andreoli, *Les dernières années de Carlo* (Lausanne: Publications de la Collection de l'Art Brut, fasc.11, 1982), 77.

2 The fundamental job of inventorying and cataloguing was carried out over several years for the exhibition *Carlo. Tempere, collages, sculpture 1957–1974*, curated by Sergio Marinelli and Flavia Pesci and organized in 1992 at the Museo di Castelvecchio in Verona, and for the exhibition catalogue *Carlo Zinelli. Catalogo generale* (Venice: Marsilio, 2000), by V. Andreoli, S. Marinelli, and F. Pesci.

3 F. Pesci, "Carlo Pittore. Questioni tecniche e stilistiche," in *Catalogo generale*, xl; M. A. Azzola Inaudi, "Carlo e la musica del linguaggio," in B. Tosatti, *Figure dell'anima. Arte irregolare in Europa*, exh. cat. (Milan: Edizioni Gabriele Mazzotta, 1997), 258.

4 V. Andreoli, A. Pasa, and C. Trabucchi, "Carlo," in *L'art brut* (Lausanne/Paris: Publications de la Compagnie de l'Art Brut, no. 6), 74; S. Marinelli, *Carlo Zinelli*, 11.

5 S. Marinelli, *Carlo Zinelli*, 2.

6 D. Buzzati, *Sono dei veri artisti*, exh. cat. (Verona: Galleria La Cornice,

1957); A. Moravia, "I pittori malati di Verona," *Corriere della Sera* (6 Sept. 1959); V. Andreoli, *Un secolo di follia. Da Freud alla psichiatria degli anni duemila* (Milan: Rizzoli, 1991), 10–104.

7 F. Pesci, "Carlo Pittore. Questioni tecniche e stilistiche," in *Carlo Zinelli*, xxxvii.

8 V. Andreoli et al., *Carlo*, 83.

9 F. Pesci, "Carlo Pittore," xli: "In the case of the collages, the problems relative to the conservation of Carlo's paintings are dramatically revealed, as most were realized in tempera on paper, fragile elements but even more so when the paint is used as a glue for attaching candy or cigarette wrappers."

10 V. Andreoli et al., *Carlo*, 89–90.

11 S. Marinelli, *Carlo Zinelli*, 21: "In fact it is on the formal level that the playful spirit emerges of this artist who could have had the disordered ingenuity for comic strips."

12 M. A. Azzola Inaudi, "Carlo fra pittura scrittura e musica," in *Carlo immagini oltre i confini*, exh. cat., European Parliamentary Headquarters, Brussels, 1999 (Verona: Grafiche AZ, s.r.l., 1999), 18ff.; M. A. Azzola Inaudi, "Carlo e la musica del linguaggio," 270; S. Marinelli, "Carlo, dentro e fuori della storia," in *Carlo Zinelli*, xii.

13 V. Andreoli et al., *Carlo*, 80.

14 E. Husserl, *La crisi delle scienze europee e la fenomenologia trascendentale*, 3d ed. (Milan: Mondadori, 1968), 133–293; M. Heidegger, *Il senso dell'essere e la "svolta": antologia storico-sistematica del "primo Heidegger,"* ed. Alfredo Marini (Florence: La Nuova Italia 1982), lvii–lxiv, 70–84.

15 S. Marinelli, *Carlo Zinelli*, 3.

16 V. Andreoli, *Les dernières années*, 83; V. Andreoli, *Un secolo di follia*, 106–7.

17 S. Marinelli, *Carlo Zinelli*, 14. In my opinion, Carlo's response likely was in Veronese dialect, which was his mother tongue and usual mode of speech.

18 V. Andreoli, "Carlo e il suo psichiatra," in *Carlo Zinelli*, xvi: "In short, I vindicate Carlo's madness as a way of being, as a way of seeing the world, as an expressive conjecture. It is Carlo's art, and Carlo is a mad-man. Certainly an extraordinary madman. . . . An artist who does not need to be saved, executing his madness and perhaps trying to erase it. As his psychiatrist, I decisively affirm that he is one of the most typical schizophrenics, but at the same time he is a schizophrenic who has cre-ated, thus Carlo Zinelli is a man, a schizophrenic, a great artist."

19 "Abcd, entretien avec Bruno Decharme," in *Abcd une collection d'art brut*, ed. B. Decharme and B. Safarova, exh. cat., Musée Campredon, Isle-sur-la-Sorgue (Arles: Actes Sud, 2000), 299–307.

20 S. Marinelli, "Carlo, dentro e fuori della storia," in *Carlo Zinelli*, viii.

21 Jean Dubuffet, "L'art brut préféré aux arts culturels," in *Prospectus et tous écrits suivants, réunis et présentés par Hubert Damisch avec une mise en garde de l'auteur* (Paris: Gallimard, 1967–1995), 198–202.

Contributors

John Beardsley, senior lecturer in landscape architecture at Harvard's Graduate School of Design, is a noted scholar, curator, and author of American vernacular art. His many publications include the books *Black Folk Art, Gardens of Revelation,* and *Earthworks and Beyond: Contemporary Art in the Landscape.* Most recently he has contributed to *Souls Grown Deep: African American Vernacular Art* and *The Quilts of Gees Bend.* He has taught at the University of Pennsylvania and at the University of Virginia. Beardsley was awarded a John Simon Guggenheim Memorial Foundation Fellowship in 1996.

Caterina Gemma Brenzoni is an art historian based in Verona, Italy. She has worked as a curator for the Castelvecchio Museum there, as well as for other institutions in the Veneto and Lombardy. A scholar of both medieval and modern art, she lectures frequently on both topics. Head of the Verona branch of Città Nascosta (Hidden City), Brenzoni is also the author of several children's books about Veronese art and culture.

Annie Carlano is curator of European and North American Collections at the Museum of International Folk Art. A former curator at the Museum of Fine Arts, Boston, and at the Wadsworth Atheneum, Hartford, she has published extensively and has taught at Parsons School of Design (Paris campus), the Fashion Institute of Technology, the State University of New York, and Bard Graduate Center, New York.

Victoria Y. Lu is professor of art history at Shih-Chien University, Taipei, and a member of the board of directors of the Taipei Contemporary Art Foundation. A specialist in Chinese and Taiwanese contemporary art, she has published in Taiwanese journals and has written for international publications including *Inside Out/New Chinese Art, The Rising New Moon,* and *Encountering the Others.* Lu recently curated the exhibition *Visions of Pluralism: Contemporary Art in Taiwan 1988–1999* at the National History Museum in Taiwan.

John Maizels, editor of *Raw Vision*, is a specialist in the field of Outsider Art. His publications include numerous articles and the book *Raw Creation: Outsider Art and Beyond*. As director of the Nek Chand Foundation, London, he has organized the restoration of the Rock Garden at Chandigarh.

Susan Brown McGreevy, former director of the Wheelwright Museum of the American Indian, is a cultural anthropologist specializing in Navajo art and culture. Her most recent books are *Indian Basketry Artists of the Southwest* and *Navajo Saddle Blankets: Textiles to Ride in the American West*. She teaches Navajo and Hopi art at Santa Fe Community College and is a research associate at the School of American Research and the Museum of Indian Arts and Culture.

Jacques Mercier is an authority on Christian Ethiopian art, culture, and religion at the Centre National de la Recherche Scientifique, Laboratoire d'Ethnologie et de Sociologie Comparative, Paris. He is the author of several books on Ethiopian art including *Ethiopian Magic Scrolls* and *Art That Heals: The Image as Medicine in Ethiopia*.

Randall Morris, a specialist in the self-taught art of the Caribbean and the Americas, has published frequently on the work of Martín Ramírez. He is currently writing a book about the concept of *homeground*. Morris curated the recent exhibition *Redemption Songs: The Self-Taught Artists of Jamaica* for Diggs Gallery, Winston-Salem State University. He is a faculty member of the Folk Art Institute of the American Museum of Folk Art, New York.

Index

Photo Credits